CRAZY WOMEN

Johns Hopkins: Poetry and Fiction
John T. Irwin, general editor

Crazy Women

Short stories by Jack Matthews

The Johns Hopkins University Press

Baltimore and London

This book has been brought to publication with the generous assistance of the G. Harry Pouder Fund and the Albert Dowling Trust.

The Johns Hopkins University Press
701 West 40th Street
Baltimore, Maryland 21211
The Johns Hopkins Press Ltd, London

The following stories in this collection appeared in the following periodicals, to which the author and the publisher extend their thanks: *Black Warrior Review* ("The Two of Them Together" and " 'This Moment Is Ours Alone' "), *Michigan Quarterly Review* ("Haunted by Name Our Ignorant Lips"), *New Letters* ("A Marriage of Solipsists"), *Quarterly West* ("Harry the Woman Killer"), *Southwest Review* ("A Cat May Look"), and *Yale Review* ("The Tree Beyond").

The paper in this book is acid-free and meets the guidelines for permanence and durability of the Committee on Production Guidelines for Book Longevity of the Council on Library Resources.

Library of Congress Cataloging in Publication Data
Matthews, Jack.
 Crazy women.

 (Johns Hopkins, poetry and fiction)
 I. Title. II. Series.
PS3563.A85C7 1985 813'.54 84-25112
ISBN 0-8018-2633-0 (alk. paper)

Crazy Women *is dedicated to all those who will understand how negotiable and variously ironic the title is.*

Contents

CRAZY WOMEN

A Cat May Look

The Havlins lived in an old country house with an odd cupola atop the center peak of the roof. Here Havlin had fixed his telescope, and on every clear night before going to bed, he would trudge up to the solitary room and gaze at the planets or the moon. Sometimes, shortly after he got home from the office, he would fix a drink, light his pipe, and climb up the stairs to spend a few minutes of calm, adjusting his scope on sheep grazing on a distant hillside, or perhaps on the highway where he himself, only minutes before, had been driving. There was a feeling of emancipation at such moments when he could watch the succession of ghostly cars driving toward him—six miles away—enclosed in the silence of the telescope viewer.

Sometimes, Havlin would watch his children through the telescope. He admitted to himself that it was a snoopy thing to do. Still, there was a strange and irresistible fascination in watching them play beyond his presence . . . silently mouthing words to one another, shouting inaudible commands and questions, and often springing into swift gestures, movements, and collisions.

The first indication that something was wrong passed almost unnoticed one evening when Havlin turned the page of his newspaper and happened to glance at his twelve-year-old daughter, Francesca. The girl was lying deep in the leather chair, staring at their cat, Popcorn.

It was a common scene. Outside the window, a titmouse was fluttering on a low limb; the two younger boys were watching out-of-focus cowboys on the television screen. And on the opposite side of the room, Popcorn was humped up in a furry ball, staring back at Francesca.

Havlin turned to the classified section of the newspaper and looked for a used power saw, but none was listed. He had been thinking about

1

cutting down the remnants of an old hedgerow along the north boundary of his land. Then Francesca said, "He won't stop looking at me."

"Who won't?" Havlin asked, lowering his paper. But before she could answer, he saw that she was staring at Popcorn.

"It's because you're looking at him," Havlin said.

Francesca appeared troubled. For a moment she didn't move, and Havlin stared at her. People were always intrigued by this lovely young girl with snowy blond hair, green eyes, and a Latin name. Havlin and his wife had been uncritically devoted to her. She was dutiful, bright, and kind. A perfect child, they told each other.

In fact, the girl seemed so perfect that Havlin and his wife had begun to watch her closely, as if to discover the merely minimal flaws and weaknesses of humanity. It was their duty as parents, they told themselves. But as they watched the girl, duty gave way to simple curiosity. Francesca began to emerge as a perfection of girlhood, and it had all happened by accident, as it were . . . because there were the other four kids, and when you have that many, you let the silent, untroubled ones grow as they will. With Francesca, this untended growth had simply resulted in what appeared to be perfection.

Was she vain about her grades in school? Not noticeably. She laid her grade card in their hands as if she were merely the proud bearer of a gift from the benevolent teachers. Did she dislike other girls? No; to Francesca, they were all interesting, exciting friends. And in addition to these perfections, she was neat, clean, wholesomely alive, yet pure. A perfect child, Havlin and his wife told each other when they were alone and had a few minutes to speak of such things.

But now, she was disturbed by this thing about the cat. She started shaking her head. "No, Daddy," she said patiently, as if it were very important for him to understand. "I've looked away at least three times, and each time I look back, Popcorn's still staring at me."

"Well, he always was a crazy beast," Havlin said. He turned to the sports section of the paper and read about the latest developments in the spring training camps down South.

While he was reading, he was vaguely aware that Pete, the youngest boy, had picked the cat up and carried it out of the room. Francesca was making some kind of fuss. It had something to do with Popcorn's keeping his eyes on her even as Pete carried him out of the room. Later when he thought about it, Havlin pictured the cat's head turning silently on its body like some well-lubricated ball-bearing joint.

Francesca made a big thing out of it, laughing too loudly and calling for attention, but Havlin didn't respond. With five of them, you learned to

2

tune the kids out or go crazy. And of course, his wife couldn't be bothered. She was out in the kitchen getting their dinner ready.

During the next week or so, Francesca was constantly talking about the cat. Havlin occasionally dropped his newspaper or pruning shears and obeyed her command to look at Popcorn—who did, indeed, always seem to be lying somewhere staring at Francesca.

"See?" she demanded once when the two of them were together in the study, reading. "He's been lying just like that for the past ten minutes. He hasn't moved."

"Are you sure it's been ten minutes?" Havlin asked. "Are you certain you're not exaggerating this thing?"

"Well," she said passionately, "it's been an awfully long time. Daddy, he makes me nervous, doing that."

"Francesca," Havlin said, walking over and grabbing the back of his daughter's neck and massaging it gently. "Maybe he looks back at you just because you pay so much attention to him. Nobody else even notices he's around. Naturally, he'll look at you if you look back."

"Yes," she said. "But I *do* look away. And yet when I look back, it's just like he can't see anything else. Only me."

"I wouldn't let it upset me. Now, wouldn't that be silly? Good Lord, I wouldn't think Popcorn could threaten anyone!"

Francesca nodded and didn't say anything else. A minute later, when Havlin glanced at her she seemed to be concentrating on her book.

At another such time, it was dusk, and Havlin had been raking peat moss into the rose beds along the fence; Francesca had been helping out by using the hose. She stood beside her father waiting for his orders to soak the dirt he had just finished raking. She was dressed in old Levis that Mike, the oldest boy, had outgrown; and her sweater was tattered and dirty. A smudge of dirt lay as thick as a dab of oil paint on one cheek, and her long loose hair flew about in the wind, sometimes wisping down over her eyes. But she didn't bother to brush it away.

Havlin had almost finished, and he straightened up with a loud sigh. "Why are *you* so quiet?" he asked his daughter.

"I don't know," she said.

Something in her voice made him glance at her. But he didn't say anything more until someone in the house switched the yard lights on, and the two of them started throwing the tools in the wheelbarrow.

"Looks like a clear night," Havlin said. "Want to come up and look at the stars for a minute?"

"I guess not," Francesca said. "Thanks anyway."

3

She appeared to be looking at something at the edge of the house. Havlin followed the direction of her gaze, but all he could see was the arborvitae (the one with the broken top) . . . and Popcorn, who was staring back. Havlin had forgotten about the cat until that moment.

The cat disappeared the next Sunday. On Monday Havlin was caught up in a fantastic amount of work, and for most of the week he didn't manage to get home until ten or eleven o'clock. By then, he was too tired to think about the yard or his telescope, and too weary to listen very closely to his wife's family gossip as she served him a late dinner.

But by Saturday, things at the office had been taken care of, and Havlin was able to get home shortly before noon. His wife had fixed grilled cheese sandwiches and vegetable soup for the kids, and Havlin ate and then took a nap. He was awakened by the cool spring breeze rattling the venetian blinds of the bedroom, so he put on his old pants and a T-shirt and went out into the sunlight. He worked all afternoon, raking out the ground ivy back by the wood pile, nailing slats back onto the fence, and clearing away some broken limbs from the dying cherry tree.

It was almost six o'clock when Havlin's wife rang the dinner bell. The kids came running in. Pete threw something at the dog, who jumped back barking and knocked against Havlin's legs. This made him think of Popcorn for a moment. But then he forgot all about the cat in the excitement and confusion of dinner.

After he had eaten, Havlin was sitting in the leather chair, half intent upon the evening paper and half considering whether he should take a shower right away or wait until later. It was a pleasant moment. The physical tiredness in his legs and back was a luxury after the week's mental and nervous strain.

He yawned twice, and then—closing his mouth after the second yawn—he heard Francesca speaking to her mother in the kitchen. The two of them were washing dishes, and as Havlin listened, their voices became unnaturally clear, as if they had been recorded and the volume had been turned up.

"I don't care," Francesca repeated. "I'm glad it's gone."

There was a splashing sound as her mother plunged something in the water and then said, "Why, Popcorn was a nice old cat. How can you say that?"

"I don't care," Francesca said. Then, an instant later: "Nice to some, maybe."

There was a brief moment when the tap water was turned on hard, and neither Francesca nor her mother spoke. When it was turned off, Havlin got out of his chair and took several steps toward the kitchen. He

stopped when Francesca said, "You can't have something *watching* you all the time, can you?"

Havlin heard his wife laugh and say something about Francesca's imagining things. Then Havlin's wife stepped rapidly into the dining room. When she saw Havlin, she said, "Well, what are *you* doing here?"

"I think I'll hit the shower," Havlin said.

"Sounds relaxing," his wife said. In the kitchen, Francesca was silent. He walked in to get a drink of water, and his daughter didn't look at him. She was standing at the sink, idly stirring the dirty dish water with her left hand wrist-deep in the water, and she didn't look up when Havlin filled his glass and drank.

It was almost eleven o'clock when he trudged upstairs to his solitary room to look at the stars. He put in the lens and fussed with his equipment for a few minutes. Then he pointed his telescope toward the north and began viewing at random.

A few minutes later, he thought of something he had seen through the telescope almost a week before. It had been late in the afternoon, and he had come up to look at the far hills that loomed pale and gray six miles to the west, and also to see some leafing trees on the nearer hills. He was about to go down, when he noticed Francesca's silver hair. She was doing something at the edge of their land. Her movements were strange and awkward—like some sort of solitary, rhythmic, nodding dance there on the pasture with no one to witness her . . . merely the dying hedgerow, the long spears of wild timothy that had lasted through the winter . . . the line of trees beyond a white horse fence . . . and, of course, her father.

Havlin turned the telescope down and finally got her into view. She was chopping at the ground with a rusty old hoe she had found some-where . . . chopping furiously, with her hair flying wildly about her face, and her eyes staring wide-open. The expression on her face was a little like that of a swimmer who is strangling for air . . . or perhaps that of a girl who has just seen a snake and is holding her breath while she slices it apart with long, desperate swings.

But of course Havlin now knew, without a doubt, that it had not been a snake, but something else. It was a little strange that he had been able to forget such a glimpse of the gentle child he knew his daughter to be. Possibly he hadn't wanted to think much about it.

Of course there was no point in saying anything now. Hadn't he and his wife looked for just such a thing? And wasn't what Francesca had said the precise truth he should remember now? You needed secrecy. Everyone needed it. Obviously the beautiful and intelligent Francesca needed it . . . perhaps more than the less perfect children who inhabited the world around her.

5

Mange

The man was slightly plump and bearded, with a bulging forehead. He wore a pale blue knit shirt and white slacks. The woman who sat beside him wore a white sun dress. She had tangled, shoulder-length hair with the vestiges of curled ends. She was slightly larger than the young man beside her, with a flat face, wide mouth, and eyebrows as pale and nearly invisible as the light haze on her arms.

Both of them were about thirty. The man was driving, leaning forward at the first crossroad to look both ways.

"We haven't gone far enough yet," the woman said.

He nodded. "I know, Elise, but you've got to watch these crossroads in the back country."

His saying her name suggested a mild impatience, and she nodded and pulled her hair back from her face. Did he think she was nagging? They'd worked together often enough that there might be something like the old clichéd ma-and-pa bit between them, even it if did seem grotesquely improbable.

"It's the next one," he said, saving her the trouble of pointing it out.

The yellow Datsun was covered with dust from the road. A pickup truck had passed them five minutes before, and Mark hadn't had the sense to drop back and let the dust subside. Instead, they'd driven in the pickup's wake, "eating their dust," as her father would say. Elise hadn't said a thing to Mark, then, even though it was stupid of him to give them both a dust bath. By the time they arrived, they'd be covered. Like sugar on a donut.

"This one," Mark said emphatically, crossing his forearms as he turned the steering wheel. He might have been maneuvering a semi the way he worked the turn, and Elise looked away so he wouldn't be able to glance at her and see her expression.

6

The Datsun bounced in the ruts of the back road, and now and then they could hear the long grass in between the tracks scratching the transmission and gears under the car. The township road was all but abandoned, meandering through a thick tangle of saplings and brush. "Not many people use *this* road," Mark said, leaning forward again, so he could see better.

Suddenly, coming around the next turn, they saw a wide and open valley to the right—extending all the way to the creek—and on the left, almost overhead, loomed the dark unpainted house. An old cement block garage was shoved into the hill underneath, and a crumbling stairway of older cement blocks marched directly up the hill to the wide front porch. A railing made of iron pipe followed the cement block steps; but halfway up, a section of it was missing. That part, you had to climb without anything to hang onto.

Elise wondered briefly, contemptuously, if Mark would hesitate before continuing when he got that far.

The back end of an old Chrysler stuck out of the garage, as if that was all the farther it could be driven in. Perhaps the front of the garage was filled with junk, or maybe part of the hill had collapsed inside. The cement block, everywhere, was crumbling, broken, as gray and decayed-looking as rotten teeth.

Mark turned off the ignition, and the heat came over them in a kind of sigh. The dust they'd raised sifted vaguely into the sun-drenched air and the two of them sat silently for a moment, looking up at the house.

"It looks like he's here, all right." Mark said. There seemed to be something like disappointment in his voice.

"You mean the car?" Elise said.

Mark nodded, looking up at the porch. "And the front door is open."

For an instant, they looked up at the darkness of the front porch, and the deeper darkness of the opened front door. A screen door was closed, but a third of the upper section of screen had been peeled away and hung loose against the frame. Halfway up the steps, almost as far as the section where the pipe railing was gone, a black and white cat sat watching them. Back of the house, somewhere, they could hear a dog barking. Wild vines and long spikes of grass on the hill stood in uneven patches against dry dirt and rock. Here and there, faded old plastic children's toys studded the tufts of sod, caught hanging in various postures.

Elise, who was not overly sensitive to dirt, sat staring at the scene. Finally, she said, "Are you sure this is the place?"

Mark nodded. "Look at the mailbox."

She did and saw the name "Crossep" painted crudely in white letters, the bottom of the "p" leaking clear to the bottom. The name had been painted on the mailbox while it was standing.

"I have a feeling this isn't going to be easy," Mark said, pulling on his beard.

"Nobody ever said it would be," Elise said briskly, opening her door and getting out. She turned, put her hands on her waist and stretched backwards in order to ease her cramped muscles from so much sitting. Then she stared up at the dark porch. Somehow, it didn't look cool, as dark places should look on such a hot, dry, sunny day as this: it looked merely dark. She imagined it crawling with flies.

Mark was out of the car now, and closed his door. "Well, no greeting committee," he said.

"I don't imagine Mr. Crossep is the sort who comes out to greet people," Elise muttered as she stepped across the road toward the cement block steps that led up to the house.

"Do you suppose I'm far enough off the road?" Mark asked from behind her.

"You're fine," Elise said without turning around.

By the time she had reached the section without the iron pipe railing, she could hear Mark's heavy breathing behind her. Well, he'd caught up, at least.

Once again she raised her face and looked. Still nobody out on the porch. Not even any flies visible from this distance, although she had no doubt there would be plenty there.

Somewhere behind the house the dog still barked. It had heard the car stop, and it couldn't stop barking. No doubt it was tied, which seemed odd for a place this far out in the country.

As for the cat, it had disappeared. Maybe it was over in the weeds, peering out at them from behind the remains of a plastic toy. And maybe the plastic toy had once belonged to the old man's son, Ron, who was indirectly responsible for the two of them being here in the first place.

When they reached the wide porch, they could see how badly the old house was rotted—the floor boards sagged and showed gaps at a few splintered edges. Somebody might fall through, but there wasn't much evidence that anybody who owned such a place could be successfully sued for damages.

There was a slight breeze, the house being so high on the hill, and the porch wasn't infested with flies after all: only two or three hung torpidly on the wall beside the screen door. Maybe the flies were all inside, where it was more comfortable.

Mark reached the screen door before Elise did, and she let him

8

knock on it with his fist, which made it rattle in its frame. The sound echoed from the dark emptiness within.

Somewhere in back, a man's hoarse voice yelled, "Shut up!" and the dog stopped barking instantaneously, as surely as if his barking had been switched off by means of an electric current.

Both of them turned to face the side of the porch and waited; and before long they heard heavy footsteps. Then Ned W. Crossep appeared, stopping at the side of the porch and staring at them through dirty eyeglasses. He was naked to the waist, with a furrow of gray hair down his chest. The top of his head was bald, although the hair at the sides was neatly trimmed. He had a wide face with thick eyebrows and a big jaw that seemed too heavy for the scrawny neck and chest beneath. The expression on his face was not so much hostile as it was distant. He might have been fifty yards back in the woods looking at them as he stood there for a moment, watching what they were about and waiting for what they might say.

"Mr. Crossep?" Mark asked.

"We pronounce it 'Crow-sepp,' " the old man said warily.

For a moment neither Elise nor Mark said anything, equally convinced that this was exactly how Mark *had* pronounced it.

Maybe Elise could help out. She said, "I'm Elise Farrell. I phoned you yesterday?"

The question was of course not a question at all, but a reminder. And yet it was hard to tell whether Mr. Crossep took it that way. He seemed to be thinking it over, as if she were awaiting an answer.

"You knew we were coming," Mark said in a tone that suggested something contractual in their being here.

"I knew," Mr. Crossep said. Then he nodded and walked around to the front of the porch, where they were surprised to see that he was wearing baggy dirty gray shorts. His white, varicosed legs and bony knees were ridiculous enough, but his dark socks and heavy work shoes made his appearance even more bizarre.

"It's as cool out here as it is in there," the old man said, shooting his index finger toward the house. "You can set right there on the steps if you want."

"Sure," Mark said; and Elise said, "Thank you."

There was the back of an old unpainted kitchen chair sticking out from under the porch, and Mr. Crossep pulled it out and fiddled with it until it was straight upon the uneven ground, and then sat down. If he leaned back in it, he might go toppling backwards down the hill, head over heels, paralleling the cement block steps, and land somewhere in the dirt road, not too far from the Datsun.

9

But he seemed sure of himself. There was something cussedly spry about him, and his big rugged hands were sun-tanned and powerful-looking, as if they should have been attached to arms far more impressive.

He narrowed his eyes at Elise. "You told me you wasn't newspaper, and I believed you," he said.

She swallowed and said, "That's right, Mr. Crossep. I didn't mislead you. We're from See-Ay-See-Pee, as I explained." She pronounced it as all-one word, with the accent on the third syllable, as in "Mississippi."

"What's that?"

"That stands for 'Civilians Against Capital Punishment,' " Mark said.

Mr. Crossep thought about that a moment, and then slapped a fly on his forearm. Mark couldn't be sure, but he thought he saw the fly fall to the ground, dead. It was a quick movement, and enough to put an end to any fantasies that the old man was about to fall backwards off his own steep hill.

"We're here because of Ron," Elise said. "I mean, I explained all that over the phone, you'll remember."

The old man's expression seemed stubborn, oblique. He seemed to be thinking: Don't tell *me* what to remember! I'll remember what I goddamn well *decide* to remember!

But of course, he didn't say anything at all, and Mark took up the matter. "We want to help you, Mr. Crossep. You and Ron, both."

"You can't do both," he muttered, looking up at something over their heads. Maybe it was a hornet on the porch. Mark had seen what appeared to be a hornet's nest above the window on the left side. The window itself was closed with a dark brown blind that showed pale cracks in it, like a topographical rendition of a dried-up riverbed.

Elise nodded. "We know about your letter, of course,"

"Did they publish it in the newspaper?" Mr. Crossep asked, sounding more interested.

"Part of it," Mark said carefully.

"Which part?"

Elise started to speak up, but Mark said, "The main part. Enough to let your wishes be known."

Elise rubbed at a smudge of dust on her skirt. *Wishes be known!* What a sappy way to put it!

"That's what I wanted, all right," Mr. Crossep said comfortably, crossing his skinny legs and arms simultaneously.

"I think you should know about our organization," Elise said.

Something in her voice seemed to alert the old man, make him

wary. "I don't want to know about any goddamn organization," he muttered.

"But you see," Mark said, leaning forward on the step so that his elbows were on his knees (an insurance man about to close a sale), "that has to do with what we're *doing* here!"

"I didn't ask you to come all the way up here," Mr. Crossep said in a sullen and far-away voice.

"No, but it's very important to all of us. And of course, you understand how important it is for Ron."

"The less said about him, the better."

But you're his father! Elise wanted to cry. However, she remained silent. Maybe Mark would be able to get a wedge into the old man's thinking, somehow.

"Did they really print it in the paper?" Mr. Crossep asked after a moment.

"Yes, they certainly did," Mark stated, nodding firmly. But then he seemed momentarily at a loss, and began to tug on his beard.

Elise knew this was a sign of uncertainty, and said, "We're simply trying to help as many people as much as we can."

"Some people don't need help," Mr. Crossep said darkly. And then, even more darkly, he said, "And there are some who don't *deserve* help."

Mark nodded vigorously. "And we understand that, when you wrote that letter, at least, you felt that way about your son. We understand that."

"And not a goddamn thing has changed."

Right then, the dog started barking again, and Mr. Crossep raised his head and yelled, "Shut up, back there!" The dog lapsed into silence as before.

"I don't want you messing into this business," Mr. Crossep said to them. "I want the law to take its course. I want them to hang that son of a bitch or electrocute him or get rid of him any goddamn way they can. You call him my son . . . well, let me tell you something, that son of a bitch was never right in the head for a day in his life. If I'd ha knowed he'd grow up to cause all this trouble and kill them people, I'd ha wrung his goddamn neck like a little rooster the minute he was born. Not that them people he killed was much. Still, he's mean as a snake, always has been, and always *will* be. Now there, what do you think of that?"

Elise gazed down at her skirt as she patted it with her hand. "I think you're making it awfully hard for us, Mr. Crossep."

"How's that? How's come I'm making it *hard* for you?"

"You see," Mark said, closing his eyes and scarcely parting his lips

as he spoke, "we are dedicated to the principle of doing away with capital punishment as an obscene and primitively brutal holdover from the past."

For a moment nobody said anything. Finally, Mr. Crossep took his glasses off, held them at arm's length, and looked at them. Then he said, "I don't know what you're talking about."

"Maybe *I* can explain," Elise said softly, gesturing with her open hand. Mark was pulling at his beard again, staring off into the distance. The valley before them was peaceful and green, and the far hills were pale in the afternoon haze.

She heard Mark inhale and hold his breath as he turned toward her. She frowned and gathered her thoughts, while Mark plucked at his beard and Mr. Crossep brought his glasses back to his face and put them on. His furry eyebrows were arched, she noticed for the first time, as if in some expression of aborted hilarity.

"I'm waiting," he said, adjusting his glasses.

"I'm just trying to express myself clearly," Elise said, smoothing her skirt out again with her hands. Her knees seemed to be thrust up too high, so she lowered her feet to the next step down, feeling it wobble beneath her heel.

"What it is. . . ." Mark began, his patience giving out.

But Elise interrupted him, convinced that she had staked a claim upon the next move, and should not be hurried either into tactlessness or fatuity, just because the two men were instinctively in a hurry to get things over with.

"What it is," Elise said, touching Mark on the arm so that he would desist, "we have our commitment to See-Ay-See-Pee. And the fact that we're doing absolutely everything we can to have the death sentence of Ron Crossep commuted to a life sentence of some sort . . . all of our efforts are negated, canceled out completely, when *you,* Mr. Crossep, this boy's father, write a letter to the newspaper saying that the boy should be executed!"

"Did they really print my letter?" Mr. Crossep asked again.

"Yes, they really printed it," Mark said, showing a little impatience, which surprised Elise, not altogether unpleasantly.

The old man shook his head and leaned back in his chair, making the two front legs rise slightly from the ground. Maybe he would go spinning backwards off the hill after all.

"Can't you understand how we feel?" Elise said, cupping her hand before her, as if weighing some intangible value in it.

"I don't care about you one way or the other," Mr. Crossep said.

"And I don't know no more what you're talking about than if you was talking Eye-talian or Rooshian."

"But surely," Mark said, "you can't be entirely indifferent to what happens to your son!"

The old man let his chair pop forward onto all four legs and looked at Elise, as if she were about to say something, too. But she only nodded, so he adjusted his glasses with his dirty thumb and said, "No, I don't guess I care the way you figure I should. What I care about is, they ought to put that son of a bitch out of his misery just like that." He snapped his fingers. "I give up on him about twenty years ago."

"Mr. Crossep," Elise whispered passionately, "he's only *twenty-two now!*"

The old man thought a moment and then nodded. "Yep, that's about when I give up on him. He was bad from the start. The way a dog will give birth to a bad one, now and then: all mange and itch and dumbness. Best thing you can do with one that has bad blood is take it out and hit it over the head with a shovel, then dig a hole and let it fertilize the ground. That way, it's worth something."

"I can't believe you're talking about your own *son!*" Mark said. But by the time he'd finished saying it, he'd turned to Elise, who was utterly motionless. She didn't seem to be breathing, even.

Mr. Crossep scratched himself under the armpit. "Let me ask you two something: you ever talk to him?"

"No," Elise said, shaking her head, "we haven't."

"Ever seen him?"

"No."

"Well, maybe you'd better go take a look before you get so up in the air over him being executed. If you don't know nothing about him, how's come you're so worked up over having them keep him alive?"

"It's the principle, of course," Mark said. "The *idea.* If you start thinking that one person isn't fit to live, then it's easy to think that way about anybody. Or everybody."

Mr. Crossep laughed and shook his head. "You hit the nail on the head right there: Ron ain't fit to live, all right!" There was something almost like pride in the way he said it.

Mark gestured with both hands before his face. "You know, nobody asks to be brought into this world."

"Of course not," the old man said. "Who's there to ask?"

The sharpness of this answer seemed to stun both of them for a moment. Then Elise said, "But we all start out helpless and vulnerable, and what we become is mostly in response to the things that happen to

13

us—the way we're treated by other people, our parents, our brothers and sisters. And the rest of it we can't help: we can't help being what we *are*."

"He wasn't worth a goddamn from the start. You wasn't there, so there's no point in arguing. You haven't never seen him, even, so I can't figure out why you're getting so worked up."

"We've tried to explain, Mr. Crossep," Elise said.

"Well, I can't figure it out. I can't figure out why you even come here in the first place." He had his glasses off again and was pointing them at Mark and Elise.

Mark started to repeat the name of their organization, but Elise knew how useless that would be, and interrupted him. "Mr. Crossep," she said, frowning and staring at her feet on the second step down, "do you have any other children? Or is Ron the only one?"

"I got three or four more, someplace."

Elise nodded. "I see. Three or four more. You're not sure which?"

"I know pretty well. Depending on how you count."

"What does that mean?"

"It means, one of them, name of Wanetta, has the brain of a four-year-old. Maybe five. She's on welfare some damn place, but I ain't sure where. Probably down river. Probably got some mangy brats of her own, I don't know."

Elise closed her eyes and thought.

"Is your wife still alive?" Mark asked.

"I ain't sure. If she is, she ain't around here no more. But I heard a year or two ago she was dead. She wasn't much, neither."

"Wasn't much?" Elise asked.

Mr. Crossep pointed his index finger at his own temple. "If she's dead," he said finally, "she'd be the last person to know it."

Mark started to laugh, but the look on Mr. Crossep's face was so distant that it would have been hard to determine whether he'd intended to make a joke or not. Best not to laugh.

"I think we're losing sight of the subject," Elise said in an austere tone. "The subject is your son, Mr. Crossep. He's your son whether you choose to accept him or not. He has always been your son, and as long as he lives, he will *be* your son. There are some things that opinion can't change. And the fact that you have written a letter to the newspaper saying that you actually believe it would be better for your son to be executed . . . this is very hard, Mr. Crossep."

"It's not so hard," Mr. Crossep said. "Some kids just don't turn out right. Whose fault is that? Is it mine? If it is, I can't figure out how. That son of a bitch was mean and sneaky and a liar all his life. There ain't nothing going to change that. Why should I care if they kill him? It's what he

14

deserves. I wouldn't mind doing it myself. I'd just as soon put a pistol up against his head and pull the trigger as blow my nose.

"Didn't he kill them two innocent people? Not that *they* were much. But it's all this goddamn trouble. Over what? Why would I want him to be kept alive: all he'll do is cause more trouble and more than likely kill somebody else. He don't even get any pleasure out of it, I figure. I saw him drown a kitten once, right over there in a tub of water." Mr. Crossep pointed with his finger, although what he pointed at was the rim of hills above and beyond the Datsun. Still, he probably had a specific place in mind.

"Do you think he got a kick out of it?" he went on. "Not so's *I* could see. He held that kitten under water and just kind of looked away, like he was thinking of something else. Maybe what he was going to do next. Do you know what I figured?"

"What?" Elise asked, almost breathlessly.

"I figure he just wanted to feel it stop moving. That's what I figure. Now if he got pleasure out of that, all right: but like I said, he wasn't hardly even paying attention."

"Good God!" Mark whispered, shaking his head. He put his two hands down on the top step beside his hips, and in doing so, lightly touched Elise's hand, making her jerk it away.

"We were thinking," she said after a moment, "that you might be willing to recant."

Mr. Crossep narrowed his eyes, and before she could paraphrase, asked: "What's that?"

"Take it back," Mark said.

"The letter?"

"What you *said* in the letter," Elise explained.

The old man shook his head. "Now why would I ever want to do that?"

"You know," Mark said, "it isn't just Ron we're talking about." Elise nodded and said that was right.

Mr. Crossep closed one eye at them. "What you talking about now?"

"It's called *precedent,* Mr. Crossep. If somebody can be executed for a crime, no matter how bad, then it makes it easier to execute somebody else. And the next time, it'll be easier yet. And pretty soon, they'll be able to execute people for just about anything. People will get used to it."

Mr. Crossep thought about that. "Well, I figure Ron isn't the only one."

Mark closed his eyes, and Elise said, "You mean, the only one who in your opinion *deserves* to be executed."

15

The old man nodded. "I could name you five or six myself, right around here. And for all you know, I could be one of them. Maybe I am. I wouldn't mind, if I turned out to be one of them. I figure things shouldn't get so goddamn complicated. I figure life should be, you know, *simple.*"

"I think we're wasting our time," Mark said out of the corner of his mouth, still facing the old man.

"I think we've been wasting our time," Elise said more loudly, speaking to the old man directly.

"Wouldn't surprise me none," he said, nodding.

"We're not communicating," Mark muttered to no one in particular, standing up and brushing the dirt off his hands.

"One thing they talk about," Mr. Crossep said, not moving from his chair.

"What's that?" Elise said, standing up beside Mark.

"Don't they talk about population and everything?"

"What do you mean?" Elise asked.

Mr. Crossep leaned forward with his elbows on his bony knees. "They say people are breeding too much everywhere. I seem to have read that somewhere."

Mark nodded. "Sure, that's a problem."

"Well," the old man said, grinning and for the first time showing that he was missing two teeth in front.

"Well, what?" Mark asked.

"I know what he's saying," Elise said, touching his shoulder.

"So do I," Mark said, twisting his shoulder away from her touch. "But I want to hear him say it."

"That son of a bitch is as good a place to start as any, it seems to me."

For a moment, neither of them said anything. Then Mark said, "Does that go for his sister, too?"

Mr. Crossep stood up. "As far as I'm concerned, it goes for anybody. What the hell you making so much out of it for? What's anybody got to look forward to, anyway?"

"Whatever kind of question is that?" Mark cried.

"The oldest question in the world," Elise said, tugging on his shirt. "Come on, let's go."

"Don't think it hasn't been a pleasure," Mark said, his voice too high and loud. "Because, it hasn't."

"Never mind," Elise said.

But the old man couldn't have cared less, and when they reached the top step, both of them turned around to see him leaning over and easing a gob of spit onto the ground. He wasn't even looking back at them.

16

The Datsun was so hot, both of them started to sweat the instant they closed the doors. When Mark turned it around, they looked up at the house, but Mr. Crossep was nowhere in sight. The dog was barking again.

Slowly, the Datsun waddled back up the track toward the township road. Soon they were in the shade again, the Crossep house and the valley behind them. It was cooler, but the air was close, as if they were inside a room.

"What a hateful old man!" Elise said finally.

Mark nodded. "I know. And that's the reason he's right."

"He's what?"

Mark crossed his arms again and made the ridiculous trucker's turn onto the township road. "It came to me while we were talking."

"What did? What are you talking about?"

"We *haven't* seen Ron Crossep, and if we did, we might agree with him. What I'm saying is, he might be a chip off the old block."

"That's malicious nonsense," Elise said through scarcely parted lips, "and you know it."

"I guess I have to finally admit to myself that I just don't agree. I don't think the case could have been presented any more eloquently."

"God, I don't believe I'm hearing you say these things!"

"Be honest: would you *really* care if somebody electrocuted that old man back there?"

"We're not talking about him, and you know it. We're not talking about anybody specifically, and you know that. I can't get over what's happened to you all of a sudden. If the law isn't blind to human peculiarities and even—well, *hateful* qualities—then the battle's lost, and you know it as well as I do."

"I know it, I just don't believe it any more. Not after listening to the articulate Mr. Crossep."

"He's a pathological case, Mark. And you know it as well as I do."

"I do not know it and neither do you. It's a matter of judgment, which means belief. It's not like observing that he's bald or wasn't wearing a shirt."

Stunned, Elise remained silent, her thoughts in a turmoil. The terrible heat in the car's interior seemed to be part of what she was experiencing; but alongside that, *parallel* with it, somehow, was what she had to conclude was Mark's repudiation of all that they had worked for so long. Where did his sudden conclusions leave C.A.C.P.? Out in the cold. Where else?

Somehow, she realized that there was no point in bringing this up with Mark. Maybe it was just his mood—temporary, frustrated, exacer-

bated by the heat. She pulled her hair back out of her face and stared at the shimmering township road.

The two of them had worked pretty well together, and now she sensed it was all about to end. There was always a certain wistfulness in endings. Even though their relationship had never had anything like passion in it. There was something of the male/female thing always at work, of course; but she hadn't felt his masculinity enough for it to be all that important.

Except now, paradoxically. Something had shifted in him when the two of them had been facing Mr. Crossep. She'd felt the shift as they'd talked; she'd heard things in Mark's voice she hadn't heard before. The two of them had come to some sort of agreement that left her out. They hadn't even known it, of course; but it was there.

There wasn't really all that much pain in her realization. In a way, it was the end of a little marriage they had had, without ever acknowledging that it existed. This wouldn't be the first time she had found it somewhat strange that the two of them seemed to fall together, to share a case more often than others seemed to. If anyone had asked, they would have both resorted to the cliché of personal chemistry.

Which was perhaps as good an answer as any. But whatever it had been, Mark would no longer be part of it. He was about to leave C.A.C.P. for good. She could feel it all through her.

Along with a kind of loneliness. And perhaps just a breath of terror, as if somewhere, somehow, Mark and the old man would meet in secret, and join forces against her, so that people like Ron Crossep would be executed more and more casually.

Killed like flies, she told herself, glancing over at Mark who was not at this moment crouched forward, but was, rather, reared back, like a king of hard-assed truckers, very much in control, half in charge of the whole goddamn world.

The Two of Them Together

When Luke came home from school, he was surprised to find his mother waiting silently for him just inside the front door. She was dressed in her finest clothes and standing there looking at him out of two circles of blue eyeshadow. She was as dressed up as she had been that day over a year ago when she'd told him that his father had left them for another woman. Probably, she had been standing at the window for a long time, watching for him to get off the school bus. Luke could imagine how she'd stood there, ceremoniously dressed for disaster, the fingers of her white veined hands locked prayerfully together.

"What are you doing home from work?" Luke said, throwing his tan rain jacket over the back of the chair.

"I got off early," she said.

"Why? What's up?"

"I have something to tell you."

Something the size of a small wrist turned in his stomach when she said it that way.

"Aren't you going to ask what it is?" she said.

"Sure. What is it?"

"Dad's in town. *My* dad. Your grandfather."

"So?"

"What on earth do you mean by that? You've never laid eyes on him once!"

"It's not my fault," Luke said, looking to the side.

"I didn't say it was. Do you realize I haven't seen him either in all that time? Over fourteen years!"

Luke nodded and thought: *It wasn't your fault, either,* but he didn't say anything.

His mother walked over to the sofa, picked up a green satin toss

19

pillow, and held it in both hands before her stomach, as if to shield herself from some poisonous radiation. She hadn't said anything about Luke hanging up his rain jacket; she hadn't seemed to notice his throwing it over the chair. She looked at the toss pillow as if she'd never seen it before. The scent of her perfume filled the living room, stronger than pipe smoke.

"It smells like a funeral in here," Luke muttered, half under his breath.

"And he's never once laid eyes on *you*," she told the pillow, frowning at it. "Here you are fourteen years old, and he's never laid eyes on you!"

"He's right here in town?" Luke asked, trying to help his mother out a little.

She nodded at the pillow and threw it back onto the sofa. Then she raised glistening eyes to the ceiling and inhaled dramatically, and he knew she'd been crying. Probably half the afternoon. Maybe even at work. It half sickened him.

"He was always very strict and moral," his mother said, using the words as if they referred to some exotic practice or belief that was difficult to understand.

"You've told me all that," Luke said, feeling an obscure nudge of desperation.

"We weren't married, your father and I; and when he found out I was pregnant, dad was furious. There wasn't anything else I could do but leave home. You'll never know what I went through, when that happened."

"You were married later, so it was all right," Luke said, repeating the old formula she had given him years ago. As if he had received and stored this argument for her, so it could help her understand and forgive the fact that he was practically a bastard.

She slumped in the sofa, clasping her fingers in her lap. He noticed her painted fingernails. He pictured his grandfather as an angry, pale-faced old man with a tight little mouth all puckered and seamed. He had never seen a photograph of him. His mother claimed she didn't have one.

Out of her sudden depth, she surfaced and smiled. "I am glad about one thing," she said. "I'm glad you'll finally have a chance to meet him. And he'll have a chance to meet you. Finally to look on you. The two of you together."

Luke closed one eye and sighted at his bedroom door down the hallway. "He's coming *here?*" he finally asked.

"Of course," she said. "God, I hope everything will be all right!"

"It probably will be," Luke said, nodding. Lately, she seemed to

hang desperately on his statements; and yet, she could never remember what he said. But this didn't prevent her from consulting him on the most unlikely matters and make a point of showing respect for his opinions.

"Over fourteen years," she whispered. "And finally coming to see me after all that time. Us."

"That's a long time."

"All your life," she said lugubriously. "And you've never once laid eyes on him."

"Sure."

"Maybe he'll want to take you out for ice cream or something. I think it would be nice if the two of you got to, you know, *know* each other."

"God, I hope he doesn't want to do anything like *that!*"

She pointed at him. "One day out of fourteen years certainly isn't too much to spend with your grandfather, is it?"

He thought about that, but then gestured mutely toward his room. "I didn't even know he was coming," he said miserably.

"Sometimes opportunity doesn't phone ahead," she said, narrowing her eyes at his forehead.

Actually, he *was* a little curious to see his shadowy grandfather. This surprised him, a little. It even made him uneasy.

He started toward his room, and his mother said, "Please wash your hands and face and put on a clean shirt. He's coming for dinner."

"You didn't tell me *that!*"

"Well, he is. I thought you understood."

I thought he was just dropping in!"

"Dinner!"

"Oh no!" he said, pounding his feet as he walked to his bedroom.

"Oh yes!" his mother yelled after him, "and don't you forget it for one minute!"

Shortly before Luke's father had left home, he'd returned from the old house where his mother had just died, bringing with him a huge box of model airplane kits. He gave them to Luke, explaining how he'd collected them at Luke's age, and built over a hundred. All his father's aunts and uncles had given him kits for Christmas and birthdays, and his own father brought back at least one kit from every business trip. Since he was a public health inspector, his business trips were frequent. But eventually Luke's father had lost interest.

"It was like pulling some kind of plug," his father had said. "And finally your grandmother gathered them all together and stored them in the attic, where she stored everything. I thought maybe you'd like to

21

build them. If you don't, no sweat. You can throw them away, as far as I'm concerned."

When Luke took the old kits out of the box, the first thing he did was line them up and count them. There were twenty-six kits, all brand new in spite of the fact they were over forty years old. Then he studied the pictures of the airplanes they were meant to represent. Most were biplanes from World War I.

Luke put the box aside in his room and forgot about it, until one day about a month after his father had left home, when he got out the kit for a Grumman fighter and opened the tube of banana oil, which filled his room with its sharp odor.

The first two models he made were defective in small details, but the third—a Spad—was perfect. After that, Luke spent hours in his room, gluing the frames and struts together and pinning them to the diagram sheets, and going to sleep at night breathing the faint pleasant aroma of the banana oil and savoring the fact that while he slept, the frames and struts were hardening, and the next evening he could glue tissue paper to the frame, and then dampen it, so it would tighten and smooth out as it hardened.

His long hours of absorption in his hobby worried his mother. She began to think that part of his pleasure came from his isolation from her during those long hours in his bedroom. She could almost feel him secretly trying to escape from her presence. This is when she started the truth sessions with him. Insisting that he occupy a seat opposite her in the front room, she quizzed him about various things, always ending up with questions about what it was in her that drove men away.

"It must be something in my make-up," she said, pressing the tips of her fingers against her lips and starting upwards.

Luke at first thought she meant lipstick and eye shadow and things of that sort; and then he realized how foolish an idea this was, and was glad he'd managed to keep quiet.

But his silence was part of what bothered her. She could have forgiven chronic foolishness in him. Certainly it would have been preferable to his drifting farther away with every unanswered question. 'What *is* it in me?" she cried out to her perplexed son.

"First, my own father; and then yours . . . and probably, within another year or two, *you!*"

Luke stirred restlessly in his chair and looked toward his bedroom.

"Is that all you can do?" she cried. "Look for escape? Isn't that what I've been *talking* about? Isn't it?"

"I guess so," he said miserably; and his mother, instead of breaking

out in a fit of weeping, merely nodded and gazed past him out of stony eyes.

And when they had sat there long enough without speaking, Luke stirred gently, and then—as if feeling his way through some impenetrable darkness—walked to his room, leaving his mother motionless and alone.

Now, on the day when his grandfather was supposed to come visit them, Luke was working on the second from the last kit—a BeeGee speedster with a fuselage as squat and shapeless as a pickle jar. It was hard to believe such a thing could fly.

But when he tried to work on it, he found it hard to concentrate. He kept listening for the front door bell.

The house was unnaturally quiet, which was a little disturbing. Usually, his mother got home a half hour after he did, and the first thing she did was turn on the television set to "General Hospital."

But this afternoon, everything was different. Even the dozen models he had hanging on strings from the ceiling seemed more inert than was natural. Usually there was a slight movement of air in his bedroom—sometimes from Luke's preoccupied whistling, but at others from more mysterious causes—so that he could almost feel the planes turning in slow silent dignity above his head as he worked.

But this evening they just hung there in a motionless conspiracy, as if they were nailed in the air.

Maybe his mother was similarly inert—lying in bed with her eyes closed and her head raised, so that she wouldn't muss up her hair before her father showed up.

When the doorbell rang, Luke's mother was in the bathroom and she called out in an airy voice for Luke to answer it. Even in that brief moment, it occurred to him that this was somehow deceitful of her—perhaps an old tactic from childhood. She might have been expecting the paper boy.

What could her father be like that he would make her act this way? How odd it was that he had never seen a picture of her father. Did she have one that she kept hidden?

Luke's passage to the front door seemed dense, as if all the familiar things in the room had suddenly become heavier and more powerful; filled with a sullen expectancy, perhaps. And the door faced him with the look of something that knew what was on the other side and awaited Luke's first sight of his grandfather with a dull and helpless curiosity.

As if to reinforce this brief fantasy, the door stuck when he pulled on it, so that when Luke jerked it violently open, it almost hit his forehead.

23

Then he saw his grandfather standing on the other side of the screen door; a white-haired old man with a rugged, wrinkled face. He was standing with his hands in his pockets, the idle way a man stands and watches a construction project or wastes his time in some other way when he has nothing to do.

His grandfather was wearing a steer hide jacket (an "expensive" steer hide jacket, his mother would have noticed) and a pale gray turtleneck sweater. One wrinkled eye sagged a little from the aging flesh of his face, and his smile was an ambiguous one—the corner of his mouth raised a little as if by an act of the will. The Frankenstein monster had lifted its mouth like that in the one scene that made room for the poor dumb creature's momentary happiness. Luke instantly took all this in, plus one other fact: the shaved sides of his grandfather's head showed quite clearly that one of his ears was missing. In its place was nothing but a little nub of flesh, no bigger than a wad of bubble gum stuck to the side of his head.

"So, you're Luke," his grandfather said when the storm door was pushed open.

"Sure," Luke said. "She says to come on in."

His grandfather nodded and stepped into the house without taking his hands out of his pockets, looking over his head. "She does, does she?" he said a moment too late. "Well, that sounds like her."

"Fourteen years!" his mother cried as she rushed into the room. "Oh Dad! I can't believe this is happening!"

The old man nodded and took his daughter into his arms, sort of, and then patted her shoulder with one hand.

Luke was embarrassed and irritated, but he supposed that the old man had seen her cry often enough before he was born, which was hard to imagine.

When Luke's mother pulled back and tried to smile, the old man sniffed and said, "You heard me tell you I wasn't going to stay for dinner, didn't you?"

"Dad," Luke's mother said, "I know you said that, but you've just *got* to!"

His grandfather closed one eye in a wink and said, "Well, we'll see."

"I made Mulligan's stew," his mother said. "I remember you used to love the way Mom made it."

"That was a long time ago."

"But it was your favorite dish!"

"Sure," the old man said. "At one time it was. Hoover used to be president, too."

"And you've got to take Luke for a walk, Dad."

24

"A walk?"

"Just around the neighborhood. It doesn't have to be for long."

Without looking at Luke, her father nodded vaguely and glanced at his wrist watch. "Maybe this was a mistake, my doing this."

"Listen! Don't even *say* that!"

He shook his head wearily. "A lot of water over the bridge and under the dam."

Luke's mother laughed shrilly. "God, I haven't heard jokes like that for so long it makes me feel funny."

"Try to control those funny feelings," her father said. "Sometimes, they're not so funny."

She laughed again, and glanced at Luke, so he could share in the humor.

"But I *will* take off my jacket," the old man said, starting to take it off.

"Of course," Luke's mother said, grabbing at it with ineffectual slaps before he was out of it. She slowed him down with her attempts to help. "Here, Honey," she said to Luke, before he was completely free of it, "hang up your grandfather's jacket."

"He's gotten pretty big," the old man said, putting his hands in his pocket again and looking around.

With that, Luke's mother started sniffling and went into the kitchen.

"Same old leaky faucet," the old man muttered. "No washers."

Luke glanced out of the corner of his eye and saw that his grandfather was not looking at him. He was staring out the front window, where his mother had been watching for him only a little while ago.

Then the old man cleared his throat and turned to him. "What's your favorite subject?" he said.

"What?"

His grandfather violently twisted his head to the side, as if the turtleneck was choking him. "You know, *subject:* Algebra, English, geography. *Subject!*"

"Oh," Luke said.

"Well?"

"I'm not sure."

"You're not *sure!* What kind of answer is that?"

Luke tried to think of an answer but couldn't.

"How are your grades?"

"Pretty good, I guess."

"Well, what are your best grades in? Algebra?"

Surprised, Luke nodded.

"Well then," the old man said, turning back to the window, "your favorite subject is algebra."

25

"No, it's not," Luke said.

"What was that?"

"I said algebra isn't my favorite subject. Not exactly, anyway."

His grandfather stared at him a moment. "You don't like algebra?"

"Not exactly. It stinks."

"Usually you don't do so well in something if you don't like it."

Luke shrugged.

"What do you like to do then?" the old man asked. "If anything."

"Build model airplanes."

"What?"

Luke didn't answer but turned around to look at his grandfather, who had put his hands back into his pockets and was jiggling some change. He shook his head sadly. "Sounds queer to me," he mumbled. Then he thought a moment and said, "What I mean is, *odd*. Not queer, exactly. Not like they use the word now, anyway."

"Actually, sometimes I don't really mind algebra all that much," Luke said.

His grandfather stared at him in perplexity for a moment, and then went back to rattling his change. His expression suggested that it was too late for Luke to change his mind about algebra. Finally, he said, "I think this was all a big mistake. I should have left well-enough alone. I don't suppose she says much about me."

"Not too much," Luke said.

The old man nodded, and then Luke's mother came back into the room, apologizing for being such a baby.

Later, he would realize that this meeting with his grandfather had been one of the turning points in his life. It was momentous in ways that he would never quite completely understand. It was to become one of the surfaces of his life: an emblem of what is available and what is to be guarded against.

But even these realizations—fragmentary and exasperating in promise—were the accumulation of years and the ongoing, unpromoted rehearsals of memory. Afterwards, one of the things he'd wanted explained was the old man's missing ear. Why hadn't his mother ever mentioned it? Bruised and humiliated by her father's visit, she told him it was a detail she'd forgotten. Actually, she said, she'd never noticed it as a girl, even. It had been cut off in an auto accident by flying glass. At least, this was the story she'd been told, but it seemed she didn't quite believe it. For one thing, the rest of his face had always remained unscarred.

As for the dinner that day, it had been unpleasant. Silence loomed over the table like a storm cloud, in spite of his mother's hysterical

attempts to drive it away with bursts of nonsensical chatter. The old man wasn't much help: he expected too much from his daughter and cared too little.

Once, his grandfather turned to Luke and said: "What I've never understood is the purpose of your name."

"The *purpose?*" Luke's mother asked from some great distance.

Not taking his eyes from his grandson, the old man said, "Yes. Luke was a physician. Did you know that?"

"We liked the sound of it," Luke's mother said miserably.

"It's a lousy name," Luke said, balling up a piece of bread in his hand. "But I don't mind it."

When they finished eating, Luke's mother suggested that the two of them go for a walk.

"What on earth for?" the old man asked, raising his eyebrows.

"Dad," she said in a choked voice, "I want you two to get to know each other. Especially after the way things have, you know, turned out."

His grandfather turned and stared at Luke, and at that moment, Luke hated him. And yet, he knew that he would have to take a walk with him, just as the old man knew it, too; that he would have to do this much, at least.

So they shrugged on their jackets, while Luke's mother stood watching out of glistening eyes. Luke imagined that she would go to the kitchen and start to cry the instant the door was shut; and the thought disgusted him.

"Well, let's go," the old man said, rubbing his hand over his mouth. Probably he knew that the walk was better than the alternative, which would have been an emotional storm that neither he nor his grandson could have tolerated.

Her mouth trembling, Luke's mother said good-by, and the two of them let the storm door close behind them. Overhead, the sky had darkened. "Looks like snow," the old man said in an angry mutter.

Quietly, Luke said to himself: "Rain."

"This was a dumb idea," the old man said after they'd gone a hundred yards without speaking. "I should have had better sense than to try to start this old business up."

Luke didn't say anything, and the old man started walking a little faster. When they came to the corner of Mayberry, which was a main thoroughfare, they stood and watched as a city bus rushed by like a moving wall. For some reason, they were both standing too close to the curb; and if Luke's mother could have seen them, she would have been alarmed.

"Is she often like this?" his grandfather said, gesturing with his thumb in the direction of Luke's house.

Luke thought a moment and said, "Sometimes."

"I tried to tell her all those years ago," his grandfather said, shaking his head. "But she wouldn't listen. Kids are like that, even daughters." He spit as if the words had soured his mouth.

They took four steps together, and Luke adjusted his pace so that they wouldn't be in stride. His grandfather took long steps; he was probably taller than his father, although it was hard to tell. But his father had been strong; he could break an apple in half by just gripping and twisting.

Nevertheless, the old man walked fast, and Luke could hardly keep up with him. When he had fallen behind about ten feet, he trotted to catch up. His grandfather was talking as if he hadn't realized the boy had fallen behind.

"Is she just as insecure and unstable as she always was?" the old man asked, snarling the words at him. Then, before Luke had a chance to say anything, he said, "Of course she is. I could tell it the minute I stepped inside the house. God protect a man from ever having daughters. Take my advice or you'll see what I mean. Is she like that all the time?"

Luke was briefly tempted to say, "Pretty much," but he clamped his mouth shut and concentrated on his stride. Either the old man had slowed down, or Luke had found a way of keeping up with him. He had to swing his arms and shoulders, which probably looked goofy, but it did the trick.

Then his grandfather leaned over and grabbed Luke's right ear between his thumb and forefinger and twisted it so hard, the boy yelled and swung both fists at him in an ecstasy of surprised anguish.

But the old man grabbed both of his wrists and pulled them up to his chest. "So, you'd like to hit your own grandfather, would you?" he hissed.

With tears still streaming down his face, Luke nodded and in the same hissing voice said: "Lemme go! Lemme go!"

"You're a fighter, then," the old man said, breathing into the boy's face. "Is that it?"

"I don't care what you think I am," Luke whispered, still jerking spasmodically as he tried to free his wrists.

There was a grim smile on his grandfather's face now. "Are you through thrashing?" he asked. "Is the pain over?"

After two more futile jerks, Luke paused, and then—looking away toward the empty street—nodded.

"Then it's time for you to be set free," the old man said, throwing

28

the boy's wrists outwards like two handfuls of dirt. For a moment it appeared that he might dust his hands off, but he didn't. Instead, he put them back into his pockets and started back towards the house.

For a while, they walked in silence, but when Luke's house came into view, the old man slowed down and finally stopped. Then he leaned over, as if he wanted to whisper something to his grandson.

Warily, Luke paused and looked up. "What is it now?" he asked.

Briefly, his grandfather's bloodshot eyes looked at him, and then glanced back towards the picture window, where Luke's mother had stood waiting for him not so long ago.

Then, in a voice so hoarse it was obviously used only rarely, and to divulge the greatest secrets, the old man said, "Don't ever let them get a hold on you."

And Luke thought a moment before answering, "I won't."

Harry the Woman Killer

I

He heard his mother calling from her bedroom and paused for a moment, staring into the globular window of the automatic washer, as sudsy clothes whirled around in a soft electric hum.

"Harry," she called again. "Come here."

He stared up at the cross-beams of the basement, as if he could see into her room. Then he folded a dirty shirt and started up the steps.

At the top he wasn't breathing hard, and he thought that wasn't too bad for a slightly overweight man of thirty-eight.

"Harry, can't you hear me?"

"Yes. I'm on my way."

"I should *hope* so."

He stepped into the bedroom and saw his mother sitting in the rocker, nodding her head.

"Help me into the bed," she gasped.

Harry lifted her thin body into the bed and asked: "Is the doctor gone?"

She nodded yes at him; her face was yellow and dry-looking. Her eyes looked out at him through loose pouches of skin the size of mice.

"Harry," she said in a frail voice, tugging the covers up over her breast, "he has told me the truth."

"The truth?"

"Yes, and close your mouth."

"What do you mean, 'the truth'?"

"That I'm dying."

Harry turned his back and put his hands in his pockets.

"I'm not afraid," she was saying. "I don't have any faith, though,

Harry. The only reason I always wanted you to go to church regular and teach Sunday School was because I wanted you to be a good boy."

Harry stared at his image in her dresser mirror. He could see his own wide face, the face of a man prematurely aged. "I know it," he whispered, hardly opening his lips: "and the only reason I taught Sunday School all those years was to please you."

"Are you speaking, Harry?" she asked in her strongest voice yet, enunciating each word angrily.

"No, I was just mumbling."

"Well, stop mumbling."

Harry turned around. "Goddamn it, what if I told you to stop telling me what to do?"

Her voice fell into an awful hush. "Wherever did you learn to speak to your own mother that way? Not from me, you didn't learn such derespectful language to your mother.

"There's no such word as 'derespectful,'" he said.

"Now isn't that a fine thing," she said with a bitter smile, "correcting the language of your mother, who was speaking well long before you were ever born!"

"There's no such word. *I* can't help it. There just isn't."

"Here I am dying, and you disagree with me on my deathbed."

Harry pedaled rapidly into the living room and got the unabridged dictionary. His mother was talking to him, but he wasn't listening. She could probably hear him licking his thumb and leafing through the pages.

"Ungrateful," she keened. "Didn't I just tell you that the doctor says I'm dying?"

Harry returned to her bedroom, pointing at the dictionary. "No such word," he said. "Hah!"

"Harry, Harry," she said. "Don't contradict your mother when she's about to die."

"You're always saying you're about to die," he grumbled, heaving the dictionary on the bed. Her body bounced. "I'm going to stop listening to you."

"A stranger," she said. "My own son has become a stranger to me, his own mother." Her voice assumed the goofy oracular diction that both appalled and intrigued him. "Something awful in you, there is!"

"There's *nothing* in me," he shouted. "So get off your high horse."

"Something strange and unfathomable," she went on, chewing at the hard words without her teeth. "Something frightful, when you stop and think about it. At times like this, I get a chill all over."

"Do you want a blanket? Is that what you're working up to?"

"No, there's more to it than blankets. The chill is deep, Harry. And you put it there. Only I honestly don't think you can help it. I don't think you *know!*"

"All I know is I've heard you say screwy things like that before, and it still doesn't make any sense to me."

She was biting her lips in a grin, now, and Harry realized that she was weeping, or thought she was. Then she started grunting for her son to get her medicine from the refrigerator. Her eyes were shut and her breath sounded like the fluttering of tiny wings.

Harry went into the kitchen and prepared her medicine. When he brought it back, his mother was lying inert, with her eyes staring at the ceiling from behind their pouches.

"You won't go out, will you, Harry?"

"No, I won't go out," he said.

"I knew I could depend on you. The doctor says I won't be around much longer to bother you."

For a long while Harry stood in the dark hallway, listening to her breathe, while he clipped his fingernails.

It was clear that his mother was actually dying this time; her manner was different from that of the rhetoric of her past talk of death, threatening to leave him to a cancerous guilt. Now, she became strangely, somberly, intensely quiet. She spent long periods of time, apparently listening to the silence, her lips pursed in fatalistic concentration.

Twice, she called him at his work. He was a clerk in a retail auto supply store; he was the oldest clerk there, both in years and time of service, so he was more or less allowed to come and go as he pleased, for—as the manager said—Harry would never abuse a privilege such as that.

Finally, the doctor suggested that he stay at home, because his mother couldn't possibly live the week out. She ought to be in a hospital, where these things can be handled decently, he said . . . but the old lady refused to go. A nurse came the next day, but his mother—croaking balefully from deep in her pillow—told her to go away. Harry knew that she didn't trust women; she had never trusted them. But she gasped out to her son that the money he saved by not hiring a nurse for her when she was dying would help pay for having the house painted this summer.

The weather had suddenly turned hot, and Harry was wearing superannuated pastel blue slacks with an elastic waist and a faded yellow shirt. He was sweating copiously, and the damp spots under his armpits had a way of turning cold and chilling him. The ridiculous threadlike hairs that

usually circulated airily above his baldness, now remained pasted by heavy sweat in dark streaks over the freckled and tanned skin on the top of his head.

All night Friday he imagined he heard his mother crying out for him, and when he walked toward her room the next morning, his heart was beating so fast and hard that his pajamas trembled.

But she was obviously alive . . . her mouth sucked back in a black gape . . . the expression on her face like that of an old woman who has just stuck her foot in frigid water. Her bony, convex breast was rising and falling in a violent, rhythmic pattern.

Harry had pineapple juice, whole wheat toast and coffee for breakfast, then he tried to give her her medicine. He got her to open her eyes, and she looked at him for a while; but then her eyelids closed with a finality that suggested the metal-weighted lids of a doll. But he knew she could hear.

Eventually, she opened her eyes and looked around like a tourist; he threatened to shove the medicine down her open mouth, but apparently she didn't believe him, for her expression showed no fear at all. It would have strangled her.

After this, he went out in back and sat under the cherry tree with his Sunday School lesson in his lap. Robins were busily eating the cherries, and Harry watched them for a while, telling himself that he should tie fresh newspapers in the tree to rattle in the breeze and scare the robins away, but he knew he wouldn't do it. His mother would have wanted him to do it; she hated birds. When she used to pace through the yard with her arms folded, she would frequently glance malevolently at the sky, daring any bird to pass over her lawn and drop its white dirt into it.

Harry stared at the lesson from Luke and turned the pages dreamily. The biblical words held no meaning for him today. Fraud. She had never once believed; she had only wanted him to be good.

He stared at her window and wondered if it had ever occurred to her that her son might not really *want* to be good.

But his mother's room was shaded in silence, and a sparrow was hopping along the rainspout just above her head. He wished she could have seen it there above her.

Along about five o'clock he went into the hallway and phoned the nurse who had come several days earlier and had been dismissed by his mother. He asked her if she could come that evening, and she said yes.

Then Harry went into his mother's bedroom. He turned on the bed lamp. His mother's eyes were wide open, and her mouth was moving.

He walked over to her. "What is it?" he asked.

Her mouth yawned once or twice, and then she managed to say hoarsely: "You're going away, aren't you Harry?"

"Yes," he said. "I'm just going out for tonight."

"For tonight?" his mother asked. He didn't repeat the answer.

She'll die now, Harry was thinking. She'll die to stop me from going.

Then he asked: "What do you think I'm going to do after you die? Have you ever thought of what's going to happen to me?"

"How can you consider yourself at a time like this?" she muttered.

Before Harry could think of anything to say, she was asleep again, her mouth making tiny kissing noises about her morbid breath.

The nurse arrived on time. She was a fat woman with very dry orange hair and a pasty skin. She wore purple lipstick and her corpulent legs bulged massively in thick white cotton hose. She had a stuffy nose and as she talked to Harry she prodded and squeezed a nasal spray up first one nostril then the other.

She talked as someone who was competent and unimpressed by the imminence of death. She seemed to think it was the most natural thing in the world that a dying mother's only son would choose to go out tonight. It was as if she said to him: "Go ahead and enjoy yourself; I am a specialist in this sort of thing. You can certainly depend on me! I won't let your mother cause you any trouble with this business."

He shaved again, although he had shaved that morning. Then he put on a clean white shirt and his summer suit. He considered going into his mother's bedroom and kissing her good-bye, but he thought better of it.

As he walked toward the front door, he glanced into the bedroom and saw the nurse sitting there reading a paperback novel, her legs folded together like bulging sacks of flour.

She was smoking a cigarette and nodding at him to indicate that everything was all right. Harry hesitated a moment; his mother hated the odor of cigarettes . . . it drove her into a fury.

But he went out the door; the smell couldn't bother her much now. Or at least, not for very long.

At the bus stop, he bought a newspaper, and then a bus glided over to the curb and the doors wheezed open. He got on, feeling strange, adrift, vaguely excited. Maybe he was transubstantiated; maybe he had become an abstract man. He could almost feel himself merging into independence and the lasting anonymity of manhood, from the guarded freakishness of his past life.

34

The bus sped swiftly toward the center of town. The heat and the odor of hot tar and gas fumes increased until his whole body seemed to be a kind of mouth sucking hungrily upon the cruelty and hardness of the city.

He got off the bus and started walking toward the burlesque house, which had been revived a few years ago. Although it was past eight o'clock, it was still light outside. The streets seemed empty and dream-like. It had been years since Harry had been downtown at this time of night. His work, his reading, and his mother had left no time for anything else.

Inside the old theatre it was cold and smelly. Harry sat near the front with a score of other men, mostly old and poorly dressed. A few teen-aged boys entered shortly thereafter, and then—with the audience absolutely silent—the lights dimmed and the show started.

He watched fascinated and subtly shocked by the jerkily sensual dancing of the hard women, and the gaudily dressed comedians, and the crude jokes. And yet he did not stay very long. He got up and left, and one of the comedians actually said something to him, but he didn't know what it was.

He went outside into the hot pool of light; and as he stood at the entrance, he felt framed by the strings of naked lightbulbs that bordered the entrance to the theater.

He walked for a while along the streets until he came to a small coffee shop. He went in and ordered a glass of buttermilk and two bismarks. Maybe she was dying at this very minute. Maybe she was calling for him.

After he ate the bismarks and drank the buttermilk, he went outside. A slightly cooler breeze chilled his back, and, at that instant, Harry was aware that his clothes were soaked and heavy with perspiration. He was still holding his newspaper tightly in his fist, and when he came to a streetlight, he stopped in the middle of the sidewalk and shook the paper out and tried to read it.

Then he started walking again. The dull rhythm of his feet against the sidewalk almost put him to sleep. He passed several women and looked at them, but they didn't look back; so eventually he just walked on with his head down and his stomach thrust tiredly out.

He finally came to a drugstore. He went in an leafed through several outdoor magazines before he decided to call home. He stepped into the old-fashioned phone booth, almost passing out from the sudden compression of heat when he closed the door. He dropped two dimes down into the phone and listened to them clang to their destination. Then he dialed his number and waited.

The nurse answered.

"This is Harry," he said. "I called to ask."

"She's still holding on," the nurse said.

He had so much expected the nurse to say that she had died that he was shocked. Something whirred in his mind like an electric mixer, and he found himself holding onto the phone to keep from falling.

The nurse was asking: "Are you still there? Can you hear me?"

"Tell her I'm on my way home right now," he said in a strangled voice.

"I'll tell her; but I'm not saying she'll hear me."

When he'd finished, he stepped out of the booth into the fluorescent brilliance of the drugstore and bought a pack of Juicy Fruit chewing gum. His hand was trembling, and the painted skinny girl behind the counter stared at him.

He rushed out the door and stood on the corner, looking for a taxi.

II

"And you didn't even go to her funeral?" Edith asked.

"Nope."

Her eyes glistened. "Not many men are strong enough to do something like that. That's terrible."

She was sitting across the booth from him. She was drinking coffee, and Harry had just finished a glass of buttermilk. "*I* wouldn't have the nerve to do that," she said, after a moment's silence.

She was a short, chunky woman with her hair dyed gunmetal black and packed behind her head in a solid bun. Her white blouse was open at the neck, and Harry noticed a faint crescent of yellow perspiration stain curled under each armpit. She frequently laughed explosively, going "Pah!"—a habit that was already beginning to irritate him.

"And your father. How about your father?"

Harry frowned and stuck the tip of his index finger in his buttermilk.

"I want to hear all about your past," she said, in a lower voice.

"Well, actually, there isn't really very much to tell, I guess."

"There's *always* something to tell," Edith said. Her voice scared him a little, the way she said it.

"I suppose."

"Well?"

"It's pretty painful," Harry announced, looking over her head and speaking out at the window, as if it were an audience. He started blinking.

36

Her eyes shone. "I'm a good listener, and the coffee shop's practically empty. Nobody can hear you tell me."

"My father was a strange man," Harry said. "He died four years ago."

"There's nothing strange about that."

"He had suffered a broken hip two years before. He was elderly, and that's what really started him going downhill."

"He must have been pretty old when you were born."

"Yes, he was. Anyway"

"How did he break his hip? Fall on the ice?"

"No, I hit him."

"You *hit* him?"

"With the car, I mean."

"How on earth did that happen?"

Harry frowned and said: "My father was a very generous man. He was living on a railroad pension. We weren't badly off. I mean, we didn't suffer for the lack of anything. But Dad would . . . well, he liked to *help* people, only he had an odd way of going about it."

"Like what?" she asked.

"Well, he'd read these eight or ten newspapers every day, and every story he saw that told about somebody who had had some bad luck—like the widow of a man who was killed somehow, or some little boy who had lost his pet dog . . . anything like that, why Dad would write them a letter and put a dollar bill in it."

"Why, that was a nice thing to do!" Edith said.

"It certainly was," Harry said quickly.

"But how did . . . I mean, you said you hit him."

"I know. He would give me letters to mail every single day. And one morning in November, I was late for work and I forgot the letters. I was backing out of the drive real fast, and Dad was standing there on the drive by the sidewalk, waving his letters and crying out for me to stop, but do you know something? I didn't see him until too late, and by golly I just ran him down. I swear, it was an awful thing to do!"

"Why, you poor man! And you blame yourself, don't you? I mean you couldn't help it!"

"Of course, I couldn't help it. It was an accident."

"That isn't what I mean; I meant you couldn't *help* blaming. . . ."

"What?"

"Never mind. And then your mother dying just this past month."

"Thirty-four days ago today," Harry said.

"You've suffered," Edith said. "I can tell!"

They were silent for a moment, then Harry asked her if she would like to go to a movie with him that night, and she said yes.

And right after accepting the invitation, she said: "I'm certainly glad you don't smoke, Harry. Do you know something? I just can't *stand* the smell of cigarettes."

Harry and Edith were married the month after that, and they settled down to housekeeping in a small cottage in the suburbs. Edith had a grown son in college, but she seldom talked about the boy. Instead, she devoted herself to making a comfortable home for her new husband.

That summer, Harry decided that the cottage needed a new coat of white paint, and he made a purchase through a friend at the auto supply house for a special one-half price.

He started painting the house during the weekend in July. By Sunday, he had finished most of the windows. After breakfast, he went outside and started again.

Edith appeared at his side, dressed cleanly and neatly in a white dress and wearing a white hat with a veil shadowing her eyes.

"Harry," she said. "I wish you'd stop painting today. After all, it *is* Sunday. And if you won't go to church with me, you should at least stop painting. At least while the services are going on."

"I want to finish the windows," Harry said.

She didn't say anything. Then he heard her walking down the asphalt drive to the sidewalk, where her high heels made a different, pocking sound on the cement. Her footsteps were soon out of hearing, and Harry suddenly felt terribly hot. So hot, in fact, that he had to stop and go sit in the shade of a box elder tree the previous occupant had planted by the garage.

He finished the house early the next week, having taken some of his accumulated vacation time. Then he settled down to do plenty of reading. He liked biographies, for the most part, and historical novels. He knew a great deal about the eighteenth century and ancient Rome.

But things were not as peaceful as they had been. He would stop reading, occasionally, to see Edith staring at him with her mouth compressed . . . her black eyes inert with trouble.

"What's the matter?" he asked once.

"Oh, nothing."

"Well, you were staring at me while I was reading, and I thought you had something on your mind."

"No, it was nothing, Harry." Her eyes got vague and lazy, and she started patting the hard black bun of hair behind her ears.

Harry started reading again, but was brought up short by her saying, "Except"

"Except what?"

"Except they wonder why you never come to church."

"Who does?"

"Oh, neighbors. My friends. They've mentioned it." Harry went back to his paper.

"And I told them you used to teach Sunday School, too. They thought that was wonderful."

For some reason, Harry's heart started beating fast and his breath seemed to turn gluey and get stuck in his throat.

"I wish you hadn't told them that," he said, holding the paper too close to his eyes.

"Well, they *need* a Sunday School teacher there, Harry. And after all, that's important."

"What is?"

"Why, *religion* is, for Heaven's sake."

"I wish you'd let me read."

She did let him read, but she mentioned it several times again that month; and by September, Harry had given in, and was teaching a straggly, unimpassioned group of junior high school students in a basement room of the church.

The minister was immediately fond of Harry, and so gratified at having him help that he would pat his shoulder every time he saw him and wink, as if to say: "That's the way we win ball games, boy!"

But in October, Edith came down with a serious, inexplicable illness. Her plumpness faded from her like a mirage, and her untended hair swiftly turned gray.

She lay on her back in bed, staring hopelessly at the ceiling. Harry wrote to her son in college, but the boy didn't answer his letter.

"Good God!" Harry thought, after the mailman passed by their door for the second straight week. "His mother's seriously ill. The ungrateful little bastard!"

For some reason, the thought of the boy—whom he pictured going to parties or striding across the campus carrying beautiful new books that cracked when you opened them . . . the thought of him made Harry close his eyes and swallow at the bewildering gorge of fury.

He wrote to the boy again; but there was still no answer.

And Edith continued to lose weight and strength, until the night-gown she lay under was like a fantastic creation of dirty gray strings, tied

together cunningly there in the bed to suggest a woman's shape . . . and her face mottled until it looked bleached, like a recently shaved head.

One twilight, when November was half gone, she said to him: "What will you do when I'm gone?"

"Shut up!" Harry cried, tears burning his eyes. "Why do you *always* have to say things like that?"

He put on his coat and went outside, and stood with his face to the wall of the house. It was the western wall, and the weak November sun was shining directly upon it, flashing it with a cold, luminous wash.

Suddenly, he was startled to notice that the paint was peeling already. The damn cheap paint he had bought at half price from that bastard at work.

And he was alone with her, now. She seemed to *know* that she was going to die.

Staring at the sideboards of the house, he was suddenly horrified to discover that the paint was not only peeling, but was turning *yellow*.

"I'm going to get you some ginger ale!" Harry yelled at the closed window of her bedroom. "It'll make your stomach feel better."

Then he went to his car, got in, trembled the key into the ignition and raced the cold engine so hard that the whole car tilted sideways with each crescendo of roaring.

Then he backed swiftly out of the drive, forgetting for the barest instant to look back to see if the driveway was clear. But there was no one there, and Harry swerved wildly back into the street so that his left rear tire slugged gummily into the high curb opposite, causing the car to bounce back.

Then Harry started driving . . . having forgotten all about the empty bottles and carton he should have brought with him—driving much too fast down the street, and then onto the main highway, which led to the carry-out store.

III

"Everyone has some special gift, Harry," the psychiatrist said. "What is yours?"

Edith had been in her grave five months. Through suffering, Harry had gotten thin. Now, he sat in his tattered-but-clean terry cloth robe and contemplated the psychiatrist's question.

"Friendship?" the psychiatrist asked, raising his eyebrows in an expression of friendly inquiry.

When he still did not answer, the psychiatrist—whose name was Blankenship—seemed to feel his pick had struck a vein of truth. "Why

40

not friendship, Harry?" he continued, leaning back in his chair with his hands clasped behind his head. He gazed at the milky fluorescence of his office ceiling. Outside, a chain saw was snarling as it chewed up tree limbs blown down on a distant section of the sanitarium grounds. There had been a heavy rainstorm the night before. Now, however, the sky was an oceanic blue, pure and undefiled. Harry could see it through the maple limbs outside Dr. Blankenship's office.

"Our society puts so much emphasis upon tangible success," Dr. Blankenship continued, "that we forget the humble virtues, do we not?" Seeing that he waited for a response, Harry nodded. "But in the last analysis, these so-called humble virtues are not really so humble, are they?" (Harry shook his head no.) "So that we really ought to revise our priorities . . . that is, our *hierarchy* of values."

During all this time, Harry was vaguely aware that Dr. Blankenship did not want to appear to be talking down to him as a patient; but this realization only depressed him, rather than making him feel grateful or proud.

When their session was over, Dr. Blankenship put his hand on Harry's shoulder. Harry was now forty-four years old, and Dr. Blankenship was a few years younger. And yet Dr. Blankenship called him "Harry," while Harry would not have thought to call the younger man "Arthur" (which was his name). In some way, Dr. Blankenship had earned this right.

This fact also depressed Harry a little, even when Dr. Blankenship patted his shoulder and ushered him from his office, saying that he thought probably they had been able to isolate Harry's chief gift as a human being. He was friendly.

"The reports that come to me from the staff," he went on, withdrawing his hand from Harry's shoulder, so that he could concentrate on the memory of those reports, "are unanimous in their confirmation of the fact that you are a cooperative, interested, willing—in a word, *friendly*—member of Ward Seven."

The sound of Dr. Blankenship's voice following him down the hall infuriated Harry, made him feel downright murderous, even after the heavy doors closed and he was walking in the open hallway that bridged the main building and Ward Seven. As if in wrathful sympathy, the sound of the snarling chain saw got louder with each step.

While Dr. Blankenship's facile and insensitive diagnosis continued to depress him long after he left the sanitarium, the premise of that diagnosis stayed with Harry, and became a part of his thinking . . . even though he knew that it is obviously impossible to *prove* that every human

41

being has some unique sort of gift, no matter how trivial it may appear to the world.

Harry was fitted with a toupee, after which he returned to his old job in the parts department. His fellow workers greeted him with cheerfulness and even a little horseplay. One of them—a Chicano who always wore a bow tie—asked him several times if the nurses out there were good lays. Harry smiled ambiguously and tolerated all their comments.

But not for a moment was he deceived—his real gift was not friendship. Perhaps this was the only thing he had learned since Edith had died.

People commented upon how much weight he had lost, and indeed he seemed a different person when he walked along the street to his parking lot, and saw his image amble into the dark reflections of the slanted store-front windows, and then step out again. This was a different man who walked on the other side, and the difference was just a little strange and exciting.

The remarks about the nurses interested him, for he was in need of a woman, and was beginning to look around to see what women might be available. He sold the house where Edith and he had been happy those pathetically few years, and moved into an apartment. He sold his Pinto, and bought a 1975 Karmann Ghia with a rebuilt engine. He had it painted red, and then returned once again to the local church in order to teach Sunday School. Everyone was glad to see him, including the minister. For a brief moment, Harry was as near to being a happy man as he had ever been. It seemed to him that he was entering the future, and there were possibilities—maybe even adventures—awaiting him, and he would be free to make a number of interesting and important decisions.

During this time, Harry also underwent a gradual realization that women were looking at him differently. Something more than his recent metamorphosis was evident in this. While he was now actually almost handsome (at least, compared to what he had been during the days of nagging warfare with his mother, or during the few years he had vegetated comfortably with Edith), there was nevertheless something deeper, more secret, more powerful at work. For example, one morning when he was eating breakfast at McDonald's, he looked up to see the girl who had waited on him only a few minutes before leaning with her elbows on the counter and staring open-mouthed (*actually open-mouthed*) at him!

What she had been intent upon, whether she could have understood it consciously or not, was Harry's special gift. That was what her attentiveness was pointed toward, whatever it might prove to be.

This Harry understood with perfect clarity. And it had nothing to do with friendliness.

But the girl at McDonald's wasn't the real one. The real one turned out to be the young woman who replaced the secretary of the parts department for her two-week vacation in August. Her name was Linda Potter, and she had her birthday during that time.

"So you're a Leo," Harry said to her one day, when she brought a fistful of invoices for him to check out.

"I'm a Leo-ness," she said with a light-hearted tone that indicated the response had been rehearsed.

"Well, well," Harry said, a little put off.

Nevertheless, he watched Linda Potter walk back to her desk by the pay counter, and admired the way her pleasantly muscular buttocks worked underneath her tight skirt. It so happened that Manuel, the Chicano, was standing right behind Harry's right elbow, also watching her departure. When she was seated, Manuel said, "I'll tell you something, *Jefe:* a chick with cheeks like that could bust a man in two!"

"Hah, hah," said Harry mirthlessly. But in spite of Harry's instinctive disapproval, the warm-blooded Manuel's words kept repeating themselves in his head, like two lines from a beautiful poem.

And several days later, when Harry happened to look up from a box containing a defective distributor coil, and saw Linda Potter staring at him with her lips slightly parted, he knew deep in his heart that something was up, and he'd better act upon it.

Accordingly, he invited Linda to have dinner with him one evening, and go to a drive-in movie afterwards. At the drive-in movie, Harry made out. So did Linda.

But instead of being elated or proud. Harry was somewhat depressed by the whole experience. He couldn't sleep that night. In his head, he kept hearing Manuel's voice asking, "Whassa matter, man, want she no *good?*" And also in his head, he could hear his own voice patiently explaining that she was *very good indeed,* only . . . only. . . .

"Only *what,* man?" Manuel's voice asked insistently, while Manuel himself was probably home, sound asleep with his fat Momma (as he called her), or balling her mercilessly (as he implied).

"Only," Harry's voice went on, "only there is something the matter with her."

"Sheet!" Manuel's ghostly voice exclaimed. "I coulda told you that the minute I heard she was going out with *you!*"

"It's just a feeling I have," Harry protested. "As a matter of fact, I

don't know anything about her at all. She's a complete mystery to me, like Ursula Andress or Joey Heatherton."

"How about Ann Margret?" Manuel's voice asked.

Harry nodded. "Or Ann Marget."

"Sheet!" Manuel's voice exclaimed, and his image withdrew an oily rag from the rear pocket of his coveralls and proceeded to blacken his hands by rubbing them on it.

The real Manuel, however, was more resourceful than the exiguous version created and cast by Harry's mind. And on the very next day, he came forth with the very information that Harry had admitted lacking in his fantasy the night before.

"I tell you what," Manuel said closing one eye like Leo Carillo in an old movie. "Lovely Leenda is a masticist."

"A what?" Harry asked, feeling his skin chill.

"One of them women who likes to get beat up."

"A masochist," Harry whispered.

Manuel nodded. "I hear all about it from a guy was working with her where she work full-time a year ago. Over to Clancy's, where she was a bookkeeper. She been married to two cats who took her for everything she had—money, broken bones, skin off her ass, pride . . . you name it, they got it. She went to a psychiatrist, and she told this guy's girl friend everything. She is looking for the man who is interested in killing her. Not just who *will* kill her, you know, but is *interested* in killing her. That's a big difference, if you know anythin about psychiatry."

"I know, I know," Harry whispered, looking past Manuel's head.

"Hey, man, what you see out there? You look like you lost your mind for a minute." Manuel turned around largely and looked. "I don't see nothing but a wall, man. Come back and join the human race, why not?"

But Harry didn't stick around to listen. Instead, he went to the men's room, turned the faucet on full force, and let cold water stream over his wrists. Then he doused his face in cold water, and wiped it so hard, it turned a furious red, like sunburn.

Then, in a shaky voice, he started to sing a little song, improvising both words and melody as he went:

Linda, Linda, so you're the one,

So lovely, shy . . . the one, one, one!

It was a strange little song, and kind of dumb. And yet it was a song, beyond doubt. A real song, and it was his to sing as loud as he wanted. He might even sing it to Linda. He had a hunch she would love it.

A Marriage of Solipsists

He started to snore, and then bit off the sound and half-choked on it. Then part of his mind came to a point and listened to his body breathe somewhere down deep in the thick weeds of his chest.

No, that wasn't it, either. Because he could hear the flock of grosbeaks just outside the window in the honey locust trees that bordered the house. They would flourish there like little trumpets, and after listening to them awhile, he would say, "It is spring again. Even with the snow on the ground, it is spring."

His head twisted, and suddenly in the dream he saw a locomotive standing on a track, steam leaking in jets from its undercarriage and side. It was an old-fashioned coal burner, and the landscape all about was cold, empty, flat. Somewhere on the high plains, thirty years before, the engine lay hissing and cumbrous, the center of a different world.

But this was only an interlude, and once again he understood the room he was lying in: it was a dark and crooked little room with flexible walls. The material it was made out of was the essence of betrayal. Despair and sadness blew against the eaves of this room, causing them to come gliding like the bottoms of old ships back and forth over his sleeping head.

With that one, he woke up and turned to see that he had slept only fifteen minutes. Usually, his naps lasted over an hour.

He took this realization in and then sat up on the bed, leaving the pale spread wrinkled like a soft, dark fossil. The grosbeaks were there; he had heard them clearly, almost all the way through his sleep. They were a little chorus—a humorless, Aristophanean chorus rattling the air with a corrupted Greek.

He made a face and tasted his mouth grimly. He stood up and then noticed his image glide rapidly past the mirror as he paced his nine steps

to the bedroom door. He opened the door and listened. Silence. Ethel, bless her heart, was in the sewing room down below, over thirty steps from the kitchen.

He turned down the circular stairway, letting his slippers move softly in the thick carpet, and felt the whole world turn according to his peristaltic descent. Solipsism, Ethel. Solipsism. Will you share my solipsism during our brief journey together from marriage to death (of one or both)? Can we establish this covenant with each other, whereby our little cells of self can at least reverberate to the pulsations of the imagined other?

This had been part of his wry and whimsical courtship game; and Ethel had taken it up, slyly and warmly, accepting his antic mind and heart with fascination. Still, like a subtle clue, the game was threaded through their hours and days together.

But Ethel and he, Greg, were now home clear, having raised their children for better or worse (mostly mediocre), and having shepherded them into their own lives as best they could (not very damned well), they could now share their solipsisms together, relieved periodically by parties and trips and medical examinations and naps of lunar desolation.

Greg went into the kitchen and listened to the house breathe—the distant susurrus of the automatic washer, coming from the basement; the belch and tremble of the hot water heater, the nervous dim rattle of the furnace, the antique walnut clock in the kitchen, ticking valiantly from its bed of pale-flowered wallpaper.

He opened the liquor cabinet, withdrew a fifth of vodka, unscrewed the cap, and then went to the refrigerator for a bottle of Sprite. With the soft sound of the refrigerator door opening, there was still another sound introduced to the little orchestra of household noises: the phone ringing in the back entranceway.

He could see the movement Ethel would make, letting her chained pince-nez glasses drop to her bosom, and pursing her lips with curiosity about who was calling. She would take a breath before lurching to her feet—a trait she had manifested long before anyone could possibly have considered it symptomatic of excess weight and beginning senility.

The vision quietly caused him to smile, but he was still careful and quiet in his movements. He poured the vodka quietly into his glass, quietly filled the glass with Sprite, quietly dropped two ice cubes into the glass . . . all while the phone was ringing three more times. Ethel was taking a long time getting to it; but then she answered, and Greg heard her say, "Why, hell-low!" Number three response: not one of the family (that was simply "Hi"); not one of their closest friends (that would have brought forth a first name); but one of the third order—friends they'd

either met fairly recently, or ones they had encountered at rare intervals for years at others' parties.

Greg smiled inside and sipped his drink. The antique clock struck two o'clock, and then abandoned the kitchen to an even greater silence.

Ethel's voice was saying the usual things for a number three phone call. Oh, they'd been busy with a lot of little things, but nothing really interesting. Yes, the children were all fine. Etc. Etc.

Greg swirled his drink and sipped it once more. Ethel's voice was silent. Had she hung up? Had Greg missed an exchange? Had thirty seconds simply dropped out of his life like coins through a hole in his pocket?

But no, her voice came back. It wasn't *quite* as loud this time, and instinctively a part of his mind focused upon it so that he could hear.

"I really don't think we should," Ethel said.

Should what?

"I'm afraid it's Greg. He's had a little problem lately controlling his drinking when he goes out, so he's decided to give up partying for a while. I mean it's *his* decision, so you can see that it's nothing remotely like alcoholism; he's just come to this decision that if he's at a party, he likes to drink more than is really, you know, *good* for him."

Greg's face changed slightly behind the eyes (his inner face) and he looked up at the clock again. It said two minutes after two. Approximately. Briefly, the old anxiety he'd had as a child came to him: how do you really *know* what time it is? How can anyone say *exactly* when a new hour or a new day begins?

He sipped his drink and lowered it to the counter. "I certainly hope you understand," Ethel was saying. "Because otherwise, we'd just *love* to come. But Greg has decided it's better this way. *You* know. For a while, at least."

Greg literally narrowed his eyes and looked out the window. The grosbeaks were not in sight.

The refrigerator went on, and its humming was soon joined by the sound of his wife saying good-by.

He could feel the house tremble slightly as she approached the kitchen. She came into the dining room and then slowed down a little as she saw him leaning against the counter, drinking. Briefly, the look of resentment one has at being surprised moved through her eyes.

"I thought you were upstairs taking a *nap!*" she said. She did not look at the glass in his hand.

"I didn't sleep very long," he said.

For an instant she stood there in the middle of the kitchen, her look stunned and unmoving, as if she had forgotten what her errand was.

47

"You know," Greg said, swirling his drink and looking at it, "I think my hearing's going bad."

"Why do you say that?"

"I could hear you talking on the phone, but I couldn't quite make out what you were saying."

Ethel's eyes unfocused and she adjusted her hair with her hand. Her wedding set glistened briefly in the light of the kitchen. Her cheeks were pink, as if roughly rouged; they had been this way lately, and it occurred to him that she might be permanently blushing for him as he appeared in her dark suspicions.

"Well, who was it?" Greg asked. "I couldn't hear you."

"It was Betty," Ethel said. "Betty Childers. You know the Childerses. We've seen them at parties and places. He's an executive at the Watson Company. I forget what he does there, but he's an important man. They have a lovely house in Broadhurst."

"What did she want?" Greg asked.

"Oh, she asked me if I could come to a luncheon next Thursday at the country club. They're having a meeting of the local Arts Council, and she'd heard I was interested."

"Are you going?" Greg asked, finishing his drink.

"No," Ethel said. Then, bless her heart, she swallowed and repeated the word: "No, I don't think I'll get involved. Life's too complicated already for me to take on anything else."

"What?" Greg asked.

Ethel looked at him and repeated what she'd said.

Then she said, "You really ought to have your hearing checked. It isn't right for you not to hear me when I'm right here talking to you like this. I've noticed this a lot, lately: you don't hear things."

"As you grow older," he said, "things close in. You grow more and more into yourself. Like an omphalos, you know?"

"Don't say silly things," Ethel said.

"What?"

"You heard me."

"You grow more and more inside yourself, and exterior things matter less and less. It's sort of mystical, in a way."

Ethel had remembered why she'd come into the kitchen, and she went over to the cabinet beneath the sink and got out a small sponge.

"One of the cats tracked sand up from the cat box in the basement," she said. "I saw its tracks in the hallway when I was talking to Betty Childers just now."

"So the solipsism gets deeper and deeper," Greg said. "It's like a cocoon you weave just by breathing, and it thickens the longer you live."

48

"You haven't talked like that for a long time," Ethel said nervously, before leaving the kitchen.

He nodded and stared through the back window at a rose bush that was walking like a great spider through the back yard.

The lie sat like a parrot on his shoulder. When he walked through the house, it swayed this way and that to the movement of his body, gripping hard. It was alive, independent, alert, and a little bit cunning. If he turned his head swiftly, he might catch it in the act of flying heavily from his shoulder over to the back of their captain's chair (this was in the study), or to the mantel above the burning fire.

He moved slowly over to his desk and sat down. A decanter of scotch sat on a silver tray on a recessed shelf in the wall. He sat and stared at it from the depths of his deep brown, vinyl chair, turning back and forth slightly on its pivoting center leg. He squinted his eyes and looked at the bottle, then he turned his head and the parrot lumbered over to the mantle. He didn't see the parrot itself, only the cold shadow floating mercurially on the rug and over the bushel-sized globe of the world.

Greg took a deep breath and leaned his head back against the chair, so that he was staring at the ceiling. Of course, she "had done it for his own good"; but the violation was there, and it could not be forgiven.

Then a strange thought came to him: Ethel was not solipsistic at all. No more so than the other members of their family, or the number two people, or even the number three people. Betty Childers, for example. They were lonely (*all* people experienced loneliness), but this was in some ways the opposite of solipsism. Loneliness was sorrow at the remoteness of other people; solipsism was the loss of the reality of other people. They *couldn't* be far away, for they did not exist at all.

And all this time, what had held them together (that little clue that reached back to the fiercely idealistic, sensitive, and ironic young man he had been) was this paradox that they might—half playfully, half seriously—meet together in their isolated convictions of abandonment, and share a wry and bitter warmth.

What confusion! *Were* there children, for instance? *Was* he sentenced to return to that old sophomoric anxiety about the reality of others the minute they left the room? If the world were created one second ago, with each of us programmed to believe in both individual and collective histories, we might be exactly as we are now . . . except for this one person who *conceived* of the monstrous trick, and thereby for an instant stood outside of it.

There was a knock on the door, and Ethel asked, "May I come in?"

"Yes," he said, swinging around in his chair.

"I've brought you a drink," she said, putting a tray on the desk in front of him. "I knew you were out of ice in the study, because you told me so last night."

Greg lifted his eyes from the tray and stared at his wife. She was smiling down at him. "I felt like one, too," she said.

Then she put his glass in front of him on a coaster on his desk and picked up her own. She turned away slightly and stared at his books, saying, "Well, here's mud in your eye."

"Mud," he said, and drank.

One of the cats jumped up on the bench by the window and started licking its paws out of a smiling mask. The parrot had fallen into the wastebasket. It was dead.

Well, Ethel was really up to something.

Greg spent the next afternoon hosing out the garage, standing there in rumpled slacks and sweater, a pipe hanging from his mouth, and the faint sharp taste of gin soaked into his stomach and throat. He swallowed several times, comfortably, and left his pipe unlighted. The taste of tobacco was good and it harmonized with the gin. Oh, how they could harmonize.

They had once been troubled by rats in the garage, but Greg hadn't seen one for years. Their cats kept them away, perhaps. The garage was a heavy, large edifice: stucco exterior, windows that Greg himself had painted ivory only last summer. A few martins had nested in the eaves in the back, and sometimes he and Ethel would sit in back and watch them.

They weren't "going anywhere." They didn't have any commitments. That is what Ethel had said, only that morning. "Isn't it wonderful that we don't have any commitments?" she said. She had been dressed in a pink slacks outfit and she brought out gin and tonics to the patio. He stared at her, wondering what she was up to.

"Mud in your eye," she said.

"Mud," he answered.

"Just the two of us," she said, settling her ample bottom into one of the metal patio chairs. Greg had painted them only last summer, with the same paint he had used on the garage windows.

"Cozy," Ethel said, sipping her gin and tonic.

Greg looked at his watch. Eleven-o-three. He sipped and squinted his eyes into the sunlight of the backyard.

"Where have all the martinis gone?" he asked.

"They don't live there any more," Ethel said. (She knew his language.) "They still live all over the neighborhood, though." When he finished his gin and tonic, she made him another one. He drank it, too,

and sat there faintly lopsided in the head, while she made toasted ham and cheese sandwiches in the kitchen, and he brooded upon the strangeness of her behavior.

The phone rang, and he didn't hear her answer, although he did hear it stop ringing. (His hearing really *was* getting bad.) A few minutes later, she came out on the patio with their sandwiches and a cold beer apiece, on a tray.

"Who was it?" he asked.

"Couldn't you hear me say her name?" Ethel asked. "I mean the phone isn't all *that* far away."

"No, I couldn't hear a thing."

"It was Ginny Sands. You really should have your ears checked."

"What did Ginny Sands want?"

"She wanted me to come to lunch with her next Thursday, but I don't think I want to be bothered.

"It would be nice," Greg said. "I mean, to get out."

"No, I don't want to get out. I just like it here. It's so nice and peaceful.

"It is that," Greg said, sipping his gin and tonic and staring at the untasted beer.

Then he lay down and took a nap, and when he woke up, he put on his old clothes and ambled out to the garage.

Several martinis flew overhead, and he heard gurgling under the cement floor of the garage when he turned on the hose. The only thing was, the gurgling seemed human, like the voices of drunkards drowning in their own damned desirable sauce.

When he took a shower and put on clean clothes, it was almost four o'clock. Ethel, bless her heart, brought him a bourbon on the rocks, and he sipped at it as the room got pleasantly dark.

"Isn't this cozy?" she asked.

He found himself sitting on the patio again, his feet comfortably raised, a drink of something in his hand. He had forgotten how he had gotten here. Birds were circling high overhead, and it was evening. They were like the figures on a clock dial, moving slowly, slowly, looking for an hour hand.

Two days later, it came to him. He had fallen asleep in his special lawn chair that he kept back beside the hydrangeas and shaded from the warm morning sun by the arbor. It was like that old story of the great French mathematician who used to go to sleep with his brain soaked in the details of a problem, and he would wake up with the problem solved. *Voilà.* What was his name?

Greg sat up in the lawnchair and saw the ground ripple slowly, as if there were literally a ground swell pulsing through the Brumbager's, the Collins', and the Shaper's. On and on and on.

What was the French mathematician's name?

Greg blinked and tasted the stale, sour smell in his mouth. He had been working in the back yard, while it was cool, carving a new border for the rose sections. Ethel had interrupted him a little after ten-thirty, bearing a tray of Bloody Marys back back to him, saying, "I thought you'd appreciate a little break. My, you've been working *hard*!" Her cheeks were crazily flushed, as if with excitement and elderly desire.

Then she led him back to the lawn furniture by the arbor, and they sat there commenting on the beautiful weather, and sipping from their Bloody Marys.

When he was finished with his, Greg said, "You know, I'm sleepy."

And Ethel said, "Well, there's no earthly reason you can't just lie back in your chair and go to sleep!" She said it with an almost mystical conviction. Then he thought she was going to say, "Isn't it nice, not having any obligations?" But she didn't and Greg wondered briefly why the words had come into his mind; and then he knew: she had been saying this over and over the past week.

And the phone rang several times, and always she had answered it, and always she claimed it was an invitation for her alone, and always she had turned it down.

When he drifted off to sleep, Greg thought about this, and about her protecting him from drinking. And then when he woke up half an hour later, he felt drained, weak, vague; a heavy burning sheet of sunlight lay across his right arm and across his rumpled trousers, his groin and legs.

But he knew the answer: Ethel was determined to keep him all to herself. She didn't want him to drink so much (she had been scolding him for forty years about it), but if he was determined to drink himself to death (an early solipsistic grave, he said deep down), she would preside over the ceremonies. *She* would preside over the ceremonies. *She* would take care of him, no matter how nutty and forgetful she was getting lately, even if it was the slow suicide of alcoholism that he was intent upon.

It was all so clear to him. It fit his sense of the jealous and proprietary passion she had so often evinced since they had married all those years before. It was so terribly, fascinatingly *like* her to take it upon herself to invent such an excuse when she witnessed his increased drinking (or what she *insisted* was an increase, although if this were so, it was too gradual for his detection . . . but then his memory, like his hearing, was darkening in his head).

His solipsism, then, included her . . . by virtue of her insistence, her almost maternal possessiveness, her fierce love. She was part of his craziness—increasingly forgetful these days, moving more and more slowly, *distrait.*

Greg ambled vaguely through the yard, stopping now and then to touch the leaves of their flowers, as if to test his ability to feel them. "Not *all* abandons one," he murmured, tickling the underleaf of a floribunda as if it were a little chin.

Then, as if in answer to the assertion, the phone rang, and Greg listened to it ring twice, three times, and then four, before he heard Ethel's voice say, "Well, hell-low!"

Number three response.

Then later he is lying drunk in his bed, his mind whirling down inscrutable vortices and washing, lapping, sliding against the scum of unidentifiable stone pilings.

"It was Poincaré," he says to himself. "That's who it was." But now he's not positive he can remember the question that this is meant to answer.

A truck accelerates from the traffic light on the highway half a mile away, and for an instant Greg witnesses the terrible alternation of green to red, as the traffic light pulses in the cool dark.

Then, equally fascinated, he listens to the phone ring deep in his mind, and he freezes . . . intent upon not answering it, waiting for Ethel to come and lie into it once again, for if he is to be killed, it is Ethel, bless her heart, who will preside over the sacrifice.

The window chokes and swallows the curtain, like a mouth gagging on a scarf that the wind has blown loosely into it. The radiator of the old house glows dully like bronze teeth.

In the distance, a girl is laughing at some invisible television show, drunk with the idea that she might someday be beautiful and happy. And possess a man that she can guide clear to the edge of the dark water.

No one has ever been more cool, more dignified. Day and night pulse slowly, silently over his face, but Greg stands erect, or sits in dignity, his hand loosely fondling a glass. Rain comes and falls heavily upon the house and the back lawn, hammering the petals of the full blossoms into soft smears upon the peatmoss–darkened earth.

The lawn greens brightly after the rain, and then there is a long night, and Greg finds himself out in back in the freshness of morning, pushing the power mower. He cannot remember starting it, and won-

ders briefly if it has not always been running, lying in the gloom of the shed, waiting for him to return.

He paces slowly, carefully, down the aisles of mown grass, feeling the longer spikes tickle his naked ankles. He is wearing sandals, yellow Bermuda shorts, and an old, faded-brown, open-necked golf shirt. The sun burns like oil frying on the surface of his skin, but inside he is a little cold. The grass is still cool, and his feet are affected. A breeze flutters the leaves of the Chinese elm, and there is a wren sitting on a limb, staring at him.

Ethel has not interrupted his mowing. And he is relieved. He has found that he begins to dread her aproach with the tray, containing iced bourbon or scotch . . . or gin and tonic, or vodka and Tang. ("We are eclectic drinkers," he had stated once, years before at a party, and Ethel had looked at him with her eyes twinkling and said, "Well, *you* are, old sport." She had gone through a period of talking like a female Gatsby.)

Back and forth he traveled, pushing the throbbing, snarling lawn motor, feeling the shower of cool grass on his knees at the same time his face got hotter and hotter. He switched it off and looked at his watch: it was eleven-o-seven. He looked up at the patio, the back door.

Silence. A drone of silence. A car somewhere on the street, and a tiny horn somehwere on the highway. Beep.

A little shaky, Greg left the power mower glowing in the sunlight, six or seven rows away from the shade of the blue spruce (when he hit this shade in late June, he knew he was exactly three-quarters through with the back yard, considering the shaded area behind the house and the other beside the shed).

Back to his lawn chair he went, and as he was sitting down, another discovery came to him: it wasn't homicide she was thinking of. No, not even remotely that: it was to keep him under control, *but keep feeding him too much booze, so that he would get sick of it, totally, without at any one time getting dangerously, staggeringly drunk.*

Of course. That had to be it; and the truth was, it was working. At last he was pleased that she wasn't bringing him another drink, after all these days, even weeks, of feeding it to him, like an anxious, neurotic mother overfeeding her baby.

The effect of this idea upon Greg was a complex one; inside his mind, he made a wry face, causing a shadow of it to flick over his features and blow away in the faint, cooling breeze. But he sighed, and gave thanks that he had never challenged her over her lies on the telephone . . . the lies she had told to keep him home and within her power.

And God, the loyalty of the woman! The drink she always had with him, or pretended to have (diluted, he supposed) . . . although this, too,

was costing her something, for she had seemed haggard a few times lately, and absent-minded . . . as if she might be having second thoughts about such an elaborate harness of trickery to drop about her husband's head.

Ethel, bless her heart, was showing the strain.

But God, it was working.

Greg eased back into his lawn chair and began to drift off into sleep. The breeze picked up, and he twisted the chair around so that his feet extended into the sunlight. The wren was now singing loudly from the arbor, somewhere above his head. The martinis were soaring far above (or perhaps they were blackbirds or swifts—his eyes were getting bad, too).

Then there was the phone ringing.

It rang once, twice, three times. Then it rang a fourth and fifth.

"She must be in the bathroom," Greg whispered inside. He got to his feet and walked as quickly as possible across the patio and into the house. The phone stoped ringing the instant he pulled the sliding screen door shut.

He went to the phone anyway, and lifted the receiver. A steady buzz.

He lifted his chin slightly and cried out, "Ethel! Ethel!"

There was no sound. He went through the house downstairs, stopping in the kitchen, where he saw the vodka bottle standing on the counter. Apparently, she had started to fix the Bloody Marys and then had changed her mind. Gone to the toilet, maybe.

But the downstairs bathroom was empty. So she must be upstairs.

Greg climbed them slowly, his hand working steadily up the bannister, and when he came to open the door of the master bedroom, he saw one of Ethel's arms curved outward, in the stylized, graceful, ballet gesture of a maiden's arm dropping a flower to someone below.

A current of fear thrilled in Greg's stomach and he hurried into the bedroom. Ethel was sprawled cruciform on her back, dressed in her aqua slacks and a mussed white blouse. He lifted the eloquent arm with one hand and spoke her name. Then louder: "Ethel! Ethel!"

Suddenly, she snored at him. Her eyelids parted slightly, showing the edge of her corneas briefly before they closed. He leaned over and pulled her up to a sitting position. Her hair stayed mussed, like the permanently warped head of an old wet mop. Her mouth eased open. Two bright spots glowed unevenly on her cheeks, and then her eyes came open halfway as she tasted her lips.

"You've had too damned much, Ethel!" Greg said, shaking her. "You're drunk!"

"I'm tired," she said, drifting down onto the bed once more.

"Is *this* what it's done to you?" Greg cried, shaking her body and making her head move back and forth.

"Isn't it nice?" she said, turning her head to the side. "We don't have to do anything we don't want to anymore."

"What are you talking about?" he cried.

But she didn't answer. And Greg stood there by the bed with his fists doubled up as the realization spread like a stain throughout his mind.

"It wasn't me at all, was it?" he cried, shaking her once again. "It was you all along. You just said it was me, but it was *you!*"

"If the phone rings, don't accept any invitations," she muttered, and then she passed out once again.

The Gray Lady

One of the first things he saw upon regaining consciousness was the face of the gray lady peering down into his. She was middle-aged and still pretty; and she appeared vaguely familiar to him, although he didn't know her name. He had seen her somewhere on the campus of the university where he had taken a graduate assistantship only weeks before.

Her hair was a glistening white, and it was molded neatly about her head with dark combs that almost matched her eyes. Her lips were painted red, and her eyes were brightly alert, only faintly disturbed by the madness of an unrelenting hope.

Every weekday morning, at her allotted time, she came to him. First, he would smell her perfume, and then she would lean over him maternally, gazing down into his face, her lips pursed in concentration. Her gray uniform was always fanatically clean—starched and neat—and usually she rested the vague, accommodating softness of her bosom against some part of his middle body.

This, however, was something he could detect only by a general feeling of weight being pressed against him, for he was almost totally paralyzed from the motorcycle accident. Although he could see clearly enough, he could not move and he' could not speak.

On her second visit, she had said, "I know your name, and all about you. You're a graduate assistant in English, and you've had six or seven poems published. Haven't you? And you just came here to teach this fall, and really don't know anybody yet. Isn't that right?"

She stared down at him as if he might suddenly stop this nonsense and answer her after all. Then she said, "I'm also working at the university. In the alumni office, part time. My husband's in physics."

Again she waited, seemingly for the time required for answering to elapse, and then she went on: "Dr. Chalmers sends his best, and says he

hopes to come visit you before long. You know: your chairman, Dr. Chalmers."

She gossiped for a while longer, and then left him—presumably to distribute chewing gum, books, and candy in the ward, and to warm others with the brightness of that look.

For a while he lay there thinking of how remote he had always considered himself, and how he had always taken pride in his isolation. He had been invited to two parties already, and at both he had managed to insulate himself from the others. When each hostess had come up to him to draw him back into a conversational ring, he had resisted, saying the identical thing: "Thanks, but I really prefer being alone."

Later, he was to think of how affected this seemed, but in trying to remember the hostesses' reaction, he wasn't sure they had paid much attention. Still, he castigated himself, and wondered if—if they *had* thought about it—people had resented his illogicality. After all, if he really preferred being alone, he shouldn't have come to the parties in the first place.

However he wasn't sure that the hostesses' really heard what he was saying, beyond a vague recognition that he was something of a social problem. They had both left him quickly, and presumably that was what he had wanted; but the fact was, he was miserable at the thought, and went over each scene in his mind, again and again.

And then, a few days later, half-drunk on his motorcycle, he was approaching a curve on a county road. His front wheel hit a mud trail left by a tractor, and the motorcycle went out from under him as it if had been hit by a gigantic golf club. For an instant, he was flying, and then the motorcycle hit something, sounding like an enormous hand clap, a fraction of a second before he did. He could still hear the sound, although he naturally didn't see what the motorcycle hit; he didn't see anything at all, until waking up in the ward.

Once, beyond his vision (for he couldn't turn his head), he heard the gray lady talking to the day nurse.

"Doesn't he have visitors?" she asked.

"No, not that I've seen," the day nurse answered.

"What a pity. No girl friend, no mother? No friends?"

The day nurse did not answer, and he imagined that she was shaking her head no. Maybe intent upon some other task—reading a thermometer, for example, and trying to ignore the gray lady's persistent questioning.

"Doesn't he have nice eyes?" the gray lady said.

The day nurse didn't answer that, either—probably from a sense that the notice of such a thing was beneath her professional dignity.

But the gray lady was not to be put off. "Can he hear *anything* of what we are saying?" she asked.

Once again, the day nurse refused to answer, and he heard her heavy footstep go thudding up the ward. Then the bed moved, and her face was leaning above him, smiling. "Can you hear what I'm saying?" she asked.

"His hearing's all right," another voice explained from some vague distance.

"Well, that's fine," the gray lady said, not looking away from his face. "Then we'll just have to teach him to talk again. Or at least, to *communicate.*"

As if on some strange and pointless cue, a distant ambulance siren was wailing. The ambulance was probably coming to this very hospital, bringing some bloody casualty into the very emergency ward where he himself had been admitted several weeks before.

In spite of all indications and early prognoses, he was able eventually to move the fingers on his right hand. The gray lady—who had not even given him her name, although she had never failed to visit him daily for long periods—seemed to regard this as almost a personal triumph. Behind the casual things she said to the nurses and attendants was something like: "See what hope can do? And perseverence? And warmth and love?"

She attacked that right hand the minute his fingers began to move, and before long she had it trying to print letters on a pad with a pencil. But it was terribly difficult, because the articulation was at first limited to the first two joints of the fingers, and making a recognizable letter was really impossible.

"First," she said, "we will have to establish a simple language, consisting of *yes* and *no.* If you understand, move your index finger twice against my hand."

He did so, after a despairing pause, and she almost clucked with triumph.

"From now on, that's our signal. All right?"

Two more movements of the index finger. He could not see her face, now, because she was too far toward the foot of the bed. But for him to share in his own triumph, she stepped forward and smiled down upon him, within view. For an instant, he thought she might kiss him. But she did not, and the bed only lurched as she went back down toward his

hand, placing the pad beneath it and talking once more about how he should try to make letters.

He realized that she hadn't taught him *no;* perhaps because she didn't believe in negatives. But of course he knew it had to be one move of the finger. Or none.

"We'll start with the simple ones," she said. "Like *I* and *O;* all right?" Two nudges of the finger; a breeze of perfume and another celestial smile.

"The *I* will be easy," she said. "Just a straight downward mark."

Before he moved the pencil, he decided that he would do the opposite of what she said, and make the *I* with a straight *upward* mark. If she had any subtlety at all, she would realize that this signified that he wasn't about to have her take him over.

But the fact was, he couldn't manage an upward mark, and after ten minutes of nagging, he made the desired downward mark. She had taught him his first letter.

She taught him several other letters—*T* and *A* for example—during the next week.

Insufferably cheerful, and sophomorically erudite, she explained his progress to the day nurse one morning. "We have to make a compromise," she said, "between utility and convenience. That is, there's no point in teaching him *Q* and *Z* this early, because they are relatively unimportant letters, even though they are easy to make."

During this lecture, the day nurse was quiet, and he imagined that she was busy about her tasks and trying to ignore the gray lady as much as possible. Then it was that he began to think that he and the day nurse were in a strange kind of league against the gray lady, and were trying to resist the fury of her determination that he should recover. The day nurse respected his solitude as if she were aware of all his lonely posturing in the past. She was another hostess, and this was the dullest party he'd ever seen.

Somebody moaned from a nearby bed, but the gray lady did not seem to notice. Or at least not to care. Following the moan, she said, "His *T*s are superb."

But of course the gray lady was not there for most of the day, and whatever progress she made during her visits was in danger of being drained by the long hours she was away. His body continued to function with the help of tubes that drained away the poisons that accumulated from the nourishment that other tubes poured in. His eyes blinked, he swallowed and the fingers on his right hand moved. But this was all.

One morning, the Gray Lady pressed over him and said, "There's

60

no point in learning more letters. Is there? You can make *O*s and *T*s and *M*s and a half dozen others. So I know you can make any of them you want. Right?"

His right fingers were cupped in her hand, but he didn't move, until she nagged him to answer. And eventually he moved them twice.

She frowned, and said in a scolding voice: "You know, you sometimes act as if you don't *want* to get better."

He tapped his fingers twice, and she actually got a hard look on her face. "Now let's not make jokes about a thing like that," she said. "Do you promise?"

He tapped once, and she said, "Don't you say no to such a question as that! Why, that's awful. Give me a *yes.*"

Outside, he heard another siren; and for some reason the sound terrified him so much that he tapped his fingers twice, and she loomed over him, bearing a forgiving smile on her face. Her body was pressed against him, and he wished he could have felt the warmth and softness of her bosom.

"You must concentrate on a message," she said. "You've made nine letters over the past two weeks, three of them twice, and one of them—*I—four whole times!* Now I want you to concentrate on spelling out a message. You're ready to communicate, do you understand?"

He tapped twice, and she left him that morning happily reporting to the day nurse that he was making progress, and ready to communicate.

Immediately after she left, he wondered what she had found out about him and if she had ever bothered to look up his poetry. She would be shocked if she did. And maybe secretly pleased. There was no telling.

He found himself looking forward to her next visit, in spite of himself. The hours lay upon him like deep water, and he longed to smell her perfume and see that crazy, pretty face float over him and stare down, as if from a glass-bottomed boat.

There were not many sirens that night, and he was thankful for that. He wasn't sure why they terrified him; the most obvious reason—that they brought back to him vividly the fearfulness of his accident—did not seem sufficient. For one thing, he had been totally unconscious in the ambulance, and did not regain consciousness for some thirty hours.

Perhaps the terror had to do with a less personal feeling the siren brought him—an understanding that pain and tragedy, and even loneliness, were ubiquitous. That even his own catastrophe did not end and settle anything, really, but that the same horror was happening again and again, as if some demonic god overheard all proud and foolish claims for solitude, and with evil logic hungered constantly for the blood and human wreckage that seal us off from others.

61

When morning came and the orderly changed his bed, he turned his eyes all about, trying to see as much as possible. He had by this time been able to glimpse his ward mates, as well as the orderlies and nurses. These were his whole society, outside of the Gray Lady, and when he was confronted with them he had no idea of what he might say, even if he *could* speak.

Since he could not see the ward clock, he had only the sounds of the morning routine to judge time by; consequently, he was not sure that the time for her visit had come. Still, she had not arrived. He tried to think that it was his own anxiety that made her seem late.

But of course this explanation could not satisfy for long, and when the sounds of lunch came to him, he knew that she would not be there today. For the first time, she had not come.

One of the things that most disturbed him was his determination not to write a message for her. In his imagination, she had countless times slipped the pad under his hand, the pencil in his finger, and said, "Write." His hand remained motionless. Eventually, he knew she would remove the pad and pencil, and take his fingers in hers, and ask, "Won't you please try to write something?"

And he would tap his index finger once.

But this rejection began to seem impossible, because she did not come the next day. Nor even the next.

The day nurse did not explain the absence of the Gray Lady, but then this was hardly surprising, for her attitude toward her had always been one of obvious and brusque contempt for her nonprofessional enthusiasm. At least, this is how he had interpreted those silences that often served as answers to the Gray Lady's questions and comments.

These two first days were misery for him. He lay there trying to remind himself of how silly the Gray Lady was, and how ridiculous her attempts were. What did they add up to at best? What real hope was left to him now?

In his mind there was no question. His life would be a prolonged vegetable state. He would be a mere dam, complete with locks, in the river of liquids—nourishment and waste—that were piped in and out of his body. Or a filter pointlessly converting nourishment into waste. What would he be able to write to her, if she did come back?

The next day, he felt a pad and pencil put in his hand, but he couldn't see who did it. He was convinced it wasn't the Gray Lady for two reasons: he couldn't smell her perfume, and her face did not come into view.

Later in the afternoon, however, one of the orderlies fixed a mirror above his head, so that he could see that part of the ward immediately in front of his bed, along with the shape of his dead feet beneath the blanket, and his right hand with pad and pencil.

Why hadn't someone thought of this before? Was she stupid, not to think of this? The question rotated briefly in his mind, but then evaporated. And later on that day he painfully and carefully made two letters side by side: a *K* and an *I*. But of course she wasn't there to urge him on, and he stopped the nonsense, and spent the remainder of the day burdened with dreams.

But the next morning she returned, and explained that she had been ill for several days.

"Did you miss me?" she asked, holding his hand.

He tapped once, and started to tap a second time, but for some reason he did not. But she had already dropped his hand, and was fussing with the covers about his legs. She hadn't even waited for an answer!

"I hear you've started your first message!" she said, clapping her hands as if before a three-year-old.

"And a *K;* you haven't done a *K* for me before, have you?"

She stared at him, as if half expecting him to speak. Then she got out the pad and pencil, and put them in his hand, saying "Maybe you can finish the message today."

Painfully, slowly, he made two *L*s, and then an *M* and an *E*.

She was ecstatic over his success. "You're getting well," she said, jostling his dead leg with her hand and beaming into the mirror. "But finish it. It doesn't say anything."

He stared at her for an instant, and then closed his eyes. She jostled him and said, "Here. Don't give up now. It doesn't say anything. *K-I-L-L-M-E* isn't a word. Are you starting someone's name?"

She looked down at the pad and frowned for an instant, then she looked up smiling, and said, "Of course. 'Kilmer.' Joyce Kilmer. Why didn't I think of it sooner! I found out that you wrote poetry, and I should have guessed! And you haven't learned to make an *R* yet. Am I right? Am I right?"

She clasped his fingers, waiting for some impulse from him; but he did not give any, and she threw his fingers down, and said, "Of course that's it. I'll bring some of his poems tomorrow. I used to be able to recite 'Trees' from memory, but I'm afraid I couldn't do it now."

She was so happy with her discovery that she didn't pay any more attention to him for the remainder of her visit.

The next day, she had a tattered library book with her, and she sat down beside his bed, and commenced to read:

> I think that I shall never see
> A poem lovely as a tree . . .

When she finished reading the poem, she closed the book and laid it neatly on the bed. Her eyes stared into the reflection of his, in the mirror above his head.

"I think you've done just wonderfully," she said, shaking her head. "However, there are two things: first, you spelled the poet's name wrong. There is only one *l* in his name: Joyce K-i-l-m-e-r. Kilmer. Being a poet yourself, you should be ashamed of such a silly error.

"And secondly, you'll just have to practice your *R*s. They aren't *that* difficult, now are they?"

She put the pad under his hand and fixed the pencil in his fingers. Once more he drew out a *K.*

Gently, she took the pad away, and said, "No, you made a *K.* Just close the top, like this, and you'll have an 'R'. Now try again."

Again he made the *K* and she took the pad away.

For an instant, she looked at what he had done, and then she looked up at the reflection of his face in the mirror. He was surprised to discover a look of great sadness in her eyes. Tears were stuck in her eyelashes, and she swallowed before she spoke again.

She said, her voice so low and unstable he could hardly hear: "No more messages. You're too tired."

Then she stood up, looked at the distant ceiling, and brushed her hands down her gray uniform. Her expression was still sorrowful. Outside, a siren sounded once again.

"Tomorrow you'll feel better," she said, turning away from the bed, so that her voice was suddenly muted. "And then maybe you'll forget about such horrible silly tricks."

Haunted by Name
Our Ignorant Lips

I

Well, the first thing you're going to have trouble believing is Birdie Braine herself. Almost six feet tall, with a back straight as an Indian warrior and hair just as black. A wealth of bosom, and handsome dark eyes.

That's right, "Birdie Braine." Christened Bertha by her old daddy (Wendall Braine) and her mother (born Fern Clay; that's right, too, earth to earth and ancient, because Fern's family have lived in this valley for almost two centuries, as Wendall's copy of Dell's *History of the Wyandotte Valley* will attest). Christened Bertha, but slipping very quickly into "Birdie" by all the schoolboy wits, as if humorless old Wendall had cunningly figured it out long beforehand.

Wendall once owned six hundred acres of good dark bottom land, but he began to get strange cautionary signals and started to sell it off near the end of his life and stash the money away in unlikely places: a stack of twenty dollar bills stuffed behind the painted cherry wainscoting in the dining room ("What'll you do if there's a *fire!*" Fern would shriek at him in public, when she thought he'd be obliged to *pretend* to listen to her, at least; "Do? I won't do *nothing!*" Wendall shouted back at her, pounding his knee with a palm as big as a Ping-Pong paddle. Wendall was six feet six and weighted two-ninety in his prime—that's where Birdie got her height, everybody said); but near the end, he got wary and tired, and took in his flesh. And that's the way it looked—tucked in around his starched collar in soft leathery tan folds, little gray bristles sticking out here and there (so women wouldn't caress him, he said; they'd get their hand pricked if they did), his black eyes turning softer and shallower (as if filling up with

strange memories), and their sockets going deeper all around, like two perfectly symmetrical balls-and-joints carved from light walnut.

Fern was in her grave now, no longer nagging. Wendall Jr. had run away from home, stopping an inch short of his daddy's six and a half feet and flunking out of college, in spite of a basketball scholarship ("He wasn't first-string material," his high school coach, Jerry Frick, always said; "too slow."). Then Wendall Jr. floated around the country, getting hooked up with an oil driller, and phoning the old Braine place twice or three times a year to ask for money or find out how they were.

Fern was dead. Buried in the family plot back of the old Clay mansion (red brick with white stepping-stone borders up the roof—built in 1846 by Fern's great-great-granddaddy, who'd live to muster a regiment in the War of the Rebellion and die of swamp fever in Mississippi. Capt. Clay, with a southern name, come south from Ohio in a passionate but murky cause, to die south of his Kentucky heritage).

But the Braines were Ohio and, more specifically, Wyandotte Valley, through and through, and had Creek water in their veins. Wendall reached the age of sixty-seven (his weight slipping clear down to two-hundred), and then he passed away one Sunday night in his chair during a National Geographic special. Birdie figured this out, because she phoned her daddy at nine o'clock that night and not getting any answer, went right on over there and found him slumped way back in his chair, his face hard and turning purple around the mouth and eyes, the television going on channel twenty. He looked like he'd been dead about an hour, she told people. And so far as anybody can tell, he had.

Old Wendall had built his darling Birdie girl a nice little brick ranch house at the edge of town, where she lived alone and liked it. That's what she said to everybody in that smart alexandra voice of hers. Just like back in school, when she'd introduce herself to a stranger, she'd say, "Birdie Braine. You know: cheep, cheep." Then she'd laugh, hah, hah, hah, staring curious, but a little cold-eyed, at the other person to see his reaction.

Yes, that is Birdie, all the way. She'll go wading a hundred yards through briers and poison ivy to embrace her fate. If everybody else had forgotten that silly nickname, Birdie would have kept it alive by her own reference. Birdie Braine, cheep, cheep, hah, hah.

But if anyone showed the least flick of interest, Birdie would say, "It's an old English name. They settled the Wyandotte Valley in log cabins. Had to shove the Indians aside with their elbows just to have room to swing the axe."

Of course, her last name was strange enough, without the birdie part. But she herself was strange enough to eclipse both of them, once

66

you knew her. I know, because Birdie and I are the same age and have gone through school together all the way, except for her college and my college and law school. But neither one of us could stay away. We knew where our destinies were (I'll tell you something: I've waded through some briers myself), and we came back to the Wyandotte Valley, the old ancestral home, the little white village nestled sleepily between the long sloping hills, where nothing public (or public relationally) happens. Yes sir.

Birdie has never married. No man big enough to hold her, maybe. Who knows? She's sure as hell a virgin (I tell you, I know her almost better than anybody ever *should* know anybody else), but who knows what dreams she has? Or, in the obtuse, uncaring public way of the world, who the hell cares?

But never mind that. This account is for people who care. Or who *can* care, who can see the little things hapening that make up the brick and mortar of our days, while we keep reading crazy maps made by distant organizations (not men) that presume to define our realities.

Birdie Braine was and is like no other human being who has inhabited (or does or will inhabit) the earth. Birdie is county recorder, has run for county offices off and on for fifteen years, her own little personal women's lib movement. Birdie won't stand still for men's ways. Don't get the wrong idea: Birdie is no fashionable Lesbian Libby, or any other kind of addled ad-libber; has no unnatural affection for women's bodies (this much I know about her dreams), and if she has lusts for men, she has never even let *them* show, beyond sentimental gestures and occasional remarks.

Then there was old Wendall. What kind of stories did they tell each other? What sort of games did they play? I've often wondered.

The night he died, George Sickles (the constable, who used to shoot baskets in our driveway with my kid brother) phoned and broke the news to me.

"Birdie says you're the lawyer," George said in an official voice. This was ridiculous, because everybody *knew* I did all of Old Wendall's legal work (and that included Birdie, too) and such didn't need mention, but I went along with his tone and said, "Yes, I'm the man. How is she holding up?"

"Birdie? Oh, she's doing pretty good. Maude Fulmer's here, and old lady Smith from next door. I think there'll be some others here before long. They just took Wendall away. He was sure dead. His face looked like them lead soldiers we used to make out of molds when we was kids. The same color."

"Yes," I said.

"His heart," George said.

"Well, I guess I'd better come on over."

George agreed, and I hung up the phone.

"Who was that?" my wife called from the kitchen, where we have our television set. We've put it right back by the window, and she and I have two antique Boston rockers placed right before it, and we sit and watch it every evening. My wife says that I cuss once for every time the rocker comes forward, because of the silly drivel they have on television. But I watch it anyway. She says I love to hate it.

"That was George," I told her. Then I waited about four steps and two swings of her rocker while I walked into the kitchen and I said to the back of her head, "Wendall just died. He called to notify me."

My wife stopped rocking and turned around and looked at me. "Wendall?"

"Yes."

"Oh, that's too bad," my wife said, after a long pause. She turned around and looked at the dark window above the television set. Beyond the window, there's a stone birdbath and my wife's flower borders. Beyond that, the old shed in back, and then the garage. Beyond that, a vacant lot, then another street with only three little houses on it, and then the wooded hills in back. And then, of course, the sky. Which you couldn't see, now, because the kitchen was lighted.

"Well, I'm going over to see Birdie and see if there's anything I can do," I said.

"This will kill Birdie, too," my wife said, shaking her head.

"I don't know whether it will or not," I said. Then I got on my coat and hat and walked out the side door, where my shiny new Oldsmobile sat waiting for me.

II

The immediate problem was Wendall Jr. and how to find him.

I asked Birdie where he'd been when they'd last heard from him. Birdie paused and thought. She was wearing a gray pant suit and sitting in a big stuffed chair with her arms on the sides. Her face was dry and composed, but there seemed to be a strange light in it, as if something had just exploded deep inside. (But then, maybe that's my imagination; who can tell?)

"The last time he called, he was someplace in Arkansas," she said, leaning her head back in the chair and staring up at the ceiling.

"What town," I said.

"I don't know," she said, "But we've got to let him know. I mean, I

president of our graduating class (Wyandotte High, 1941); I was valedictorian.

Birdie had written a poem in her senior year, and Miss Rumbacher had pinned a copy above the entrance to the English room. When it was taken down, Birdie made another copy by hand (her handwriting going straight up and down and as even as the stitches of a sewing machine) and gave it to me.

"I think you can understand something of this," she said. For once, she was not joking. She blushed and hustled away from me in the hallway, the sturdy calves of her legs rubbing together with each step (I had followed her up the stairs many times and had often witnessed this miracle).

I told her I had liked the poem, which was a lie because I hadn't read it after hearing Miss Rumbacher praise it so highly and refer to it a dozen times.

Later, though, I read it. Then read it again and again. Birdie was strange beyond understanding. Already, she was practicing madness. The rotting bodies of those Indian warriors had been radiating dark juices of romantico-philosophic-weltschmerz from the mound; poisoning the Braine's well water. (Killing poor old Fern and affecting old Wendall's mind; driving Fletcher to an icy suicide, according to Birdie's gradually evolved sense of things.)

The poem itself:

Old Wyandotte

Hark, hark to the falling leaves
Shuddering down from the highest limbs.
Summer pleases, but light deceives,
Autumn is truth as the light dims.

Most the world is past, is past!
We the flurry of small moments.
Join we soon the eternal cast
Attired eternal in earth's garments.

Now our civilized confusion
Into the present valley seeps;
But the ancient Indian nation
Haunts by name our ignorant lips.

Wyandotte, oh Wyandotte!
Lost land of forgotten folk!

As your Fate, so our lot;
For we are teamed in the ghostly yoke!

Birdie's mind (after all these years, still) flies up into the high branches of that sycamore tree and chirps hoarsely, a raven of madness.

Her eyes darken. She does not talk as much; never jokes. Birdie Braine. (No cheep, cheep, no cheap joke, no hah hah. Silence. Brother is being awaited. The longer gone, the more mythic. He grows another inch; still another. He is taller than daddy, and he frowns down out of a rain cloud, roiling the creek where poor little Fletcher drowned so long before.)

"I wouldn't spend too much time with that woman," my wife said in the kitchen. I was rocking in my Boston rocker. She was behind me, shining her copperware with Brillo pads.

"What woman?" I ask, knowing full well what woman.

"Birdie. She's always been strange. And now . . . well, now there's really something wrong with her. I think poor Wendall's passing away was too much."

I turned around and stared at the woman, watching her hand make little circles in the copperware. Her eyes were distant; her lips pursed with the comfort of the power to reject, the salubrious safe bloodletting of the sick.

I growled into my cigar and lit a sulphur match. The flame pulsed at the tip of the claro cylinder.

"She passed right by me today and didn't speak," my wife said.

"Well, you've gotten even with her now," I said.

"Just what do you mean by that?" she asked. "All I'm thinking about is your own good. People like that who have problems . . . well, it's best to leave them alone.

"Unquestionably," I said.

"The woman's *never* been right, and you know it."

"No doubt about it."

"Her hair was hanging loose down her back. Clear to her waist. She had a crazy little hair ribbon hanging as crooked as could be at the back of her head. And wearing that awful gray pant suit she's always wearing."

"Birdie is a client," I said.

"Oh, you make me sick when you talk like that."

"The expression wasn't invented for the purpose of making people comfortable. Maybe people in the long run, but not particular people at particular times."

"I don't know what you're talking about."

"Not only that," I said, "but I've got my eye on some of that walnut furniture her daddy has stored in the attic. I can hardly wait."

74

"We have enough antiques already to open a shop," my wife said comfortably, having arrived at a formulaic complaint that helped her order her life.

"I will be the executor. Everything above board. Birdie will need liquid assets more than old chairs and tables. Unless she finds some of that money old Wendall has hidden around the place."

"I don't know what you see in that stupid woman."

"Stupid she is not and never has been," I said, waving my cigar in the air. It is little gestures such as this that relieve people of the responsibility of taking my words seriously. They think I'm funning, play-acting, pontificating. They regard me as a vestige of an old Chatauqua preacher, even though they know not the word and little of the truth it expresses.

"Crazy, then," my wife says, conceding an old point, in which she has often been forced to concede. (But never understanding how important it is that her diction be pure for her mind to be clear.)

"Often in school, Birdie Braine was singled out for her remarkable memory, her truly uncanny gift at certain kinds of mathematical computation."

"I said crazy," my wife cries, stabbing her Brillo pad in my direction.

"I was always a better speller," I said. "And I was more comfortable with abstractions and logic; but Birdie had an amazing computer in her head. You could throw out a two digit number and a three digit number and ask her to multiply or divide, and she'd come up with the answer in seconds. Old Richards loved to make her perform for visitors."

"It's time for 'Masterpiece Theater,' " my wife said, "At least that's *one* show you don't grumble about."

"I am afraid for her," I said, "if Wendall Jr. doesn't call soon. She is surely taking it hard."

"Or is that tomorrow night?" my wife asked. "Isn't this Saturday?"

"Of course, if he *does* call, it might be traumatic for her. I honestly don't see how poor Birdie can win."

"It *is* Saturday. Honestly, I get so one day is just like another. I sometimes think I'm as crazy as anybody."

"What will be, will be," I said, and snapped on the television.

V

Summer eased past in silence. A golden river of days, crossed by the shadows of night.

What did Birdie do all this time?

God only knows.

I saw her several times in the way of business, and each time she informed me that Brother had not called. The last time was early in September, and I had to stop by the County office to check a deed. I came across Birdie in the hall. She had just come out of the ladies' room.

"Well," I said, "have you heard anything?"

"No," she said. "Nothing at all. I'm afraid something has happened to him."

"I doubt it," I said. "The watched pot never boils."

"What is *that* supposed to mean?"

I stared at her an instant and had a shock. Birdie had suddenly, at that instant, outgrown all jokes. (Oh what a fall was that!) There was honest, sincere inquiry in her expresion. What *did* it mean? (Right then I knew: she would never cheep again. She had become Bertha, harrowed and damaged and stuffy. Ah, but not to me; I would not acknowledge it.)

Before I could explain, she clutched my arm and said, "Listen, I have to talk to you, I've been thinking."

I patted her hand where it still rested on my arm. "Sure," I said, "We'll make it soon."

Immediately, I despised myself for this action, for it had to seem partronizing.

But the fact is, it did not. Or did not appear to (did not appear to appear thus).

For Birdie's (Bertha's) eyes were distant, missing my ear and spiraling off into the dark corners of the hall. Her vision was crooked, inhabiting a crooked frame of space.

"You don't know how much it means," she said.

I wondered what she meant by that. But it would be some time before I found out.

VI

This was near Halloween. Some idiot of a boy put a cherry bomb in our mailbox and blew it clean off its stand. I remember standing out there in the cool darkness with my fists doubled up, looking this way and that up and down the street. I could smell apples in the air, burning leaves. The faint trace of carbons from cars racing in and out of the Dairy Freeze at the edge of town. And of course smoke from the burst cherry bomb.

It was then (as if in premonition, for the memory can only create that moment through the screen of subsequence) that I said half-aloud: "We do not have to celebrate the rise of demons from the earth into the world of men on a ritual October night. Oh, no. These boys are nudged

and shoved forward by truly ghostly hands. They themselves are the demons, a profane and blasphemous heritage. I know them."

I went back in and my wife was walking toward me, saying, "It's Birdie on the phone. She wants you to come over."

The phone was still warm and a little damp from my wife's hand, and Birdie continued talking to me as if my wife and I were continuous.

"Yes," I said. "I'll come."

"I wouldn't," my wife said, when I hung up. "She wants you to help her look for old Wendall's money."

"Maybe," I said.

I went out to my Oldsmobile (older now, and filigreed with dust) and got in.

What I had not mentioned (but my wife's statement had implied) was that Birdie had said to meet her out at the old homestead, beyond the Indian mound. Where old Wendall's ghost might still walk. Where the high-ceilinged rooms were beginning to soak up the coldness of the nights.

The moon was full, as it should be on Halloween.

The smell of that cherry bomb was still in my nostrils when I passed the Dairy Freeze on the way out of town. It had seeped into the car, in spite of its newness. Like cold. Like time. Seep, seep.

Everything was strange, transformed.

Birdie was an old woman, going mad. Brother had crawled down into the earth and would never come back again. Call him all you want. Call, call.

I had these strange hunches, deep in my bones. (Had been having them, more and more lately. Age transforms everything; it is the only medium of change. If the change is sudden, then time has passed. Absolutely. That day in the hall, I had seen twenty years flow through Birdie as if she was nothing more than a poor minnow seine, cold and frail in the terrible current that moves all of us eventually. All. Always.)

VII

The electricity had been shut off, the house sealed. A tomb coldness came out of the antique flower-papered wall. Birdie had ignited three kerosene lamps that radiated a dull heavy light only five or six feet about each of the Victorian tables they rested on. Beyond these circles, the rooms glided away from their touch—vaguely dark and ironlike in color, heavy with the burden of things accumulated.

Birdie had kept her fluffy white coat on, emphasizing her dark eyes.

In that light, she was beautiful. It occurred to me that she had been born out of her proper time, for if she were young today, she would be considered stunning, majestic. Then, she had been merely grotesque, taller than most of the boys around her. She had, however, worn saddle shoes and walked straight, proud in her deviation.

"You're a lawyer," she said. "Tell me where Halloween pranks end and vandalism begins."

I lit a claro and blew smoke toward the ceiling. I have found that silence is inevitably the correct answer. Also, it gives you time to think.

"I suppose you think I want you to help me find the money," she said.

"Money was created by God," I said.

"That sounds like Dad," Birdie (veering toward Bertha) said.

"I couldn't imagine his saying anything like that."

"No, but it sounds like what he believed. It's what he *would* have said, if Mother hadn't made him wary of such talk."

"*Have* you found any?"

Birdie smiled tiredly. "Today," she said. "You'll never guess where."

"In the Indian mound," I said.

Her face dropped. She could never conceal surprise, and—more importantly—could never avoid its occasions.

"Where did you get an idea like that?" she whispered.

"The gods sleep there. Money belongs with the gods. Just an association of ideas."

"In the *chicken* house!" Birdie cried, indignant. "That's where I found it. A bundle wrapped up in an old chamois! It was stuck in a crack above the door."

"Golden eggs," I said. "How much?"

"Over a thousand dollars," Birdie said, lowering her voice again. A car raced by on the road, a hundred yards away. I could almost feel the pale headlights wash briefly over the Indian mound.

"Well, how much more is there, do you think?"

Birdie frowned and scratched her thigh with long fingernails. "I don't know. A lot."

"Have you heard from Brother?"

"No," she said. Then she sighed deeply, frowning at a kerosene lamp. "I was hoping he might be back here by Halloween, at least. We always used to have a big time at Halloween. In some ways, it was our favorite time of year. Even better than Christmas. The valley is beautiful in the autumn."

I nodded and blew smoke past by cigar. At that instant, there was a heavy adjustment of time, of the whole fabric of hours, minutes, days,

years. It was like a great body turning over in its bed, shaking the walls and making the old photographs nod in their golden frames.

Birdie, Birdie. You are a child, cheep cheep. And so am I, for only this brief instant. The demons outside, speeding in radial patterns outward from the cold hellfire of the Dairy Freeze, were only as tangible as the conjured memories of our own past could make them. We have been left, abandoned by our children (both those we did and did not have) and by ourselves.

Where are you, Brother?

"We are alone," Birdie was saying, agreeing, nodding, fondling the money. Alone. She wanted me to take it and count it with her. She wanted me to stay all night with her in the house, and we would pretend we could hear the Indians singing from the mound.

Ridiculous. But thinkable, therefore something *like* true. Something conceivable.

"To think," she said, "that we would someday, you and I, be sitting here in this room, talking about such things!"

"It's a scary thought," I said.

"No. Not that. Not exactly. I mean, not *completely*."

"No, not completely."

Neither of us could say what was happening inside. I know this as surely as you know the image you see in the mirror is yourself turned around to face your need to know yourself. And thereby mock.

Why was she not known to be beautiful and therefore desired? Why was she not covered with children, tugging at her bodice, snuggling for warmth and nourishment? Why had that bosom *not been used?* What ghostly, indifferent men moved in and out of her dreams, either here or in her antiseptic ranch house, made of brick and surrounded by a trim lawn?

Oh, Birdie. Oh, Birdie Braine! Sad jokestress of Time and Ideality.

She talked about the money. She spun theories about where it might be, all the intricate interstices of the walls and cabinets. All the walnut tables and desks and chairs, under whose laboriously hand-worked innards a soft chamois pack might be snuggled, suckling time from the darkening wood.

I expected my wife to phone, asking where I was. (Did she picture me snuggled into Birdie, infecting her with love and being in turn affected?) But the phone had been disconnected shortly after the time old Wendall's brains and hallucinations had been.

"What if the chicken house had burned?" I asked. "Chicken houses possess a powerful mortality, because the wiring goes bad in them. Bad risks, Birdie!"

79

"Was I talking about chicken houses?" Birdie inquired. (She was not, had not been.) "You never listen," she said.

"What's that?" I asked, cupping my hand around my ear.

"Oh, shut up. You've never grown up, after all these years. Why do you *act* that way?"

"What is there to grow up to?" I asked.

"Now you're sounding like me. Or the way I think."

"I always sound like somebody else," I said. "Or their thoughts."

"That is true of all of us," Birdie commented sadly. "But then, things come to an end."

"Isn't it nice to be present at the ceremonies?" I asked.

"I'm not sure. I'm not sure."

"Your dad was foolish for turning his money into cash and hiding it."

"He was crazy. Part of him left before he died. He had a stroke. Nobody knew about it, but I did."

Ah, but *you* are somebody, Birdie! "I heard tell he had one," I said.

"One day he started humming at the breakfast table and then he got up and did a little dance. I thought he was just horsing around, the way he did years before when we were kids. God forgive me, but I thought he was *playing*. I started to say, 'Dad, for Heavens sake, act your years,' but then I saw."

"You saw," I prompted.

"I saw the look in his eyes. He was drifting off and calling out to me. He was scared. If there had been something inside him to grab. I would have grabbed it with all my might and held on!"

She said this with her fists clenched and her jaw square and her eyes beautifully solemn. If I had turned this into a joke, she might have thought of killing me. But if I had joked, it would have been to catch at *her* heart and keep it from drowning. I could see poor little Fletcher breaking through the ice of his look, screaming out to God that he couldn't *understand*.

"Yes," I said.

"Yes," she said, nodding. "Then he sort of glided or waltzed or something into the front room, and I helped him lie down on the sofa. I was just visiting, that day. I used to come out here pretty often, though. Almost every day. Somebody had to sort of look after Dad. Brother was out somewhere, in the world. He had left for parts unknown."

"He only wanted to live," I said.

"What?"

" . . . his own life."

"Yes."

"Which brings us to the Indian Mound."

"Oh, shut up. You scramble my thoughts like an egg beater."

"Tell me more," I said. (A request that few can resist; the question itself would, if used more liberally, compulsively, automatically—quite independent of any real concern—would obviate eighty percent of the lawsuits and therefore, by implication, most of the trouble in the world. But of course, I was firm in my desire to know. And honest.)

She talked, then. On and on. A bottomless supply of suspicion, terror, love, ideality, wistfulness, and tenderness of memory. For after all, memory is something achieved, like mind. It is something larger than ourselves, which we yearn to grow into and understand, which is to say, comprehend.

Birdie said none of this, but it was the unwobbling pivot upon which her ideas turned. Saying, saying. Cheep, cheep. Her mind sighed over me like a forest. ("Will you find words for me?" it asked. I said yes, and therefore now say these things.)

Bad dreams. Bad dreams. Birdie was sleeping too much these days, practicing death. Alone. Alone.

Behind the old family house, there was the trace of a road—long since abandoned. You could see it faintly adumbrated along the fence of the cornfield, under the cold distant shadow of the hills, and then you came upon the old abutment of a bridge that had once crossed a dried-up creek. The cement was gray, soft-looking—like dead mastodon bones clotted in the tangled slaw of winter grass.

No one called. The phone was dead.

Fletcher and old Wendall were as distant, now, and as mythic as the dead Indians who eased themselves ever deeper, rain by rain, into the earth. The cemetery at Mt. Clemens gave forth noises at night. You could hear the thub-dub, like a heart or drum, clear to the edge of light radiated by the Dairy Freeze.

While she talked, I could almost feel the glow of those packs of money hidden by crazy old Wendall. (I knew that Birdie had only started to look; Wendall couldn't have hidden them so cunningly that *she* wouldn't find them.) The packs, wrapped in soft old chamois, glowed in my mind, burning bright like lumps of coal. Or little Dairy Freezes, the light of our hopes and comfort and ceremonial need for food so that we can remember and predict and hope.

No one called, except for Birdie. No one heard, except for me.

Wendall's ghost sighed and stumbled along the hallway upstairs, asking for a drink of water.

Birdie is an old woman, going slowly, easily mad. Slipping. Her sigh flutters and falls away.

Rain is falling. My wife dials her phone and hears a recording.

Birdie does not exist. She has died four years ago. Time gallops over our faces and we gasp for light.

My children drift off, down separate rivers, remembering and/or forgetting my prayers and admonitions.

Blood flows into death, one river, one way.

Fletcher drowns inside us, each time his memory rises to the surface. No one remembers a single word he has spoken, therefore he is eternally silent. And after all these years, *has not existed,* as if by cosmic decree.

This thought is enough to kill poor Birdie. Cheep, cheep. The chicken house turns over in its rising grave.

At Mt. Clemens, where Birdie's dreams live when she is not having them, I start up my new Oldsmobile and ease it out into the soft gravel, and down its slipping (like the back of an old man's neck), toward the moonlit valley and the lights of town.

A dog stands on top of the Indian Mound and barks in the mist.

Birdie reaches behind the attic door and feels the soft fold of chamois. But it is too late. The house is closed up. Forever. Brother is gone. He will not come back.

Birdie has gone, too. The two of them teamed in a ghostly yoke.

I speak her name. Birdie. Birdie.

A Woman of Properties

"It's too hot in here," Mrs. Gressly, wearing a pink pants suit, said. "Where's the thermostat?"

Mr. and Mrs. Davis looked at each other and then looked away. Mr. Cobb, the realtor, stared at his thumbnail.

Not hearing her demand answered, Mrs. Gressly decided to ignore the issue. After all, it was not her house *yet,* and the way she felt at the moment, it just might never be. She told herself she was distinctly less than satisfied, and silently formulated her feelings of the moment in exactly that way.

"Well, there's nothing wrong with the insulation," Mr. Cobb said, answering her obliquely. Mrs. Gressly thought a moment, relating this to her complaint about the heat. Then she understood: it was cold outside, therefore the fact that the house was too hot was meant to indicate that it was not leaking warmth, the way a less well insulated house might.

She sniffed contemptuously at such a shoddy concession to reason. If she had been a real estate person, she thought, she would have attacked the issue forthrightly and won. But of course, if she had been anyone else, she would have agreed with herself as she now was. Any other option for a sensible person was unthinkable.

"And here's the porch," Mr. Cobb said, waving his open hand vaguely toward the rear. It was a sloppy gesture, for if it had been meant seriously, he would have been calling the television set the porch.

Mr. Cobb was a short fat man with light caramel-colored skin and bushy white sideburns. He bore a reproachful, startled expression that Mrs. Gressly found utterly ludicrous. He'd complained of a stuffy nose twice already. When he walked, his head glided like that of a man coasting on a bicycle. He was informed, but feckless.

"That's true," Mrs. Davis said, nodding. "The house is pretty well insulated."

Mrs. Gressly turned and stared at her a minute, wondering how she could respond to something so belatedly. Mrs. Davis was thin and young, with straggly pale hair. She wore a faded green wool serape and seemed to have a head cold, too. Mrs. Gressly decided that Mrs. Davis was not only lacking in energy but also not very bright, like a lot of women her age. But of course, that couldn't be helped. And anyway, it wasn't any of Mrs. Gressly's business, yet. Mrs. Gressly didn't meddle in things that were not, strictly speaking, her business.

And at the moment it wasn't certain whether or not this house would be her business or not. She had a checkbook in her purse, and if she decided she wanted it, she could write out a check for Mr. Cobb right away. A binder for the whole kit and caboodle.

And then it happened. Just before stepping out onto the back porch, Mrs. Gressly smelled pipe tobacco. She paused and sniffed audibly. Twice, three times. She did not say anything, but she trusted that her displeasure was fully communicated. She also decided at that moment to buy this house, just so she could work at evicting the Davises. Because there was no doubt about it: he was a pipe smoker, and she would not tolerate the odor of tobacco in any house she owned. Not for long, she wouldn't.

The back porch was lofty and looked out over a ravine. Since the house was situated on a steep hill, the door at ground level in back led directly into the basement. Mrs. Gressly had come in through the basement, liking to take houses by surprise. Mr. Cobb had followed her, sniffing and mumbling real estate clichés at her back.

Now, astride some invisible Bucephelus, Mrs. Gressly gazed out upon her ravine and found it distasteful. It had the look of being used too much. She knew the sort of place: dirty plastic food wrappers floating in the muddy water of the creek and boys with dirt-smeared legs playing with war toys in the underbrush. Also a variety of beer bottles and pop cans festering in the pale grass.

"How do you spell your name?"

Slowly, Mrs. Gressly turned and saw Mr. Davis standing there behind her, puffing on his pipe. *The* pipe. He had just lit it, and the stink of tobacco filtered out past her shoulder into the soft evening air, toward the maple trees by the garage.

"What was that?" she asked.

Mr. Davis nodded, as if he'd expected her not to understand. "I'm interested in names," he said. "Surnames. It's my field."

84

"He's a professor at the university," Mr. Cobb said lugubriously. "Professor Davis."

"Call me Gary," Professor Davis said, puffing heavily on his pipe.

For a moment Mrs. Gressly seemed confused. She had not been prepared for such a question. Nobody ever asked about her name, but there was a very interesting story behind her name. She didn't quite like the idea of somebody like this Gary Davis (who was awfully young to call himself a professor, she thought) asking an interesting question.

But she couldn't refuse an answer, so she lifted her chin and said, "It was my husband's name, of course, and originally it was Swiss. It was spelled 'G-r-o-e-s-t-l-i': Groestli. His great-grandfather changed the spelling as a condition for marriage into an old American family named Perkins. He was reputed to have said that his wife was well worth the sacrifice. She was said to have had a lovely singing voice. A ravishing creature. I often advised my husband to change it back to the old world spelling, but he wouldn't listen to me. None of my business, I suppose!" Mrs. Groestli ended her explanation with a harsh laugh.

"Your husband has passed away, then?" Mr. Davis asked politely, raising his eyebrows.

Mrs. Groestli gave a hollow laugh at such an impudent question. "That's the precise term for it," she said ambiguously. "*Passed away.* Not necessarily dead, mind you, but *passed away!*" She said this as if there might be some obscure connection between his refusal to restore the original spelling of his name and his absence at this moment.

Mr. Cobb stamped his foot on the porch. "Solid as a rock," he said. "Solid oak. Double flooring, even out here on the porch. They don't build them like this anymore. Solid as a rock."

At that moment, for no apparent reason, Mrs. Groestli was filled with a sudden, wrathful intolerance, and she fastened upon poor Mr. Cobb's locution. *Why did they always say solid as a rock?* a needlessly anguished voice cried out in her head. *Why didn't they say as solid as a noodle? Or as solid as a party hat? Or as solid as a week of Sundays?*

Mrs. Groestli burrowed deeper into the house. She was not one to waste a dollar, and, as anybody could tell you, she knew real estate, inside and out. She had six houses in town already, and this would make the seventh. She kept tight records and knew where every penny went. She knew the price of venetian blinds and cement block; she knew where to get roofing nails at a bargain price, and had forty squares of unused roofing shingle stored over a double garage on Poplar Street, just waiting for the first complaint about a leaky roof.

The Davises began to lag behind, and finally drifted off. That was as

it should be. Mr. Cobb trailed along after her, jabbering about the house, as if anything he might ever say would influence her one way or the other. She was one person who would buy or not buy; she would not be sold. Especially by anybody as dopey as Mr. Cobb, who talked like he had his mind on other things.

Mrs. Groestli descended to the basement, whence she'd come. She heard Mr. Cobb's feet pattering down the steps behind her. The basement smelled of dampness and old truck tires. She hated such smells. Turning left, behind the furnace, she was brought up sharp by the sight of a full-length mirror that the Davises had stored there, face out, for some incomprehensible reason. It showed her in an unflattering light, in spite of the darkness. The mirror made her look shorter and dumpier than she really was. It made her pants suit pinker. It made her head look bigger than necessary, not to mention her hands and shoes. Her shoes looked enormous, and yet she had to admit that they fit snug enough. She walked as if she were stamping out little fires, and knew it very well, but some things can't be helped.

She heard Mr. Cobb breathing behind her right shoulder. For once he was not trying to explain things for her benefit. She gazed into the slanted mirror, leaning against the dirty wall, and then heard him say, "Mirror."

She turned and placed a gaze of utter disgust upon him, but he didn't seem to notice. Instead, he took a nasal inhaler out of his pocket and prodded it up his nostril. She could smell it, and had to admit that it was better than tobacco smoke, but not much.

While he was intent upon sniffing the inhaler, she brushed past him, headed for another part of the basement. Her contempt for him was impossible to conceal, even though she doubted he would ever notice anything. He wasn't the type.

The fact was, he had no idea whatsoever of why she needed to buy this house, and wasn't even aware that she was going to get it, no matter what he might say about it.

Furious gabber that she could also be upon occasion, she nevertheless held this secret to her breast and nourished it.

That secret reason had to do with Clyde Brickle, the owner of this house. Like Mrs. Groestli, Clyde Brickle was also an owner of properties. He owned Brickle's Hardware, where he spent most of his time and energy, but he also owned a double on Mill Street and four student rooming houses in the east end of town. There was something about a farm in Carthage Township, too; but Mrs. Groestli was a little vague about this.

Why Clyde Brickle wanted to sell this house she was now in was beyond understanding. The instant she heard about it, she'd wondered, for she knew it was in good repair; but just to make sure, she'd phoned Anse Tober and checked with him, along with Becky Thurman at the court house. She'd pushed all the buttons, and they'd all flashed green, for go ahead.

Which left Clyde Brickle's role in the whole business unclear. Not that Mrs. Groestli didn't love a mystery, but she preferred the kind that were clear and above board. This was something a little different, and if she'd been the type, she would have been uneasy. As it was, however, she knew from the instant she'd heard about it that she had to get this house from Clyde Brickle. In spite of the little games of indecision she'd played with herself, there had never been any doubt. Nobody else would have this house. There was nothing she'd let stop her.

Mrs. Groestli took pride in the conviction that she never lied to herself. And she wasn't about to start lying in a matter as crucial as this. Clyde Brickle's wife had died last summer, and maybe his selling the house had to do with that. Maybe he was going to liquidate all his holdings in town, including his hardware store, and move to Arizona. The thought of this was like a brick in Mrs. Groestli's stomach. She wanted to be victorious over Clyde Brickle; she didn't want him to escape. It was that simple.

But how simple was *that?* The answer was complicated, but it had to do with the fact that Clyde Brickle and Mrs. Groestli (whose name had then been Emily Fogle) had once dated in high school. It had been Clyde Brickle who had taken her maidenhead one Friday night in the back seat of his father's Packard, after the game with Harrisburg.

Mrs. Groestli would never forget that moment, as what woman would? But the fact was, or *seemed* to be, that Clyde Brickle *had* forgotten; or (even more unsettling) it appeared that for Clyde the whole business hadn't even taken place . . . as if it had been her own personal illusion, in which Clyde Brickle had played a part as a sort of animated lover. An incubus, or whatever they were called.

Because not long after that (to her) momentous happening, Clyde had eloped with Ginny Deems, and when the two of them returned a week later, Emily Fogle (who would someday become Mrs. Groestli) might just as well have been a lamppost or fireplug, so far as Clyde Brickle was concerned.

Ginny Deems, as Mrs. Clyde Brickle, got twin boys and a daughter out of him, not to mention one of the finest houses in town and yearly visits to Arizona, where Clyde's older brother owned a department store.

All Mrs. Groestli got was Mr. Groestli, and the most interesting thing about him was his name, which he'd disavowed anyway, so far as the spelling went.

The second most interesting thing about Mr. Groestli, however, was that he'd left her. Passed away. After his departure, Mrs. Groestli fancied that he might have been more interesting than she really knew he was for all those years, but she didn't dwell on such speculations long, for she was not a woman to fool herself.

The old wall between the living room and dining room had been knocked out, giving an effect of spaciousness to the first floor. The Davises, for all their untidy ways, had shown good taste in furnishing it (although it was too dark, especially now, without a single lamp burning), and there were long, shaggy green plants hanging from wicker baskets and bright red and green wall pieces on the dark inner paneling. The legs of a huge oak dining room table had been cut off, converting it into a coffee table. Two similar mousy sofas bracketed it.

Passing through this room again, Mrs. Groestli was interrupted by *Mrs.* Davis calling out to her.

"What?" Mrs. Groestli asked, turning her head and frowning into the naked light from the windows, which haloed the girl's dark image.

"I asked if you'd like to join us in a glass of wine," she said. "You and Mr. Cobb."

"Me and Mr. Cobb," Mrs. Groestli repeated judiciously. What was their angle? Did they think they could buy her off with a glass of wine?

But Mrs. Groestli had learned when to distrust her distrust, and she had a considerable arsenal for coping with it; as she did now, by graciously accepting and plodding across the floor until she reached the coffee table.

There *Professor* Davis sat, practically invisible in the darkness of the chair. A mere boy, with his pipe in his mouth and his head full of names.

"Don't you people ever turn on the lights?" Mrs. Groestli inquired as she accepted the glass of wine from Mrs. Davis. It was rosé, she observed.

"We like it dark," the girl said, and suddenly appeared much older. If Mrs. Groestli had taken the time, she could have visualized perfectly how Mrs. Davis would look when she was *her* age. And the poor girl would not have been pleased by the prospect.

"Swiss," Mr. Davis said. Then he added, "It sounds Swiss, the way you spell it."

That was a marvelously addled statement, Mrs. Groestli thought, for a professor of English.

She sipped at her rosé, still standing. And then she was aware that Mrs. Davis had been talking to her in her little birdy voice. She had been inviting her to sit down.

Heavily, carefully, holding her glass of rosé at ear level, like a lighted 4th of July sparkler, Mrs. Groestli settled herself into the heaviest, ugliest chair in the room, where she felt herself loom over the great round coffee table, not to mention the two children playing house beneath her elbows. Mr. Cobb was standing some distance away, his nose only a foot and a half from a horse print he was studying on the wall. What he could see in the darkness, Mrs. Groestli couldn't imagine, but she let it go. She knew she interfered too much in other people's lives, but if you had ideals and principles, you couldn't help it. People did so many marvelously foolish things, they needed the Mrs. Groestlis of this world to straighten them out a little. Only, God knows, it's a lonely job.

Mrs. Groestli sighed, and then listened to *Professor* Davis, who was talking about the print Mr. Cobb was studying. It was a Currier & Ives, of course. And Mrs. Groestli nodded without speaking, knowing deep down in her heart that it was a cheap copy. These two married children didn't know anything. It was no wonder the world was in such a mess.

When Mrs. Davis offered her a second glass of wine, Mrs. Groestli declined, saying that she couldn't take any more time.

But the instant she said this, she regretted it, for it sounded as if she were through looking, whereas she had only started. Mr. Cobb knew her ways, and would not be surprised if she gave evidence that she was about to prowl in earnest.

"For an investor in real estate," she explained, "there's no more precious time than that spent in looking over a potential investment."

The Davises stared at her respectfully, but said nothing. They gave the impression already of being trespassers in Mrs. Groestli's house, and the thought of this made her suddenly indulgent. She laughed and leaned over to touch the hardwood floor, checking it for varnish. No doubt her bottom looked like a big pink valentine in her slack suit, but she was above caring for such delicacies. She hadn't become the owner of so many properties by being intimidated by the fear of making impressions.

"Good flooring," Mr. Cobb said, sipping his second glass of wine.

Mrs. Groestli glared at him, but he was poking his finger in his wine glass, staring cross-eyed as he tried to pick something out of it. Smoke from Mr. Davis's pipe floated like poison gas in a horror movie above her head.

"I'm nothing if not thorough," she said cheerily, walking toward the stairway.

"Mrs. Gressly likes to check in every nook and corner when she invests in a property," Mr. Cobb said, putting his glass down on the coffee table.

"She's certainly welcome to take her time," Mr. Davis said. "We have to pick up our two daughters in a little while, but she's certainly welcome to stay here and make herself at home."

"I wouldn't think of it," Mrs. Groestli said comfortably, and Mr. Cobb said, "I'm sure she'd appreciate that very much."

"We really wouldn't mind a bit," Mrs. Davis said, pulling up a long strand of hair and tucking it behind her ear. "Just go anywhere you want and make yourself at home."

"I have to be leaving, myself," Mr. Cobb said, shaking his sport coat down around his shoulders. It was a slick sport coat with broad lapels and a salmon stripe in it, reminding Mrs. Groestli of a band leader back in the days of Kay Kaiser.

"Listen," Mrs. Davis said earnestly to Mrs. Groestli, "we don't really mind a bit if you want to stay and look around. Honestly!"

"Honestly?" Mrs. Groestli asked.

"Really," Mrs. Davis said, and Mrs. Groestli said, "Well, all right, then, if you don't mind," and marched upstairs, thinking that they were probably hoping that if she stayed around she would find something wrong and not buy the house after all.

By the time she returned to the bathroom, she knew that Mr. Cobb had left. The Davises were still downstairs, however. She could still smell the fresh burning of pipe tobacco, and occasionally she could hear one of them speaking or moving about.

The pleasures of plodding here and there, looking in closets, standing still and measuring the window angles, visualizing new carpeting, if she ever decided to appeal to a different quality renter . . . all of these rituals filled her with a deep satisfaction.

But there was something else: this house was Clyde Brickle's property, and Mrs. Groestli savoured the fact with complex emotions. She was taking something back from him forty years after he took her most secret possession. Not that Clyde would ever catch on; but after all, that was secondary. What she was after was nothing as crude as simple revenge; it had more to do with symmetry, in her way of thinking. Not only that, the house was underpriced.

She stood in the bathroom and gazed at her image in the mirror. It was not difficult for her to see that shy, intense sixteen-year-old girl she'd

once been, thrilled to the limits of ecstasy by being asked to the homecoming game by Clyde Brickle, whose father owned a gray Packard with red leather seats.

The sound of the faucet being turned on downstairs brought her mind back to the business at hand, and Mrs. Groestli once more studied the condition of the bathroom. Having long before decided she would buy the house, even if she had to pay the asking price (which was not a good tactic, even when the price was too low), she was now simply intent upon gathering a list of all defects for the sake of bargaining leverage.

On her previous trip to the bathroom, she had tried the faucets, and had found them a little slow, indicating corrosion in the pipes. Now she raised her face and stared at the ceiling above the toilet bowl. A small section was clearly outlined, which she assumed to be a trap door to the crawl space attic overhead.

Mrs. Groestli looked around and decided upon the laundry hamper, which looked strong enough to stand on. She lifted it up and placed it squarely on the lid of the toilet seat, which had been demurely closed (for her visit, she was certain) when she'd first come into the bathroom.

Carefully, she stepped up on the toilet seat and then, knee first, gathered her full weight upon the hamper, then, shakily, she stood. If they could see her now, they'd realize that the old bird had plenty of juice in her yet, and wasn't the sort you could fool around with. She was a little bit sorry that Mr. Cobb wasn't there to witness her acrobatics.

She pushed the panel up, and lifted her head so that she could see into the twilight area of the attic. Vents were placed at each end of the gables, giving plenty of light to see by, if you didn't have to read fine print.

What happened next could never have been predicted by anyone, not even Mrs. Groestli herself. Later, she was to think of it as one of those moments of utter, unexpected madness that she supposed everybody experiences once or twice in a lifetime. But she'd never dreamed that she, too, was vulnerable.

Because it occurred to her that she was high enough that, in spite of her weight, she could hunch herself up through the opening and be able to walk around in the attic and look at all the rafters, not to mention the underside of the sheeting. She could also check the insulation more closely, because Mr. Cobb had been vague about it. She didn't like her house losing heat, even if she herself wasn't responsible for the gas bills. This seemed a rather magnanimous attitude, when she thought about it, and it was. But it was also prudent.

That was all it took: the simple idea, and the next thing Mrs. Groestli knew, she was elbow high in the attic, her feet kicking like those of a strong swimmer, which she'd once been; and then, with a mighty shrug

and lurch, she eased breasts forward and managed to twist and pull her hips up onto the nearest beam, where she rested briefly, panting and feeling her heart going lickety-split for a minute or two. And then she stood up, and stepped over the beams, until she came to the front vent, where she could peer out through the jalousy openings, down into the street, where she looked just in time to see Mrs. Davis get in their car and close the door.

Now I'm all alone, she thought, nodding.

It also occurred to her that she'd gotten her pretty clean pink suit filthy by doing a crazy thing like this, but she didn't care. Maybe it was the rosé; she wasn't used to drinking anything at all, and maybe it had been just enough to propel her up through that opening.

Whatever it was, Mrs. Groestli had no regrets. But since she practically never had regrets anyway, it would have been difficult to detect anything like triumph or transcendence in her present acceptance of having done such a thoroughly crazy thing.

Whatever the attic was, it was awfully hot, and Mrs. Groestli found herself perspiring. The house wasn't all that well insulated, just as she'd half suspected; and if she hadn't climbed up here, she couldn't have learned this.

She stopped and took her bearings. Certainly Clyde Brickle didn't do anything this crazy or thorough when he checked a property out before buying! Feet balanced on separate beams, her body hunched slightly forward, as if to charge into the rafters before her, Mrs. Groestli thought about this, and was proud of herself.

In spite of the heat, she relished her privacy as she made her way over the beams, from one end of the attic to the other. The rafters were sound, and the sheeting was clean, dry, and tight.

No sir, there was nothing at all wrong with this house! Not a thing. It would be a real bargain. Clyde Brickle was crazy for letting it go so cheaply.

She couldn't have identified the precise moment when a slight uneasiness began to sift into her mind. At first, it was so unfocused that she couldn't have named what it was, precisely, even if her life had depended on it.

Then it came clear. She was alone in someone else's house, up in the attic, which couldn't be gotten to except through a trap in the bathroom ceiling, and she wasn't sure how she was going to get back down.

At the precise moment when she realized this, something else came to her. It was like piling on, she thought. And *no fair!* She

remembered being a little girl and thinking such things, always, when boys came to disrupt peaceful and sensible games.

This second trouble had to do with her arms. Both of them ached and started to tremble. She had made too great a demand upon them. It was no wonder; it was a miracle she had been able to hunch herself up through that hole into the attic, considering that she was soft and overweight and . . . well, yes, a *woman*. Women didn't have strength to do things like that, and yet she'd done it. But the cost had been too great. She'd strained herself, and her arms trembled like loose guitar strings being slapped by a thoughtless hand. And her stomach felt funny, like it had been turned over and then turned upright too quickly, so that everything inside was unsettled.

Oh, what a fool she'd been! What an utterly, stupidly, foolish thing to do! Why, it was the sort of thing middle-aged men did, forgetting that they were no longer young, and then having to be nursed back to good sense and health by their patient wives, who understood the folly of such deviations. She knew this very well, for her own father had been the type, overdoing everything until he'd died of a coronary at the age of fifty-one.

The thought of her father and her mother's long widowhood gave Mrs. Groestli uncomfortable thoughts. A hot attic is not the place for such contemplations, especially for a sensible property owner who knew more about houses than two Clyde Brickles and ten Mr. Cobbs.

Seriously and slowly, she edged back to the opening in the ceiling and peered down at the clothes hamper perched on the toilet bowl. The sight made her dizzy. It looked as small and fragile as a shoe box. Lowering herself onto that tiny and unstable surface was horrible to contemplate, especially when her arms were feeling weaker with each and every breath she took. And they were trembling so hard she could not have managed to put a key into a lock.

Not the sort to spend her strength on useless regrets, however, Mrs. Groestli forced herself to sit in the opening and breathe deeply. She looked at her legs dangling down toward the clothes hamper and felt despair for a moment, until she pushed it back. Seeing the smears of dirt on her pink pants suit did not move her. Dirt was the least of her problems, now. Her problem now was to lower herself through the opening into the bathroom by some method, without breaking her neck. Otherwise . . . otherwise, she would have to wait there for the Davises to return and help her down, which was a thought worse than death by rat bite.

The weight of her feet hanging through the opening seemed enormous. If she'd tried to ease herself down, holding her weight by her arms, she knew she would have plummeted to certain disaster. How had

93

she ever dreamed of doing such a thing? How had she ever managed to scramble up through this hole? And why?

Then it was that Mrs. Groestli made two decisions, one after the other. The first was that she would not buy this house after all. She didn't know why, and she didn't *care* why. She was accountable to no one, and the simple fact was, she told herself, she wouldn't have accepted Clyde Brickle's house if they'd handed it to her on a platter. No wonder he wanted to get rid of it.

The second decision she made was actually more of a vow than a decision. And that was that if she ever again did anything as silly as climbing up through some hole in a ceiling of another person's house, she hoped she would die.

The longer she sat there, the more nervous she got. Even though she knew exactly what was happening to her, she sat there staring down at the hamper with a sort of grim satisfaction in all the horror it radiated upwards into her mind.

As often happens in moments of crisis, Mrs. Groestli lost her sense of time passing, so that she was surprised to hear very faintly, as if from a great distance, the soft plock, plock of car doors being closed.

No doubt this was Mr. and Mrs. Davis returning with the conviction that Mrs. Groestli had long since departed from their house. What would she say to them, even if she got down safely in time, and they found her still upstairs, nosing around? How long *had* she been there, anyway? It seemed like hours, but she was aware that in misfortune a minute can seem like ten.

And yet, if they had gone and picked up their daughters, some considerable time must have elapsed. Had they chatted with the parents of their daughters' friends? Or their sitter? Had they stopped at the supermarket to buy pork sausage or Tropicana orange juice on their way home?

The thought of the Davises standing at the front door, getting ready to turn the knob and enter the house, filled Mrs. Groestli with an anxiety that was almost numbing. What if she got halfway through the hole and got stuck there, and the Davises came upstairs and glanced in the bathroom to see Mrs. Groestli's pink legs and bottom swinging tensely from the ceiling, her feet probing for the clothes hamper? Could anybody really ever *survive* such an ordeal as that?

Evidently, the answer was negative, for Mrs. Groestli eased her hips off the edge she had been sitting on, and felt her arms pulled upwards with such violence that she was certain the ligaments of her shoulders would be torn. And even as she did this, poking her feet swiftly at the top

94

of the laundry hamper, she realized that this was the second time that very day she had acted with precipitous folly.

Probably, she thought just before her numb feet kicked the hamper off the toilet seat, Clyde Brickle had never once in his life done anything as foolish and impetuous as this, not even when he took the virginity of an adoring sixteen-year-old girl who evidently thought the sun rose and set upon Clyde Brickle.

The doors closing had not been those of the Davises, but those of their next-door neighbors, who drove a Pontiac. Their name was Prager, as Mrs. Groestli recalled.

The Davises did not return for another half hour, and when they did, their eldest daughter, Tammy, who had to go to the toilet, raced upstairs and found Mrs. Groestli lying over the broken clothes hamper.

Probably most girls her age would have screamed, but Tammy didn't. Instead, she went downstairs and told her mother what she'd seen. She spoke in a whisper, as if there were something a little shameful in coming upon such a sight.

Mrs. Davis called out to her husband, and the two of them rushed upstairs, with the girls close behind, and tended to Mrs. Groestli, who—in spite of considerable pain—was perfectly lucid. She told them she had had a dizzy spell of some kind and fallen over the hamper. She said she was afraid she'd crushed her ribcage and broken her ankle, but she insisted that the emergency squad should not be called.

"How did she fall across the hamper when the hamper was over *there?*" Tammy cried, pointing; but her mother shushed her.

They helped Mrs. Groestli to her feet, after which she told them two more things: she would pay for the hamper's replacement and she had definitely decided against buying the house.

The Davises showed neither disappointment nor relief. They were of course intent upon taking care of Mrs. Groestli. At Mr. Davis's suggestion, and at Mrs. Groestli's direction (she knew a shortcut), the poor woman was taken to the emergency room at the local hospital.

There, her physician was notified, and x-rays were taken, showing that Mrs. Groestli had two hairline fractures in her ribs. She'd also managed to sprain her ankle, which was not quite swollen. "It must have been quite a fall," the resident physician said to Mr. Davis, thinking he was a relative, and Mrs. Groestli answered, "It was."

Of course, Clyde Brickle never heard of the episode, nor was there any reason he should. Mrs. Groestli was content with that fact, for she was a realist from the word go, as she often told people. And this claim had some validity, for in her private thoughts she never tried to excuse her

conduct that day. "I must have been out of my mind," she told herself. But later, she modified this to, "I must have had some kind of spell."

As for the Davises, they never did find out exactly what had happened. It is surprising that people very seldom look up, and it was almost four months to the day when Mrs. Davis was sitting on the toilet and looked up and called out to her husband that the panel to the attic was open. And the two of them talked about it for a while, until Mr. Davis took the new clothes hamper and put it up on the closed toilet bowl and stood up on it (his wife, saying, "Now you be careful!") and closed the hatch.

The Grave at Mount Nebo

Judith Ann Conley was washing dishes and looking out the back window when Gramaw mentioned it. From that first instant, Judith Ann knew she would be asked to take her; and yet—contrary to all her exasperation at how the old woman behaved—she was oddly calm.

"It's the only place I could ever find out such a thing," Gramaw said. Judith Ann could almost see her nodding and rocking, nodding twice for each slow movement of the rocker forward, and then nodding twice as she tilted back. Mother had always complained about having Gramaw's rocker right by the kitchen door, but Gramaw liked to have it there, so she could talk to her girls as they washed and dried the dishes.

"I'm sure it could be arranged," Judith Ann's mother said comfortably, digging the thick dry tongue of the dish cloth into a wine glass. She insisted that the wine glasses should all be perfectly dry inside before they were put back in the cabinet. Gramaw needed wine at every meal for her digestion.

Judith Ann stared hard at the back walk, which angled like a great question mark past the summer kitchen and up the hill where it stopped by the orchard gate. She'd once actually believed there was a ghost in the orchard. Her sister Charlotte had told her that; she'd said it was the ghost of an old man named Boggs who had once liked to drown kittens, and, after he'd died, his spirit had been sentenced to wander over the land until he'd found every kitten's ghost and tucked it into a grave. How the old man's ghost had gotten into the orchard, Judith Ann never found out. Usually, when Charlotte had told the story, she'd start screaming so loud she couldn't have heard anyway, even if Charlotte had tried to explain.

This had all been years before, and Charlotte had never told the story except when she was baby-sitting Judith Ann and Teddy, her

younger brother, who was too little and dumb to be scared by anything. Charlotte was now married and living in a big house in the city, with a baby of her own. Judith Ann was sixteen.

"I don't know how I'd ever make it out there and back," Gramaw said in her complaining voice. Judith Ann sighed and stared harder at the walk. It was made of flagstones, so that at dusk it looked like the vertebrae of some kind of huge prehistoric serpent.

Charlotte had noticed this once, a long time ago. Father had made the walk, just as he made about anything. He could build things without half trying, with his left hand, he was so competent. The thought of it made Judith Ann half sick at her stomach.

"I don't suppose anybody ever goes to Mount Nebo Cemetery anymore," Gramaw said, her voice getting higher as she contemplated the tragedy of time passing and old graves being unvisited.

"I'm sure something can be arranged," her mother said comfortably, repeating the old formula. Judith Ann had recently noticed that it was her mother who mothered Gramaw, turning the tables on all those years. What this meant wasn't clear. She had a dim notion that it might mean that time didn't accumulate relentlessly in one direction, all your life, the way you thought, but reached its maximum near the age of fifty-five (which was her mother's present age), and then drained away, somehow. It was like going over a hill. And if this was true, it meant that some day Judith Ann would be telling her own mother that things could be worked out, and comforting her the way her mother was now comforting Gramaw.

Which was the way (the very same tone of voice and the identical patience, she couldn't help noticing) that Mother had treated Judith Ann herself not so long ago. It was a bewildering idea, and it gave Judith Ann a headache when she dwelt upon it too long, which Mother had noticed in her own sly, oblique way. She often told her not to think so hard about things, which caused Judith Ann to wonder if she wasn't being protected from some ghastly secret that everyone else knew about but conspired in keeping from her.

She didn't believe in ghosts, of course; but now that she was older, she liked to think about that old man Boggs who was supposed to hang out in the orchard. Charlotte had once said that he had a wooden leg, and looking back on it, Judith Ann realized how *right* this was: an old man who liked to drown cats *would* have a wooden leg, and if Charlotte had made the whole business up, there was something spooky about her.

Judith Ann surfaced from these deep reflections with the realization that Gramaw had finally shut up and was just sitting back there, half blocking the doorway, rocking up a storm. She hadn't said a word for

minutes. As for Mother, she had departed for regions unknown (as Charlotte used to say), which usually meant the upstairs toilet. She kept telling her father that she couldn't drink coffee any more, and her trips to the bathroom seemed to prove it.

Judith Ann sighed and pulled the drain, thinking she would never be like that when she got old. Or middle-aged, as they liked to call it. It was pretty damned undignified, she told herself, sort of liking the way she said it in her mind.

"I don't suppose you'd ever drive me there, would you?" Gramaw finally asked, popping her voice in between the squeaks of the rocker.

"Where?" Judith Ann said, turning the faucet and riddling the sink plug in her hand with cold water.

"You know where," Gramaw said ominously. "Haven't you been listening? I said Mount Nebo."

"I wasn't listening," Judith Ann answered, lifting her chin and staring at her watery reflection in the darkness of the window. The dinosaur skeleton path had disappeared, drowned like a pearl necklace in black water.

"I said Mount Nebo!" Gramaw snapped, rocking faster.

"Well, you don't have to snap my head off, do you?"

"I do when you don't listen!"

"I just didn't hear you, that's all."

"You didn't hear me because you were mooning over that Mike Ziegler."

"I was not!"

"You were so!"

"Sometimes you mumble and don't know it."

"I thought *I* was supposed to be the one who's hard of hearing."

Judith Ann wrung out the dishcloth without answering, and Gramaw rocked faster.

"I still don't have an answer. I asked if you'd drive me up to Mount Nebo. I thought you liked to drive the car, now that you have your license. That's the story that goes around. That's the rumor in this house. You're supposed to be crazy about driving your daddy's car."

Judith Ann shuddered all over. "God, that spooky old place!"

Gramaw said, "It may be spooky, but it's where we all end up, sooner or later."

"I'll be damned if *I* will!" Judith Ann whispered.

Gramaw didn't hear this time, but she kept up her fast rocking, and Judith Ann figured she was upset about something, which only served the poor dim old creature right, when you thought about it, and gave Judith Ann an odd, peaceful sort of feeling.

The next morning she was feeling peaceful for some other reason, although that reason wasn't actually any clearer. She and her mother were sitting in the dining room, after breakfast. It was Sunday, and Father had taken Gramaw to Sunday school. Judith Ann had been half reading the paper, although her head was thick with memories of the night before, when she'd been out on a messy date with Mike Ziegler and hadn't gotten back until a quarter 'til one, and her father had yelled at her for getting in so late. It's a wonder he didn't kill her.

Considering all the facts, she didn't know how she managed to find the strength to resist her mother's hints, but she did. It was a little surprising, and maybe even impressive. No doubt it was all part of family politics, which Judith Ann was skillful in...much more skillful than Charlotte, even though Charlotte was smarter in other things, and had had a way of scaring her out of her pants when she was younger.

This morning, her mother had approached her warily about taking Gramaw up to the old Mount Nebo Cemetery, so she could look for a Naomi Griffiths, who had lived in this region 150 years ago, and had been Granny's great-great-aunt, or something, and was buried someplace, but nobody knew exactly where.

"This is a connection she has to make," Mother said to Judith Ann, frowning at the thought. She sipped her coffee and waited, breathing quickly. Judith Ann could tell from the sound of her mother's voice that she was expecting resistance.

"I've got things to do," Judith Ann said, unfocusing her gaze. She was strangely aloof from it all, a little wary that the idea of driving Gramaw up to the old cemetery didn't fill her with all that much revulsion.

"Like what?" Mother said.

"Oh, things. Why can't Daddy take her?"

"You know he wants to watch football on Sunday afternoons."

Judith Ann made a face. "Well, I don't see why *I* have to be the one to drive her all the way up there."

"All the way!" her mother repeated scornfully. "Why, Judith Ann Conley! It's not over five or six miles, and you know it!"

"Yes, but I hate those old gravel roads."

"Well, that's the township's fault! Nobody could ever blame your father for that road; he's been fighting the township to put more gravel on that road for years!"

"Well, who's blaming *him?*" Judith Ann cried, surprised at the irrelevance of her mother's comment.

"I thought you liked to drive," her mother said placidly. "Most girls sixteen just jump at the chance to go out driving."

"Not on some icky gravel road, taking their grandmother to an abandoned graveyard!"

"I'm sure it won't take long. It'll do you good to get your mind off Mike Ziegler for a while."

Judith Ann inhaled abruptly and said, "All right, I'll take her. But I'm not going to have Ted going with us. He gives me fits lately, the way he tags along."

"I wouldn't go on a bet," Ted yelled from the front room.

Judith Ann's eyes blazed as she said to her mother, "There, do you see what I mean? That's what he's always doing, eavesdropping!"

"Well," her mother said comfortably, "he wouldn't be able to eavesdrop if he went along with you and Gramaw, would he?"

"Anything he does is eavesdropping, if you ask me," Judith Ann said.

"I said I wouldn't go if you invited me with a ten-foot pole!" Ted yelled out.

"Go back to your television!" Judith Ann shouted back.

"Children, children," their mother said, "stop your bickering."

"It's the Conley blood!" Ted called out, which made Judith Ann and her mother stare at each other until they both burst out laughing.

Then Mother said it was a good thing their father had taken Gramaw to church, so they couldn't hear them talking.

And Judith Ann said, "He's heard you say that a thousand times."

"What?"

"About the 'Conley blood'; you know, the way you're always talking about their cussedness."

"I don't say 'cussedness,'" Mother said carefully, sipping the last of her cold coffee. "'Stubbornness' is the word I use."

"I've heard you say 'cussedness' a thousand times," Judith Ann said, and her mother said, "Judith Ann Conley, you exaggerate."

"She always exaggerates," Ted called out.

"Oh, shut up in there!" Judith Ann said.

"Sometimes you act like you don't know how to count," her mother said, standing up and stacking the cups together, piggy back, before carrying all the breakfast plates into the kitchen.

"Now you drive carefully," Gramaw said, when she was settled in the front seat.

Judith Ann paused and stared almost cross-eyed at the ignition key before turning it. She always leaned forward when starting the car.

"Did you hear?" Gramaw asked.

101

"I heard," Judith Ann said, "and it just so happens that I know how to drive perfectly well, so I'd appreciate it if you wouldn't hassle me."

"You're always using that silly word," Gramaw said, looking out the side window away from her granddaughter.

"I've got a lot of reason to use it."

She turned left on the highway in front of the house and then drove about a mile to the Mount Nebo Road, which appeared to be hardly more than a barnyard driveway, the way it rested on top of the earth. It had a vague, temporary look, in spite of its age, for it hadn't rubbed out the least bump or twist of the terrain.

Right away after leaving the state road, it circled and began to rise, where it entered the thick wooded hills that darkened the sky in back of their house and seemed to brood over the whole Wyandotte Valley like a mute judgment of some kind. Judith Ann had read this once in a local travel guide, and the words and ideas both stayed with her, and sometimes when she thought about them, they made her half sick at her stomach.

"Don't worry, I know the way," Gramaw said, smoothing out the lap of her good green dress with her hand.

"Why should I worry? I know where it is, and don't need directions."

"Judith Ann Conley," Gramaw intoned, "if you don't sound like your father at your age!" The old woman laughed and said, "It's the Conley blood that does it!"

Judith Ann almost wrecked the car when she heard this, but she didn't say anything. If Mother had been along, she would have laughed; only now she thought it would be best not to let on.

But she couldn't help her thoughts, and they returned to that old idea she'd had about how people might live in two different kinds of time, so that they were oldest about two-thirds of the way through their lives, and then they lost things, in the way of forgetting, and lost time with their memories. So that if you graphed a long life, it would be shaped like the cross section of a hill, with the first slope much more gradual than the second. Maybe like Mount Nebo, even.

The odd excitement of such speculations came over her then, and she found herself clutching the steering wheel harder than ever as she guided the car up another turn in the road, entering the final ascent to the Mount Nebo Cemetery. And it was then that she saw something that surprised her: the shape of the road was very much like the shape of the walk in back of their house, like a huge question mark, or perhaps the clef in a bar of music. Only here it did not end in an orchard, where an old man's ghost was supposed to be looking for the ghosts of cats, but in an old cemetery that nobody ever even thought about any more, except for a

crazy old woman like Gramaw, who was looking for a tombstone with the name and dates of a long-dead relative on it.

The cemetery was more overgrown than Judith Ann had remembered it. Half the graves were buried in wild grass and thick briers. It was probably full of copperheads and poison ivy, and Judith Ann said so; but Gramaw just waved her hand, as if pushing the idea away, and said it was too late in the fall for them to worry about either one.

"Not only that, snakes are friendly to graves."

"How's that?" Judith Ann said.

"They eat mice."

Judith Ann asked her grandmother how that helped graves in any way, but the old woman ignored the question and bent over to look at a liver-colored stone with the name BASCOMB carved in it.

"That's not Griffiths, that's Bascomb," Judith Ann said.

"I know, but I was just curious. There used to be a Bascomb who lived in a shack by the river. He had a wooden leg. He was a ne'erdo well, and I wouldn't have thought he'd ever had a grandfather who could afford a gravestone like that."

The information shocked Judith Ann and she joined her grandmother in looking at the stone, leaning over beside her so she could read the dates and first names.

"James Howard Bascomb," she said slowly.

"That's what it says, all right."

"It doesn't sound like Boggs."

"What's that, dear?"

"Nothing," Judith Ann said. "I was just thinking out loud."

"It could have been his grandfather, I guess. Or maybe a great uncle. Family trees deteriorate just like anything else."

"Do you suppose he drowned cats?"

Gramaw stood up straight and stared at her granddaughter. "What on earth kind of question is that?"

"I've heard stories about a man named Bascomb who drowned cats," Judith Ann said, taking obscure comfort in the deceit.

"Not that *I* ever heard of," Gramaw said. "Why would anybody ever be known for drowning cats? Not that there haven't been plenty of them drowned, but what a thing to remember somebody for!"

"I gather he made sort of a profession out of it."

"A profession? How do you mean?"

Judith Ann touched her chin with the tips of her fingers and looked thoughtful. "If somebody wanted a cat drowned, they'd take it to Mr. Bascomb."

103

"Why, I've never heard of such a thing!"

"Or maybe his name was Boggs."

"I've never heard of him, either," Gramaw said, circling another grave and leaning over so she could see it better.

Judith Ann turned away and took several steps down a crooked line of graves, where she stopped in front of an old marble headstone slanted in the weeds. The lettering had been worn away by time, so that the name was scarcely more than a shadow on the stone. Gramaw was talking, but her head was turned away, and Judith Ann couldn't hear what she was saying.

But even if she had heard her grandmother, Judith Ann would have been unable to answer or pay attention, because at that instant, she saw something that turned her blood cold, as she said later. Carved in the old headstone—as white and smooth-looking as an old piece of soap—she saw her own name.

For a moment, she almost blacked out. Then she heard her grandmother turn back in her direction, saying, "I don't believe there are any Griffiths over in this part."

The date underneath the name was unclear; but that might have been because her eyes had clouded over from the shock of what she'd seen. Gramaw would be able to make it out; Gramaw's eyes were as sharp as a cat's.

"One of the Griffith's married a Ballentine," Gramaw said, her voice coming closer. "At least, that's what your great-aunt Edith always said, but I couldn't make any sense out of it, because that name never appeared on any of the charts she'd collected, and if she was so sure there was a Ballentine, why didn't she put the name down? You'd think she'd have it listed if she knew it belonged there, wouldn't you? Judith Ann, what on earth's the matter with you? You look like you've seen a ghost."

"I practically have!" Judith Ann said in a breathy voice.

"What do you mean?"

She pointed. "That's my name on that old grave marker, Gramaw!"

"Nothing surprising in that: Conley's are thick in here."

"But it's *my* name!" Judith Ann shrieked.

She felt her grandmother move up beside her and saw the old woman lean over and peer at the marker. "Why, so it is!" she said. "Judith Ann Conley. And she was cut down in the prime, it looks like."

"What do you mean?"

Gramaw pulled back and said, "Why she died three days after her seventeenth birthday. Can't you see her dates? 'Born March 9, 1812, and died March 12, 1829.' "

"Oh, my God!" Judith Ann whispered.

"Your mother wouldn't appreciate such language," Gramaw said, easing past her.

"But it's my own *name*, Gramaw!"

"No need to yell and shout."

"Is she an ancestor or something?"

Gramaw took a deep breath, and out of the corner of her eye, Judith Ann saw her leaning over to inspect another grave. "I don't know one Conley from another," Gramaw said. "So far as I'm concerned, they're a deep, dark mystery."

"God, you don't know how *spooky* that makes me feel!"

Gramaw turned and looked at her, clasping her hands. "Why should it? A name's only a name. Probably no relation. The Conleys are thick in here, just look around."

"And only *seventeen!*" Judith Ann whispered awfully.

"A lot of them didn't even live *that* long, in those days," Gramaw said, turning away once again on her search for the grave of a Griffith, which she wasn't able to find that day.

For several years afterwards, Judith Ann dreamed of the gravestone in Mount Nebo Cemetery. Often, it would come to her at night when she was half-asleep, glowing as brightly as a television set in a dark room. The sight of it in her mind would awaken her, and she would lie in terrified stillness until it faded from view and she fell asleep.

Part of it had to do with her age, of course; she was not yet seventeen, and for several months before her seventeenth birthday she wondered if she would live longer than that unknown girl who'd once had her name. She acknowledged the silliness of such speculations, but this had nothing to do with their reality at night when she would have visions of the headstone.

One day at school, between biology class and study hall, Judith Ann was talking to two of her girlfriends when she saw Mike Ziegler walking down the hall with Pam Wensick. At the instant she saw them, both of her girl friends became silent; and Judith Ann suddenly realized that she no longer had any claim to Mike Ziegler . . . that he had obviously been going with Pam Wensick behind her back.

Her misery at this discovery was operatic. And yet, most of her suffering was inside, spending itself in wild, unlikely, but relentlessly silent scenarios of dismay and reproach. It was uncanny how much she could swallow and still function more or less normally.

None of her family knew, of course; but more amazingly, none of her friends knew, either. Her attitude toward Mike Ziegler was one of cool indifference. The two friends who had seen her witnessing Mike

Ziegler's betrayal had only been watching for *signs that she knew;* they were not simply spectators of her humiliation.

What all of this had to do with the grave at Mount Nebo was not clear; and yet the fact that the two events had affected her so profoundly at almost the same period of her life brought them together in ways that she couldn't ignore. At the time, she told herself melodramatically that they were the two greatest things that had ever happened to her; and they were both almost too awful to endure.

Even after she had become a grown woman, Judith Ann contemplated this truth. She realized that girls have often killed themselves for reasons more trivial than the betrayal of a Mike Ziegler. Or at least, more trivial as seen from outside—which was precisely the point. And of course, most people go through a long and presumably happy life without ever seeing their own name on a gravestone.

So there was a sort of pride in her ability to endure these unlikely events. Within six months, Mike Ziegler was nothing to her, *less* than nothing, and she wondered that she could ever have taken him seriously. And within a year, the headstone at Mount Nebo was little more than the occasion for an odd story.

Actually, it was something Gramaw told her one day in the dead of winter that helped make it all come out right. What the old lady had said was not all that remarkable, but Judith Ann knew that Gramaw had a right to say it with her own meaning, so that the words were not the same. After all, it makes a difference who says something, because some people *mean* more, even if they use the same words.

Gramaw had lost her husband when she was still a young woman, and had worked hard to raise her daughters. She seldom spoke of those hard times; but once when it was snowing outside and Judith Ann was reading *Silas Marner* for English class, Gramaw interrupted her with some inconsequential chatter, and then—out of nowhere—said: "Anything that happens to you can be your strength, Judith Ann, because it's yours alone."

When she raised her eyes from the book and stared at the old woman, her grandmother wouldn't look back—as if afraid to let her see in her eyes the truth and seriousness of what she'd said.

And why had she said it at all? Judith Ann pondered this question uneasily, unable to shake the notion that Gramaw was aware that the grave at Mount Nebo was still with her, casting an unnatural light upon things when she thought about it. In some ways, this was just as mysterious as anything that had happened; and when Gramaw had spoken to her, it was as if all of the old woman's complaining and forgetfulness had

suddenly evaporated, leaving just the two of them together, with Gramaw quietly, and without any reason, telling her the truth about things.

Whatever was behind it, the seed had been planted, right at that moment; and long after Gramaw died, Judith Ann could remember what she'd said, exactly the way she said it. Just as she remembered that awful day at Mount Nebo and the discovery, within a week, of Mike Ziegler's betrayal of her love for him.

But it was the headstone mostly. Seeing it had drained most of the silliness out of her, for a while, giving her an idea of how strong and serious she might be in what is after all a mysterious world. It also gave her something else, which has no name, but is one of the things that made her life into something more than an abstraction . . . almost as if she were destined to understand more, because this was her second time.

"This Moment Is Ours Alone"

"It was all very romantic and decadent," Marla says with a delicious shudder. "Was it not so?"

This time I don't answer, but she knows it wasn't. Or at least, knows that I am convinced it was not. It is decadent for her only because it can't be seen except through a fog of passion, inaccessible in that distant past.

"One should be intent upon other things," she says. "Things to *do*. Accomplish. That's where we should be expending emotion, Treasure."

"*Schatz,*" I remind her, and Marla warms a small smile in my direction and breathes *Schatz,* in the old language out of which her girl's dreams were formulated. Hooded, pouched with age, her eyes are still clear and as pale as a mountain lager. Her coils of white hair were once blonde and heavy.

"Still," she says, trembling her fingers against the stem of her brandy glass, "with time, *die ganze Zeit,* it all becomes decadent, in a way. The supply of actions to follow thought . . . " she pauses, frowning upon a ceremonial difficulty with the language " . . . *diminishes.*"

"That's not the same thing," I say. "It's the intent, the spirit, after all."

For a moment, we are silent. Then I go over to turn up the record. The voice is full, but of an almost disturbing clarity. "The unique voice-wedded-to-style in this century," DeKoven had written. "Like the wines made from the grapes of the Rhine," Gregory Dobek had said, introducing her years before at the memorial concert in Banff.

("Oh, the silence before that applause!" Marla whispered once, remembering. "A cannon could have been shot into that silence, and there wouldn't have been a ripple!")

Now, turning up the stereo, I let the familiar words of "Our Love Will Never End" fill the room's silent places—the small shy darknesses

under chairs and desk, the blind Giotto corpses standing in the pleats of the drapes.

This is the song that reminds her of so much, for it was sung throughout Europe for several years, "an underground classic," before it too became silent. Singing in a brooding English ("Dietrich *bel canto,*" Sismund had called it once), Marla possessed this song, and I wondered if people could somehow feel or hear it just seeing her as she stepped off a plane or turned around—surprised inside the ruins of her luminous beauty—at a cocktail party, staring into a man's eyes.

Sometimes even now she will hum along with her present voice, but not often. Never does she repeat the words. When she made that record, she had reached a height that she no longer wants to ascend; and yet, gazing upon it, she likes to remember that it is after all part of herself that loomed over a whole generation, and now looms over the both of us, turning this very room dark in the silence of aftermath.

The present has very little to offer in contrast to such a memory; but Marla is far from giving way to the despair of emotional exile.

"When I was young, I used to cry . . . " she gestures with all her fingers opened " . . . *theatrically.* Life was, after all, a sequence of compensatory convulsions."

(Surfacing, I have told her, only in sound: signaled by the recordings that made her the most famous Underground Singer in East Germany during the 1950s; she nods, and grips my hand—which signifies that she knows I, too, have saved her life.)

"Now," she says, "the sadness is spread evenly throughout the days and nights. There's no need to cry; not even when I listen to what it was I could do in those days. With—forgive me, *Schatz*—such a voice!"

"Which means the peaks are gone, too," I say. "It only follows."

"*Nothing* follows," Marla says. "The peaks remain. They weren't part of it ever. The peaks always come from above. *Der Höhepunkt.*"

As much as anything, I love this somber, impossible, heroic idealism. But it is after all something that had better be left unsaid, or it might poison some little part of her with self-indulgence. Maybe rhetoric.

God knows, she was capable of it in the old days.

Also, there is still something of the old beauty, not at all stifled in the wrinkling of her flesh. I can see it, just as I can still hear the greatness of her voice, even when she is asking what the weather is like outside, or where the cat is, or what we should order for dinner.

Marla knows part of this, and is content not to know it fully.

The song ends. "Our Love Will Never End"—but the singing of it always does. Silence.

Marla thoughtful, her fingers still on the brandy glass.

"So romantic and decadent," she whispers. Nods. Sips thoughtfully.

"Not decadent," I say, returning to the old explanation, as if it, too, were a record filed away in the silence of a gone time, but nevertheless in a place where it can always be found.

Then, like so much, brought out and played back.

I am Marla's second husband. We were married four years after her escape from East Germany, her powerful but ambiguous fame already turning to shadows.

"No more singing," she had said in an interview. "No more records. That life is gone from me, forever."

Six years after my own divorce, I had been waiting. This was the sort of waiting that can be known only in retrospect, so that you have to wonder how much of it is psychological, of the moment—a present adjustment of memory to make the past coherent . . . as unconscious as a sleeping woman's hand adjusting the covers at night, keeping you and herself warm.

We met at a party, where there were enough celebrities that Marla's presence did not galvanize attention as it would have done even ten years earlier, when her fame beyond the Iron Curtain was legendary if dim. (Part of the legend itself was the dimness, the distance from current realities; later I was to think Marla's voice was above speech, above song, even; one could sense that in some distant and dark café *in that other world,* her voice could be heard; just as it is now, only with her beside me, listening to the same miracle, as if she had never been part of it.)

Actually, she was without money or resources at this time. She had gotten along, somehow, living in the twilight world of old celebrities, able to attract a few wealthy lovers because of her beauty and the haunting echoes of what she'd once been.

I was the last of these; and within months, we were married, which meant the end of her life's insecurity, if the actuarial tables could be trusted. She once said: "I don't call you *Schatz* for nothing, Treasure!"

There was no insult in this, for it was uttered with tenderness and passion; and the fact that a woman's love for a man might be inextricably part of her need for security was not the sort of fact to put me off, much less surprise me.

Whatever surprise there might have been in it (assuming a disinterested spectator—yourself) would have been in the age of this woman. It might have been thought that there was too much imprinted in that face for new passions or fresh events to find their place. But the human face is

not a scratch pad that can be filled; not if you are one of the deep ones, the passionate ones.

I talked about this to Marla late one evening, when we were about to go to bed. We had been to the theater, where Chekhov's *The Seagull* had been played with wooden efficiency.

Half-undressed, she clasped my arm and hugged it in both of her arms, as if it had been a man's body. "I *know*," she whispered. "It's you who understand this, and I love you for it, Treasure! So much, so much!"

Later that night, she said: "Even then, I was singing for you; but, do you know? I didn't know it."

"Those songs will always exist," I said, "even if there's no one to hear them."

"*When*," she said, "not *if*."

The next day, on the radio, we were surprised to hear her record of "Lili Marlene"—a song she had made her own in East Germany, where it became personal to her in a way that was almost magic—as if the name of the song encoded her own name, before her birth, when it was sung to piano accompaniments in cellar cafés in Berlin, and the pounding of stormtrooper's boots was still in the future: a place far distant beyond the farthest reach of Willemstrasse, but relentlessly approaching.

"It is true," Marla once said: "if it is art, it has *Überlegenheit*. It does not really fit into any one particular place."

I thought about this, without answering; and after a moment, Marla added "*Schatz*"—as if she'd forgotten, and her surmise could not have been complete, without that awful appeal built into the word.

So much fear in so much love!

The story of Marla's escape from East Germany is a strange and miraculous one in the way of secular events.

Her existence there, and the continued pursuit of her music, must be viewed as an even greater miracle, however. For if she can now look back upon those days, which she filled with music (and created a *Weltgeist* that nothing could escape), and see them as decadent, surely all that she was then, to the bureaucrats of that time and place, must have been so great a decadence, in *their* terms, that it escaped the range of their political radar.

("Don't talk like that," Marla told me once: "I don't like to think of the complexities of that time. The past must always be simple, else what's it for?")

Nevertheless, it will not jump to the whip of reason. We argue about this, but in a temper of mild dismay that such options are available to the mind.

How many times she's told me the story; and how closely I've listened, to savor the least nuance in the report of how she shed everything of her old life—where her fame had grown—and come westward, into the world of capitalism and her old age. A soft and comfortable world of reminiscence, from which she can view the extra-ordinary passions of her youth.

("How is this unlike other people?" I asked her, but she shushed me gently, not wanting that girl-she-had-been violated.)

This was in 1957, and Marla was so well-known that she could never have escaped in Berlin. There was a high official named Schattner, who was rumored to be Marla's lover ("Never!" she insisted to me; then, thoughtful, assessing me, admitting: "although there were others"); no doubt he negotiated a softness in the treatment of her. It was said that another, accomplishing what she had, would have been disgraced and imprisoned.

A disguise? Too dangerous. The border guards at that time were so thorough that even legitimate functionaries were sometimes delayed overnight, kept in cold waiting rooms until the Officer of the Guard appeared the next morning and checked credentials that had been worn and tattered from so much bureaucratic handling.

Disguises were too risky, but there had been a time when Marla had seriously considered having her features altered surgically. She went so far as to consult a surgeon—an exile from Prague; but left his office with the uncomfortable feeling that he might report everything to the authorities.

Schattner was helpless; his infatuation with Marla's voice and fame were too well-known. ("If I had come before him," Marla said, melo-dramatically, open hand on her bosom, "he would have had to have me shot, just to prove what everyone knew to be true wasn't true.")

But it isn't Schattner who occupies the third position in the story I have to tell. The third position is occupied by a man whose name we have never known. Furthermore, he is a man of negligible consequence, either in this world or that other one.

Faced with an increasing urgency to leave East Germany, Marla one day thought of a cousin who lived in a small border town to the south. She gathered together as much as she could without arousing suspicion, and went to visit her cousin, ostensibly to renew old family connections.

("How alone I was at that time, *Schatz!* And I wasn't prepared for loneliness, *Verlassenheit,* because of my career. On that dark evening when I looked over the hill to the West, toward freedom, all I could see

112

was a huge black void. I was about to hurl myself into oblivion. What frightful ecstasy!")

But it was all managed. A foot trail led to the border, within three hundred yards of the road, through an area that tourists in autos, passing by, might have thought impassable. But it was all perfectly easy, except for the darkness and the fear.

In her pocket, Marla had some names and addresses, along with a little money and some pieces of jewelry. But she also, at that time, still had her voice and talent, along with that presence which is the corollary of the two.

Her cousin's nephew led her to within one hundred yards of the border. This was in March, and there was still snow on the ground. The woods were like a photographic negative (Marla says, half-closing her eyes), with the ground pale and the sky black, and the trees nothing but vague, shaggy darknesses in between.

Almost at the very instant she felt the border passing beneath her feet, a thickly muffled soldier stood up and leveled his rifle at her. He was within twenty feet of her. (At this moment, Marla says she was conscious that the man was overdressed; that he must be too hot wearing that heavy coat buttoned up around his neck.)

He commanded her to halt, which she did; but then, feeling calmer than she had ever felt in her whole life ("It was because there was such an influx of *Truth* into that instant!"), she lifted her scarf from her head and slowly shook her heavy, blonde hair loose. As if to display, even flaunt, her beauty (it must have glowed, even in that forest), and give that poor, deadly, muffled-up soldier the realization of what he would be doing if he shot her.

For a long moment ("It was I swear a quarter of an hour, Treasure!") the two of them stood and looked at each other. The barrel of the soldier's rifle was pointed directly at her heart (here, she pauses and delicately touches her left nipple with her index finger—aware of the miracle of life remaining there).

"A stand-off!" she cries triumphantly. "Stalemate!"

"No, a moment of decision," I tell her.

"Yes!" she hisses, her eyes growing wide. "Yes, yes!"

"And you made up your mind and started forward again."

"Yes."

And she did. I can see it, *know* that time; for I can visualize the way she would walk, her head held back in an expression so theatrical that this poor ignorant soldier might have heard woodwinds and cellos; and would have been so weakened by the sight—so unexpected and so brilliantly recognizable (yes, Marla would have lighted the woods with

her presence)—that he would not have been capable of raising the rifle to fire, much less pull the trigger as he now held it waist high, pointed vaguely at the left breast of a woman who had already become a legend in a country that had no place for her any longer.

"As long as I live, I'll never forget that boy's face," Marla says.

I have had Marla's old records remade. I have also tried to buy copies of them from various dealers in Europe (my best contact has been in Brussels, for some reason), so that now we might claim to have the best collection of her songs ever. With the greatest fidelity (even though some dubbing had to be done in several of the earlier recordings).

There are only two titles missing. Marla remembers distinctly recording a song, late in 1948, titled "Come to Me." I have asked her to sing it for me, but she says she forgets how it went. And of course the words are gone from her memory. It bothers her to have lost this early song, and through her, it bothers me, too. She is sure that she recorded it in English, for that was part of her signature as an artist (she did only eleven records in German, none of which helped make her famous).

The other record was called "This Moment Is Ours Alone," and Marla can remember enough of it to sing it recognizably (she says), although some of the words and the bridge are missing. Not one copy of this record exists anywhere, so far as I can tell. I have written to people everywhere, advertised in newspapers and other periodicals throughout Europe, and even in Canada, Mexico, and Argentina.

The song is filled with the usual platitudes of romantic love. ("There, I was at my most decadent and romantic best, *Schatz,*" she says. "Only, for some reason, the song never caught on.") This was in 1952, Marla had just recovered from pneumonia when she'd made the record, and she claims that she weighed only ninety-six pounds at the time.

("I could barely whisper into the microphone, I was so weak. But I needed the money, not to mention my sister, who was pregnant for the second time. So I sang it out of my weakness, a misty, delicious *Schwach- lichkeit,* Treasure! So much suffering and depth! Nobody liked it for the very reason it was so haunting. All they could hear was the echo of sickness; they couldn't hear the strength of passion that was growing at that very instant, like the Phoenix!")

Might there be a copy of this record? Marla is almost as haunted by it as I am, although she had never spoken so passionately about it until I began to ask questions. Is it possible that I have helped her to remember the miracle? And how do I know it *was* a miracle? My conviction rests upon something stronger than extrapolation; but that is surely part of it.

"It was a song about love," Marla says, "and the moment. It states

that love is always of the moment, but upon those rare and precious occasions when a moment is truly filled with love, this moment becomes forever."

"That's quite a message," I tell her, smiling.

"It is essential to everything," Marla says gravely, shaking her head to dispel my words. Then she breathes, *"Die Wichtigkeit!"*

At *this* moment, she seems to feel the heavy weight of those massive golden locks that framed her face in the darkness of her old life.

Late one October evening, the phone rang and Marla answered it.

Half-listening, I was soon aware that it was not one of our friends, but someone Marla had never talked to. At first guarded, her voice changed in subtle ways.

Then, after a moment's silence, I realized that whoever she'd been talking to had hung up.

When she came back into the living room, she was pale and walked slowly, as if uncertain of her footing.

"For God's sake," I said, "who *was* it?"

"I'd never heard his voice before," she said.

"*Whose* voice?"

"He wouldn't give me his name," Marla said wonderingly. Then she shuddered.

"Will you for God's sake tell me what he said?"

"Yes," Marla said, closing her eyes and inhaling. This was the way she got control of herself. "Do you remember the story I've told you about how I escaped?"

"Of course."

She nodded. "I've told you a hundred times, I know. Well, do you remember the guard who could have shot me in the heart, but didn't?"

"Of course."

Marla nodded again. "That was the one—that boy—on the phone. He's here, now, in this country. He told me all about that episode. He told me the date and everything. He mentioned the place. He even mentioned the way I took off my scarf and shook my hair loose. He said it was like inviting him to shoot, or something. He said he'd never witnessed anything so grand and noble. That's what he said."

"Good God!"

"He knew everything, *Schatz*. Everything."

"Is he in this country?"

Marla nodded. "Yes, he's immigrated. He said it was two years ago. He just wanted to let me know he was here."

"Why?"

115

"I don't know."

"Was it like . . . you know, *blackmail* or something? Extortion?"

Marla shook her head. "No, nothing like that. Nothing at all. He sounded. . . ."

For a long moment, she struggled with trying to identify the tone of his voice, but finally she gave up and shrugged her shoulders slightly: "well, *worshipful!* He said very flattering things."

"Good Lord," I mumbled. "And he wouldn't give his name?"

"No. He insisted. I asked him, but he wouldn't." She laughed. "He ought to see me now. What the years have done, yes?"

"Of course not."

"I know: we all age."

"Even that guard."

"I suppose," Marla said meditatively, "but do you know something? He sounded like a little boy over the telephone."

"He's surely a middle-aged man now. At least."

"Of course, that night, he didn't say a thing. Just the two of us, staring at each other out there in the dark forest."

"I know."

"And he let me go."

"I know."

"And that's how we met, *Schatz.* You and I." She smiled and snapped her fingers. "Just like that."

"I wonder if he'll call back."

"I'm sure he will," Marla said thoughtfully, "I got that impression."

"Very romantic, but not decadent," I tell her.

She smiles distantly, as always, half out of the present. Her records are seldom heard, now; and her name is only a faint memory to a diminishing group of people.

"Something in that time," I tell her, "that reaches *out* of time."

She reaches over and touches my hand, saying, "You've had too much brandy, *Schatz.*"

"We've had much more than most people who live on this earth."

"More brandy?" She laughed. "But you really are a little bit drunk, aren't you?"

Marla has been drinking as well; she has been in considerable pain, recently; there is something oddly dignified by the fact that she is suffering from a degenerative disease that has not been clearly diagnosed, as yet. Although it is associated with aging, of course.

"Degenerative," she says, "but not decadent. Am I right?"

Such gentle mocking requires no answer. What I really want to hear

116

is "This Moment Is Ours Alone." The bits and tatters that Marla can offer with her poor old voice are pathetically wrong. Inadequate. I know it as surely as if the record itself were part of my own life.

"What was it then?" she asks. "We sensed that the world was poised upon something magnificent. The violence of Hitler had cleansed the world, for all its brutality and . . . *impossibility*. A fire that cauterized."

"You don't really believe that," I say. "All that you stood for was against that."

"I know, I know," she says quickly. "But they weren't really any better, you know. I'm speaking of Schattner and the others."

"Of course."

"Only that simple little man with the rifle; all huddled up in his heavy clothes . . . *so unschuldig* like a huge boy dressed in mattresses, pointing a gun at my heart."

"And now he's in this country."

"Yes, somewhere."

(He still phones, once or twice a year, as if to see that Marla is all right; there is evidently a responsibility he persists in feeling, having spared her life that time so long ago.)

"And we don't even know his name."

"But he won't *tell!*" Marla cries, lifting her two hands in despair.

"What would you do? Thank him in some way?"

"I don't know."

"Have him come see us?"

"No. I don't think that. I don't think I could bear that one."

"Give him money, perhaps?"

Marla shakes her head. "I don't know, I don't know."

"Because he was one of us, you understand."

Marla closes her eyes and thinks; then she nods slowly, "I don't want to hear music now," she says. "Not at this moment."

But why is this? Music hasn't been mentioned.

"It's almost as if what the music stood for is fixed there inside my head. Or memory."

"I understand," I told her. "Or *through* the memory."

"But it looks like you'll never hear that little song."

I nodded.

She clasped my hand again. "Poor *Schatz!* And you tried so hard. Like the other one, nah?"

"Tell me," I said, "what was it like? Was it one of your best?"

"You've asked me that before, Treasure. Why do you keep asking?"

"Because I don't think you've ever really answered the question."

Marla smiles. (Now it is the present moment, always. How much

117

there is to fit into this narrow interval! The light of evening comes through the drapes and lies upon the wine-dark carpet like splashes of sound.)

Marla inhales and thinks. So much is there inside her head; and yet, she is in physical pain, which makes it easier.

"I'll tell you," she says slowly, tenderly. "It was the most beautiful of all."

"I knew it," I say. And closing her eyes, Marla nods.

The Sound of a Girl Singing

I died near the end of my fifth year, and my father, whispering to himself, laid me gently in a small satin-covered box. All those who had learned to love me during my short life filed past and gazed upon my dead face.

The air was heavy with the slow sadness of living flesh and woefully warm; and there was a relentless sniffling, for all the women present cried over me. I had in truth been a beautiful child, of a bright and equable disposition, and it was incomprehensible to their hearts that I should die.

It rained when they lowered my coffin into the ground, and I remember that one of the gravediggers—an old fellow with a rheumy head—also sniffed frequently, but for a reason different from that of the women.

This was in the year 1811. There were comets in that year, and earthquakes, and rumors of famine. People consulted their Bibles and prophesied the World's End.

The blackness and despair of the coffin were an astonishment. One might think of blackness as an absolute; but let me tell you, it is not. The mere blackness of a closed box is nothing compared to the compounded blackness of all that clay heaved upon it, sealing the little vessel that I was forced to inhabit from the sweet air and the glorious sun and the calm stars. To know this as I did was to hear a kind of music for the first time.

As I lay in that stone-dense trance, I began to dream myself into the dreams of other people. The autumn rains came, and then the winter snows. I made them into seasons of nightmare. Children—innocent young girls, especially—were forced to receive my terror-driven dreams, which in turn sprouted like mushrooms and weeds from their dark restlessness. Mind-thumbed with horror, they called back to me, only to forget my name upon waking.

119

But I was doing more than dreaming. I was clawing my way through the satin, and the wooden boards, and then through the rocks and clay itself. Men have suspected that such things might happen: haven't they dug up graves and opened caskets to find corpses lying on their faces? Can you conceive the nightmares behind such awful turning?

Eventually, when the cold winter began to pass away, I had reached one hand through my coffin, allowing by this rupture a cascade of dirt to slide down and fill my ears and nose and mouth with its ponderous and comprehensive weight.

This collapse of dirt upon my body stifled and delayed me several years, I am certain, while I gathered energy to begin again.

All these other cycles of season wheeled invisibly overhead, and upon occasion I was still invading the innocent dreams of the living. These were children, mostly, for it was they who were enjoying the life that I had once felt entitled to.

With the passage of years, I had eventually, like a ponderously slow swimmer in the earth, almost surfaced. I had reached a stationary position, almost perpendicular, with my head only a few inches from the surface. One of my feet was still in the coffin, but the other was free. My arms were extended, but bent at the elbows. I had used them to help pull my head and trunk upwards, and that is why I had not yet reached the air. My head was bent over, as if in prayer; but it would be more proper to say that it was bent in terror at the thought that light and air were imminent, after so long an imprisonment in the earth.

Then, on a warm spring night, my hand reached through and felt the shaggy grass and weeds of the surface. Naturally, I had no sure knowledge that it was a spring night, except for that sense of duration that one has as he sleeps, so that he will awake an hour before dawn, and know deep in his veins what time it is.

There was no stopping me now. Soon, my head had burst out of the earth, and I was looking up at the stars, marveling at their distance and their brightness. And then I felt the breeze blowing through my hair, and I smelled the green odors of grass and plants, and I wept.

By morning, I was half out of the earth, inspired by the success of my awesome journey. Climbing more slowly than a tree grows, I had passed this barrier; and by noon, I was once more standing upon the ground, silent and erect. Had I grown in stature? Something in the landscape felt diminished, although this was only part of a dire uncertainty.

Where had I learned to speak in this manner, for example? Something in me had grown old, and the grass seemed too innocent in my eyes.

I began walking, and stumbled awkwardly downhill, out of the graveyard—past the farthest headstone, in which was carved a hand with the index finger extended, pointing upwards, and the legend "Meet Me in Heaven" inscribed.

I moved past, and headed down a dirt road, toward whatever lay in wait for me. The sunlight, while bright, was more sculptured than sunlight usually appears, as if it were only moonlight, but brighter than truth.

Fences moved past as I walked, their passage as regular as a clock's pendulum. "Passion!" I whispered, and birds scuttled like dice in the weeds.

Within a half hour, I heard a dog barking, the sound drifting over my head like a half-forgotten dream of hearing.

And then, suddenly, on the road before me, I saw a young girl walking in my direction.

She was striding quickly, her head bowed in preoccupation. A small dog ran this way and that about her feet. The brilliant sun cast a strong dark shadow beneath her as she moved toward me; a fresh breeze blew strands of her hair about her face. She seemed from this distance a vaguely pretty girl, although I'm sure there was nothing singularly beautiful about her. Was it possible that I could see an elusive familiarity in her face? She seemed to me a miracle as I stood there in the roadway, holding out my hands and whispering to her.

But when she had approached within fifty feet, and I would have normally begun to see her face more clearly, something happened: the girl began to fade from sight, and the barking of her little dog suddenly sounded distant, as if he were on the other side of some great lake that is ringed by vast meadows of pike grass.

Then it was that I cried out for her not to leave me; but she slipped from sight like water through paralyzed fingers. Only this was left: the memory, or illusion, that in the very instant she was about to disappear, she did indeed hear my cry, and gave one brief abstracted glance in my direction, as if she had seen something—a bush or twisted tree trunk— that might have resembled a human being, but obviously was not.

In that instant, whether it was memory or illusion, I recognized the face of my mother as a young maid. I had often heard my mother speak of her little dog. Its name had been "Sparkle." This place had been the time of her girlhood. What was *I* doing there?

Bewildered, I turned aside into the weeds, passing like rain through the rail fence, and soon found myself walking down a meandering path through some woods, thick with hickory and walnut, that turned the air as cool as a cistern. The darkness of the woods weighed upon me, for I was still afraid of darkness.

121

And yet, only an instant before, the sun had burned my vision and had poured fire through the superstition of my flesh, as if it had been no more sentient than the curled fallen leaves upon the ground. I remembered how the breeze had rasped through me, and rattled the reeds beside the road. Now, insubstantial and lost, I began to understand that I had been cast upon this journey by nothing more than the awful hunger to live.

In the deep woods, birds stopped singing when I approached, and when I gazed at them, they fell out of sight, as if shot by some silent, smokeless gun. I sang hymns, trying to remember. But as if to mock me, the very trees I walked under sent back gibbering echoes, like the brainless lapping of a tongue.

Then there was a road, and in the distance ahead, I could see great clouds of dust looming above it. I stepped down into the worn tracks and waited until I could hear human shouting and human laughter.

I began to see figures appear in the dust, and I realized that I had happened upon some sort of caravan. Whenever I approached the figures, they seemed to drift away, as if sliding downhill upon a sheet of ice. Their faces were all turned from me, and though they cried out in great volume, their voices spoke in a language that I could not understand. Hundreds of them, perhaps thousands, drifted past and off into nothingness.

Then there was the sound of an enormous drum beating, resonant and grand, and the dust floated away, leaving me standing in the middle of a green field. Suddenly I could hear meadowlarks in the grass, but I could not see them. The grass seemed to me insubstantial and as woeful as a city.

I fell down on the earth and tasted the bitter ground with my mouth against it. I gnawed at the leathery sod, and filled my mouth with blood and dirt. The air turned dark behind my head, and I felt the slap of coolness upon my skin. Then rain drifted through my back and arms.

At this time, the realization came to me! I had crawled back into the wrong world. This was not the world I had remembered, and these were not the people I had known. They were not even like those people I had known. They were different in ways that might escape notice and yet prove surprising upon discovery, as if you have known a woman for years before realizing she has six fingers on her right hand.

It had not been my mother as a young girl. What I had seen has no name and therefore can never be called back.

I hugged the ground with all my strength, for it was all I had. Sun and moon were lies, and vision was their child.

I cried out and begged to be taken back.

The real world in which I had been buried might now seem even more ghostly than this wrong one. Sometimes, a lunatic will understand such a truth in this way. As for those times in between, they are the times I yearn upwards into the nightmares of children.

I clutched at the earth with the blind tenacity of a possum's kit and begged for entrance once again.

Having climbed in the wrong direction, just as that girl and the figures in that caravan had done, I was nevertheless sure that with courage I might find my way back. Furthermore, there was prayer, which has to do with returning.

But even as I prayed, I thought of those others, left behind. For an instant it seemed I had heard a little dog barking in the distance. Is it possible I could touch loss, like a coin found in the clay? There is a direction upwards that no one has ever been able to unriddle. Perhaps it will appear as the stars we know, reversed as if reflected in a pond where the drowned sleep.

Surely, I said, this is not how it is supposed to be. And then, at that instant, I thought there was this distant sound, a girl singing.

Five Women

My mother lost forty-seven pounds one winter and had her hair restyled.

"Don't you think it makes me look taller?" she asked my father, when he came in the door. It was raining hard outside and he hadn't worn a hat or carried an umbrella, so his head was soaked. He blinked and took off his raincoat. Water dropped from it onto the floor, and Dad wiped the rain out of his eyes, so he could see better.

"Who are you?" he asked.

"Don't be silly," Mother said. "Doesn't it make me look taller?"

"Losing all that weight is what made you look taller," he said judiciously. "Thinness emphasizes height, whoever you are."

"Will you please be serious a minute?"

"I'm always serious," Dad said.

I suddenly guffawed, and Mother turned to me and muttered: "You stay out of this, Buster!"

"Who is this gorgeous creature?" Dad asked me rhetorically, motioning toward mother with his open hand. In the other he was still holding onto the raincoat. It had almost stopped dripping. Outside, the rain continued to fall heavily, puckering the leaden surface of the puddle at the foot of the driveway where it connects with the street. The fence of the Chapmans' next door, freshly painted a barn red, gleamed with an insensitive luster in the dim light, and on our patio the wind chimes hung silent and dispirited. Beyond, the rain continued pouring straight down out of a heavy, windless sky.

"I think it makes me look taller," Mother said, nodding and walking into the kitchen.

"You're a striking woman," Dad said.

"That wasn't my question," Mother called out sing-song from the kitchen.

124

"Your new hairdo's a knockout," he said, raising his voice a little. "That wasn't what I asked, either."

Dad went over to his favorite chair, sat down, and started to take off his wet shoes. He breathed with his mouth open, like a man whose thoughts are far away. He'd left dark wet footprints in the carpet, and normally Mother would have commented upon this fact.

When his shoes were off, he closed his eyes and sighed. Then he left his eyes closed. Out in the kitchen, Mother was making noises as she started to get dinner ready. I heard the refrigerator door whip open and close twice in rapid succession. My father's whimsy didn't sit well with her; it never had. Maybe it was what had first brought them together.

Still, I had to admit that my father had been tactless. But so had she. The least she could have done was wait until he'd gotten his raincoat off. She shouldn't have been so anxious.

The weather made me feel vaguely depressed and uneasy. I went over to the storm door and gazed out at the gray air in the patio, beyond which the gray rain continued to pour down in the fat heavy drops of a waterfall.

Then I heard something in the kitchen that I couldn't make out. At first, it sounded as if Mother had hurt herself. Only a month before she had burned her hand taking a roast out of the oven. She'd held on too long, so that we had to take her to the emergency room, where a doctor had given her a white ointment and pain pills. It was nasty.

Why had she hung onto the hot tray so long? It struck me as odd then and still seems that way. She had lost twenty-four pounds by that time, and was talking of a new wardrobe. Dad had been away on business, somewhere in Pennsylvania.

But now, after a moment, I realized that she hadn't burned herself again. She was singing in anger and trying to keep the sound muffled.

I don't know what Dad was doing.

The rain stopped, and the spring came. Patti, my oldest sister, returned home to think over her marriage. Her husband couldn't seem to hold a job, even though he didn't have any trouble getting one. His name was Carl, and he was considered good-looking. He was a friendly, talkative salesman who liked to have a good time, but couldn't settle down.

"I think the charm has gone out of my goddamn marriage," Patti told me one evening when the two of us were sitting on the patio waiting for dinner. I had a date that night with a girl who had recently won the "Name the Tune" contest sponsored by a local radio station. She had pretty blue eyes and marvelous plump breasts, only her legs were skinny

like a boy's. She was embarrassed by them and wore slacks, even in summer.

Patti lighted a cigarette and Mother called out from the kitchen that she wished she wouldn't smoke so much.

"You mean to tell me she could hear me click the cigarette lighter from where she is in the kitchen?" Patti asked me.

"I smelled the smoke," Mother called out. Pattie made a face, nodded, and took a long mammoth drag from the cigarette.

"When did you say Dad will get home?" Patti asked me, tapping her cigarette even though it hadn't grown an ash yet.

"Friday," I said.

"God, he'll have a sentimental hemorrhage, seeing me here."

"I don't think it'll come as too big a surprise," Mother called out from the kitchen. "He knows you better than you think."

Patti bobbed her head sideways toward the kitchen and mouthed: "Does she listen in on *everything?*"

I hesitated a moment, half expecting Mother to answer that, too; but of course she didn't, so I just nodded.

"Oh, brother!" Patti said, and then frowned as she took another puff.

I felt a wave of unfocused misery come over me at that moment, watching Patti sitting there smoking and blowing the smoke straight up into the wind chimes that turned gently in the haze without tinkling. They had been made in the Philippines, out of some kind of hollow wood that was so light the slightest movement of air would set them tinkling and gossiping with one another. Sometimes, the sound depressed me, but now the fact that the smoke from Patti's cigarette could rise through them without starting their song seemed even more dismal.

It was a bad time for me. I was having trouble getting it together. Whatever *it* was. You name it. Now I was afraid Patti would start in asking me about Mother.

But she had the decency to seem depressed, too, and she never tried to conceal such things. She'd learned to smoke cigarettes like a gun moll in some old movie on television. No doubt that's where she'd picked up half her mannerisms. Where she'd picked up her profanity, nobody knew; and friends and visitors were always a little impressed by her uninhibited language in front of our parents, who were obviously very proper and middle-class. Why hadn't they ever tried to stop her? They nagged her about smoking, but when she used language that a young lady wasn't supposed to use, they didn't seem to hear a thing. They never mentioned the fact, the way parents ignore a child's physical handicap.

126

"Are you really going to get a divorce?" I asked her.

"I'm seriously what-you'd-call thinking about it," she said, gazing off into the evening shadows.

I nodded, and right then Mother said, "Spaghetti's on; get your hands washed."

"Both of them?" Patti called back. An old joke with her, which Mother ignored.

"Are you going out with Becky this evening?" Patti asked, standing up and dusting some cigarette ash off her blouse.

I told her yes, and then Patti asked if she still always wore those silly goddamn slacks, and I answered yes to that, too.

I took Becky to the VALLEY DRIVE-IN, where we saw two R-rated movies and had two chocolate milk shakes apiece. Once again I tried to get her out of her panties, but she once again fought me off.

"I wish you'd get that out of your mind," she said emphatically, "once and for all."

"I can't help it," I told her. And then I said something that sounded so much like Dad, I was surprised. "I'm a disgusting sex freak and just can't seem to help myself."

Becky reached over and patted my arm. "Don't say that. I know it's perfectly normal, but you know how I feel about it. I don't care if every other girl in school does it, I don't have to be like them."

"You're saving yourself for the right one," I said.

"You don't have to be so sarcastic. It just so happens that I have ideals and I have a goal in life. I'd hoped you would understand, we've talked about it so often."

Well, *she* had talked about it often enough, and now I was afraid she'd start in again. I was sick of hearing about her goal. She wanted to become a medical missionary and serve her church in South America. Her aunt was doing exactly that, deep in the mountains of Bolivia, and Becky idolized her aunt. She would probably succeed, too, because she was a brilliant student and relentlessly sincere. Just the way her aunt had been, no doubt.

Becky said you don't become a medical missionary by giving yourself away to sexual intercourse and either getting pregnant before the age of twenty or messing up your endocrine system and blood pressure with birth control pills. Her aunt had explained everything in a long letter. When I told her there were other ways to prevent conception, Becky asked me to drop the subject, because she considered the very thought of condoms and pessaries obscene.

I don't know why I kept going out with Becky, making myself

miserable, or why she kept going out with me, when she had to keep slapping my hands all the time instead of having an intelligent conversation. Becky and my cussing sister, Patti, were from entirely different worlds, even though our families were much alike.

As for Becky's having something like an interest in me, there was an explanation that struck me then, and still strikes me, as likely, but at the same time mysterious. It had to do with my father, who had once intended to become a minister. Our house had a third-floor attic, and next to the stairwell entrance to this attic was a closet, where a lot of old things were stored, including a saddle my great-grandfather had used as a cavalry lieutenant shortly before World War I.

As a small boy, I'd been fascinated by this saddle, but there was something else in that closet that in later years became just as fascinating: a manilla envelope filled with sermons my father had written when he was in seminary. This was shortly before he'd gotten married, changed his plans, and gone to law school. After several years of private practice, he had been hired by the Interstate Commerce Commission and had remained with them ever since.

His position entailed a great deal of travel, which my mother had never been able to accept. She said she missed having Dad come home every evening, and the fact he did not was part of her problem now, when all of her children except one (me, and now maybe Patti, too) were grown and on their own. Becky knew the whole story and seemed to consider Dad only one step away from having almost become a medical missionary.

After I took her home that night, I stopped and had a beer at a place called Tucker's Rest, where they sold 3.2 beer to anybody who had a half dollar. When I sat there drinking it, I just about decided I would give up on Becky and start dating a girl with low morals. There were plenty around, if the stories were true.

There didn't seem to be any future in my hanging around Becky any longer. I figured prayer and religion were all right—after all, Dad had almost become a minister when he was young—but it seemed to me they belonged in a church. At least that's where prayers belonged.

I remembered one evening after a basketball game when we stopped at McDonald's for quarter pounders and fries, and Becky insisted upon saying grace, right there in the corner booth, with headlights from the cars and the overhead lights shining on us. That was one time I didn't know what to do with my hands, so I just sort of waited until she came out of it, with a radiant look on her face and bit into the quarter pounder with cheese like it was the forearm of Satan.

When I got home that night I was surprised to see the patio blazing with light. Mother and Patti were sitting there talking to each other across the glass-top table where we used to play gin rummy in the summer. Mother's new hairdo looked a little mussed up and she had one shoe half off, with her heel sticking out of it. Her eyes looked blurred, from fatigue, maybe, or perhaps crying. Patti had a yellow pencil stuck in her hair, and on the glass table between them were the remains from two packs of cards, arranged more or less to suggest a long-abandoned game of double solitaire.

Neither one of them spoke, but from the looks on their faces, they might have been about to ask: "What are *you* doing here?"

I said, "I live here, remember?"

Neither one of them seemed to think much of that. It wasn't funny, and nobody thought it was; but more than that, it wasn't even perplexing. The least Mother could have done was complain about my being late. Or to say, thank God I'd gotten home all right. I figured there had to be beer on my breath, so I blew my lips like a horse, as if I was mighty tired.

Still not a word.

"Good game?" I said after a second, sitting down on the porch glider.

"Double solitaire," Mother said slowly, nodding.

"Right," I said.

Neither of them looked at each other. Patti was staring down at the cards, and Mother was gazing vaguely through the screen.

"I'm home," I said.

"And sort of late, if you ask me," Mother finally said.

"Well, you two are still up I see."

"At least you're home safe," Mother said, standing up and stretching a little. Actually, she did look taller, only her face was a little haggard, as she liked to point out. Somewhere in the distance there was a bang, like a firecracker or perhaps a blow out.

"I'm going to bed," she finally said to neither of us, and then left the patio.

After a moment, Patti said, "Well, Sport, did you make out with What's-Her-Name, or didn't you?"

"Why don't you get off it," I said, trying to sound decent, if not righteous. Instead of murderous.

"God knows it's the truth," my oldest sister said. "I'm not much, when you come right down to it."

"That's not what I said," I told her.

She nodded darkly. "I didn't say it was."

I pounded my head with the palm of my hand. "What?"

She closed her right eye in a wise wink and lighted a cigarette. "Do you know something?"

"What?"

"I've always looked over the other ones. I mean, over their heads. To you."

I twisted sideways, lifted my feet up on the glider, and stared at her.

"The oldest and the youngest," she said, nodding at me in encouragement, talking over the heads of our siblings, as if they were there.

"I know."

"You and I are more alike than either of us is like Jan and Terry."

Patti had discussed this idea before, and it had always made me uneasy, giving me a sense of possessing an inscrutable obligation of some sort, without knowing exactly what it was, or what it entailed.

Then it occurred to me that Patti might have been drinking. Maybe a little vodka bottle in her purse, pouring it into her iced tea at lunch when Mother wasn't looking.

"You *are* aware of how things are," she finally said, tapping her cigarette nervously and not looking at me.

"What things?"

She closed her eyes for a moment and took a deep breath. "I'm talking about our mother, for Christ's sake! She's crazy, in case you haven't noticed."

I didn't look at her. "You mean the hair-do and weight loss," I mumbled.

"Among other things," she said in a suddenly airy tone.

"Jesus," I whispered, picking up the tempo from her.

"And of course Dad's been a total loss from day-one."

That threw me and I felt my head whirl as if my neck were nothing but a tangle of loose springs.

"Our parents are both crazy and mismated," Patti muttered. "I figured you'd noticed it long before your time."

"Something's sure as hell wrong," I said, wondering what it might be, exactly.

Patti nodded. "I knew you knew. Maybe you picked it up from me. Jan and Terry could live their whole lives and never find out, but some people just catch on faster than others."

"Terry's always been a straight-A student, though," I said, trying to get some kind of grasp on what was unfolding.

"Jesus," Patti whispered, breathing smoke, "I'm not talking about crap like that: I'm talking about *knowing* something!"

I nodded. Maybe I was feeling the beer. Or maybe Patti was drunk

130

on vodka-laced iced tea. The whole patio seemed to be floating and the lights were suddenly brighter.

"Sometimes I can hardly stand it," Patti said then, frowning.

I started to say something, but stopped when to my utter astonishment I saw tears in her eyes. Thick as salve. But I had faith she would never let them run down her cheek.

Having that evening pretended I knew what she'd meant, I could not find the courage to ask my oldest sister what she had found out about our parents. However, it was evident that something at the center of our lives as a family was turning slowly, inexorably, into something else, which had to be unpredictable. I was vaguely, secretly horrified, but revealed nothing.

When school ended in June, Becky and I broke up. It was she who suggested it, and after I agreed—sitting there beside her in Dad's car, dazed and oddly relieved—it was she who cried and became hysterical.

Why, a voice inside my head asked, if she is this upset, did she suggest we break up?

But later on I decided (correctly, I think) that Becky was weeping not for me, but for the transitoriness of all human connections.

This was the summer that our Mother—suntanned and slender, with a stylish, piled-up hairdo—decided to go into real estate.

"She's always loved houses," Patti explained, "and this is part of her rebirth, if you know what I mean."

I didn't, but nodded anyway. The more Patti assumed I knew, the more imprisoned I was in a cell with invisible bars.

Dad was traveling, as usual. The State of Pennsylvania, and the Interstate Commerce Legislations appertaining thereto, absorbed all his time and attention.

"He's probably got a whore lined up somewhere in Harrisburg," Patti muttered at breakfast one morning after mother had left for the Chenoweth Realty offices on the other side of town. She was planning to take her test in September, and often quizzed Patti and me on such matters as corporeal hereditaments and statutory liens, as if we had mastered these concepts long ago, merely by the fact that we had never been housewives and mothers.

The summer was long and hot, and even though I spent as little time at home as possible, it seemed that there were long lazy periods when Patti and I inhabited the house in boredom and silence. When she was alone, Patti dialed long distance, collect, and talked for hours. I don't think she

131

knew that I was aware of these calls, but I couldn't have avoided knowing about them.

For a while, I assumed they were to her estranged husband—and no doubt some of them were; but many were not. This I found out later, on a hot afternoon in August when Patti was taking a sun bath on the lawn behind the patio. I had just finished mowing and was trimming the flower borders when she spoke to me without opening her eyes.

"I suppose you know the divorce is going through," she said.

I nodded, but she couldn't have seen. As a matter of fact, I'd heard nothing about it. How she could assume I knew so much, when half of me didn't even care, was astonishing.

"Not only that," she said, jerking herself over on her stomach and loosening her bra strap, "I'm going to get married again."

"Swell."

"You don't have to say it like that," she said, fastening her straps again and rising up, back bent, to glare at me.

"I didn't say it like that."

"Well, it sounded like it."

"I mean, terrific. I hope you'll be happy."

"Oh, Jesus!" she whispered, reaching for her pack of cigarettes and shaking her hair loose. The temperature was already eighty degrees, and the day was supposed to get hotter.

I stood there and watched as she lighted a cigarette and then clapped the lighter shut. "They don't know anything about it, yet, and I'd appreciate it if you didn't tell them."

"Okay."

For a moment she was silent, and then she said, "Do you know something? Sometimes you act like you were about nine years old. Do you know that?"

"I do not."

She just shook her head. "There's a reason."

"For what?"

"There's a reason I don't want them to know."

"About your getting married again?"

"Of course, dumb ass! What did you think?"

"If you don't stop talking to me that way," I said, working the clippers, "I think I might bust you one right in the face."

She thought about that a moment and then sort of laughed out of the corner of her mouth. "I guess I don't blame you. Forget I said it, okay? I mean, I've got to talk to somebody about this business."

"If you get married, they'll know about it sooner or later, won't they?"

132

She narrowed her eyes at me and drew on her cigarette. "Maybe. Maybe not."

"You mean a secret wedding?"

"Something like that."

"Why would it be secret?"

"I've got a pretty goddamn good reason, if anyone wants to know."

"People get remarried all the time," I said.

"Thanks for telling me."

I gave the clippers a few fast squeezes. "I don't know what you're getting at. In fact, I *never* know what you're getting at."

"Oh, you know all right."

"Who's the victim this time."

"That's not so terribly goddamn funny."

"Well, who is it, anyway."

"He's an artist. You know, a painter. He paints these big canvases, and if you knew about such things, you'd probably recognize his name."

"Don't bother telling me, then."

Patti frowned down at her knees. "I want to tell you, godammit, but you're not making it very easy."

"I don't know any painters, if that's what you're saying. But I suppose he's got a name, anyway, and if you're going to marry him and tell me about it, you might as well tell me what his name is."

"It's a funny name: Claude Urdang."

"I never heard of him."

"Listen," Patti said, "that's not the point. The point is, they'd never understand. Can you guess why?"

"No, why?"

She snorted a bitter laugh. "It's the craziest goddamn thing you'd ever think of!"

"Like what?"

"Well," Patti said, flicking the ash off her cigarette and closing her eyes, "the truth of the matter is, he's sixty-three years old."

"Jesus Christ Almighty," I said.

"Exactly," my oldest sister said, and then Mother drove in the drive and parked the Oldsmobile crooked against the spiraea, the way she always did, leaving it there as if it had been abandoned in some sort of emergency.

Early in July, Dad was in a car accident in St. Clairsville, Ohio. He was returning from Pennsylvania, and at an intersection his state car was hit broadside by a pickup truck driven by an out-of-work electrician. The

133

electrician was not hurt, but Dad had his nose and three ribs broken, and suffered deep lacerations on his face and right knee.

He came home after two days in the hospital, and Mother nursed him. She seemed to forget all about real estate; but then she hadn't sold anything yet, anyway, so the sacrifice was nominal.

"Jesus," Patti said, "I'd never take him back!"

I had just come home for dinner and I was hungry and in no mood for Patti's conversation. It was a puzzle to me why she was still hanging around, and once or twice I'd almost asked her what she was waiting for. With our parents home now, the long collect phone calls to Claude Urdang had stopped. Or else she was making them from some other place. But I didn't want to ask her; I didn't want to get her started.

"It seems to me I just this minute made an observation," she said before I could get in the house.

I stopped and shook the change in my pants pocket. "Where is everybody?" I said.

"Our beloved mother and father are out taking a walk. It's almost obscene the way she babies him."

"It seems to me you're jumping to a lot of conclusions," I mumbled.

Patti stood up and pointed her index finger at me. "Like what? Like she's thrown everything over the minute he needs her? How about all the time he leaves her here alone in the house, stewing in her own juice?"

"It's his job, for God's sake! What do you expect?"

"Let a single man do that kind of work," Patti said. "It's not for a married man. You know damned well he cheats on her when he's gone all that time!"

"I don't know anything of the sort," I said.

Patti laughed and clapped her lighter shut, having just lit a cigarette. She had been looking at me all the time, and I could tell she saw that I wasn't looking back. She didn't miss anything like that.

"It's part of the male animal," she said in a calm, bitter voice.

"I suppose you're telling me that Carl ran around," I said, rattling my change again.

"Him and every other men I've ever heard of. God, how I hate it!"

"Well," I said, feeling my way, "you've got a right to hate it if it exists, but how would you know? It seems to me there's a lot more talk about it than there is, you know, *doing* it."

She snorted a mirthless laugh, blowing smoke from her nostrils. "Listen to the voice of experience!"

"Well, where do you get *your* knowledge? What makes you think you've been around so much?"

"I'm sick of the whole business," she said, staring at the tip of her cigarette. "I'm talking about sex. Do you know something?"

134

"What?"

"That's one reason why I'm marrying an old man. By the age of sixty-three, it seems to me even a man should have some sense."

"I wouldn't know anything about it," I said. "But that's a crummy reason."

"Sick and tired of it, clear to the depths of my soul," Patti whispered passionately. "Whatever happened to love? Will you kindly give me a goddamn sensible answer to that question?"

My answer was never given, because right at that instant the phone rang. I went inside, picked up the receiver, and heard Becky say hello.

"What's new?" I said, trying not to sound as surprised as I felt.

"Listen," she said, "do you suppose the two of us could get together?"

There was something I'd never heard before in her voice, and my heart slugged twice and then three times, like it was pumping sludge, before I answered. "Sure," I said.

"This evening?"

"I guess so."

"Could you come over to our house?"

"Sure. What time?"

"About seven thirty?"

"Okay."

"My parents are out of town," Becky said. "They're visiting some friends on Cape Cod."

I had been in her house a dozen times before, but never without her parents there. They were even more protective than mine, which was natural, in a way, since she was a girl and they were full of old-fashioned notions. Even Becky admitted it.

She was jittery when she let me in, standing back from the door as if she was afraid of being seen. She didn't look at me, but asked if I wanted a beer or something.

"A beer?"

"Sure. You do drink beer, don't you?"

"Every chance I get," I lied; but somehow it didn't come out right.

She nodded and I watched her go into the kitchen, leaving a cloud of perfume. She was wearing a loose dress, sort of a mu-mu, and I didn't think she was wearing anything underneath. It was a lavender dress, probably her mother's. She left me sitting there on the sofa breathing in her vapors.

I may have had difficulty in understanding the ways of women, but there wasn't too much room for doubt concerning what had been prepared for me this evening.

135

When Becky came back, she handed me a bottle of beer with one hand and caressed my cheek with the other. "Everything has changed," she whispered, and then caressed my cheek again.

"Jesus," I mumbled and clasped her wrist in my hand.

"Not too fast," she said.

"I won't, believe me!"

"Why shouldn't I believe you?" She was frowning and unbuttoning my shirt.

I reached behind her thighs with both hands and brought her toward me. She must have used a half-pint of perfume. Making up for lost time, maybe.

"Drink some of your beer," she said.

Still holding her by the backs of her thighs, I said, "Why?"

"Because I want to smell it on your breath."

I nodded and drained half a bottle.

"Not so fast," she said. She sounded a little choked.

"God," I whispered.

"You won't have to attack my panties this time," she said smiling gravely and tenderly into my face and clasping my head between her hands.

"You're beautiful," I said.

"Don't say things you don't mean."

"But I *do* mean it."

"Did I put on too much perfume?"

"No, it smells good. Honest!"

"It's all for you. You know that, don't you?"

I told her I did, and she told me to be quiet. "It should be the way beautiful animals do it," she whispered.

"That's right," I said, but she shushed me again.

She didn't hold back anything, and acted as hungry as I was, but shortly before midnight we calmed down enough to talk, and I asked her what her aunt would think.

"I don't have the foggiest," Becky said, "but I'll tell you one thing."

"What?"

"I'll have the rest of my life to find out."

"You mean you're going to go see her? Or write and tell her about us?"

She shook her head. "Of course not. Nothing like that. Just don't worry about it."

"I wasn't worried."

"There are other ways to find out, after all."

"Find out what?"

136

"Silly," she said, touching my cheek with her fingers again. "What was it you asked?"

A week later, Patti finally left home for good, having told our parents about Claude Urdang. They were going to live in Tacoma, Washington, where Claude taught at an art school.

Our parents were surprised, even bewildered, but not as disapproving as she insisted upon their being.

I had seen a snapshot of the man she was going to marry, and thought he looked older than God. He was thin with a white goatee. Put him in a tophat and he'd look like Uncle Sam. He had the same stern and righteous look about him. And yet, he looked like an artist, all right.

Becky's family moved to Connecticut shortly after school started in the fall, and of course she went with them. I haven't heard from her since; but I often think about her, which is only natural, and wonder if she'd known she was about to leave, even then. Beyond doubt, she had a need for secrecy, but I am convinced there were mysteries still deeper than anything as straightforward as that.

Patti's husband died four years after they were married. I'd never met him. She still lives in Tacoma, where she works for the State Division of Forestry. It's not a very impressive job, I suspect; but then Patti really doesn't care about such things. I think of her as taking picnics by herself and living a sad and lonely existence in a small apartment with ferns and venetian blinds.

Dad has been transferred to the central office and comes home every night. I've been living and working in Pittsburgh since I graduated from college.

Does mother seem happier? It's hard to say. She has kept her weight down, and no longer pretends to work at selling real estate, although she claims that the experience was worth its weight in gold.

Dad has turned completely gray and is scheduled to retire next year. One day he nodded in Mother's direction as she stood on a chair and lifted some recently washed drapes up to the window valence.

"Do you know what makes women tick, son?" he asked.

I was visiting for two days before going back to Pittsburgh, where I planned to get married before long. My parents had both met my fiancé and seemed to approve of her.

"What?" I said.

"Men," Dad answered succinctly, nodding gravely at Mother, as well as at so much wisdom contained in so few words.

Irrelevant Ideas

Mike Danziger often measured the equation in his mind: on the one side, that fine redwood-and-glass house settled in the exact center of a two-thirds acre lot; that beautiful young woman to call his wife (albeit his second one), a life-style that included the best of everything, from winter trips to the West Indies to a dutiful brace of Mercedes purring obediently on the wide asphalt spread of the tear-drop driveway. All of this, measured against his long and weary hours of toil, his staggering schedule, the mind-stunning fatigue of his business trips to keep on top of the branches in Pittsburgh, Indianapolis, and Toledo.

Not only was his toil acute, it was chronic. Although she was ten years younger, Moira worried about him, and had often told him to slow down, to enjoy the harvest his industry had created; but as it often happens, Mike Danziger did not listen.

Returning unexpectedly from his Pittsburgh trip in July, Mike tried to phone Moira to give her the good news that he was returning a day early. The line was busy, so he decided not to wait and try again but continue on home and surprise her.

Tired, leaving his valise in the car, entering the house, he heard the shower beyond the bedroom going. *Her* shower. He rushed forward, eager to startle her by his appearance. But as he stepped past the bedroom, he came upon a complete stranger standing there, fastening his belt. It was evident that he had just pulled his slacks up, for his shirt was still slightly mussed about the waist.

Three or four inches shorter than Mike and thirty pounds lighter, this man had the astonishing appearance of a hitherto undiscovered species of clean animal. A slender and expensive gold watch was fastened deep in the thick fur of one slender wrist. The wide, hard jaw was darkened by a too-heavy beard; and long black sideburns cupped those

jaws trimly, as if in simian hands. Two pale blue eyes stared back at Mike Danziger with the mute astonishment of someone who thinks he's alone and looks up to realize that another is watching him. Even his exit, for all its swiftness, had a muted air of belated realization, as if this clean, small, feral man had only just discovered he was late for an appointment.

From Moira's distant bathroom the shower continued to run, suggesting heat, steam, and healthy female cleanliness.

When he recovered from that first wave of incredulity, Mike ran after the man, but by the time he reached his still-warm Mercedes in the driveway, he could hear an engine starting up beyond the shrubbery. And at this instant he vaguely recalled seeing a care parked by the side of the road, just before he'd turned in the drive; but at the moment he could not remember anything about it.

Slowly, he turned and stared at the house, knowing that somewhere inside, Moira was still showering. This would no doubt prove to be one of her thirty-minute showers with the massage head. He could see her dear clean face shining under her shower cap, her eyes huge and glistening. A steamy aureole would surround her warm, supple body, as if were as entirely radiant as the head of an angel.

Contemplating this scene, Mike Danziger climbed back in his Mercedes and drove it slowly out the driveway, and down the street in the direction his wife's lover has just taken. He did not intend to follow him, for he knew it would be impossible to catch him now. He knew that this man would have traveled beyond reach. Rather, he simply drove away, trying to get things together in his mind. Trying to figure out what had happened, and how and why it had happened.

Getting control of himself, he drove slowly and deliberately back to the highway he'd just arrived on only a few minutes before. Somewhere inside the raging of his emotions, he was able to start sorting out priorities and devise something like a plan of action. Meanwhile, he drove and drove, like a man sleeping under water.

At eight o'clock, he decided to stop in the lobby of a Holiday Inn and phone her, pretending he was on his way home and wanted to let her know he was coming. He rang his home number and waited. The phone buzzed twice, then three times. A sudden cascade of laughter came out of a nearby cocktail lounge, and Mike Danziger glared at the entranceway, forgetting that he himself had often been the loudest laugher of them all in such places.

Six rings, and then seven.

Obviously, she had gone out in the other Mercedes. Perhaps she

139

was loking for *him,* whoever he was. What would his name be? Tim, Mac, Jerry?

Frowning, Mike replaced the receiver on its hook and tried to imagine in which direction her search for her secret lover, that son of a bitch, would take her.

But of course, this was futile. The man had been reasonably good-looking—fit, trim, well-groomed—and he had been wearing expensive clothes. So on the surface, at least, there was nothing wrong with Moira's taste.

The surge of wrathful confusion in his head almost made him dizzy, but once again he got control of himself. Two men walked by, headed toward another gust of laughter from the bar. Let them go; let them go.

It was probably a good thing that she wasn't home. He realized that, now. He wouldn't have been able to keep control of himself. At that instant he realized that there might be a much better way to handle this business. A much subtler, more effective way.

Yes, it was a good thing she'd gone out in the other Mercedes, in search of her lover boy.

Mike Danziger nodded and walked over to the registration desk and signed his name. He had a hard night's thinking ahead, and he wanted to get started.

The next morning he was on the phone for over three hours, taking care of a dozen problems with his business. At twelve-thirty, he went down to the lobby shop and bought some bathing trunks. He took a brief swim, sunbathed for half an hour, and then had a vodka on the rocks, a cold turkey sandwich, and a pot of black coffee at a shaded table near the pool. After that, a good cigar, maduro but mild, which he made last a half hour.

Back in his room, he showered and napped. Then he was on the phone for another hour, during which time he came to the decision to fire one of his retail managers, who was giving pretty clear signs of moving on to another company. ("Defecting" was the way Mike thought of it.)

At four o'clock, his body felt good—pleasantly tired and sleepy, but full of sunlight and influenced by the rich comfort of having done a good day's work. It could almost have been like any other day; and in the contemplation of this fact, Mike began to feel a good old-fashioned strength and pride in himself. He was in control. He now knew pretty much what he was going to do, and he knew that he could do it. Remain in control all the way.

He went downstairs to the lobby, and walked over to the same pay phone he'd tried to use last night. He hadn't wanted to use the phone in

his bedroom. Because he looked upon that as his business phone, and what he was doing now was a different sort of thing.

Getting the coins out of his pocket, he laid them beside the phone and dialed his home number. It rang three times, then four. A roar of laughter almost identical to that he'd heard the evening before came out of the bar. The same dreary old actors in the same dreary old parts. Then Moira answered.

"Did I get you out of the shower?" Mike asked.

"Oh, no."

"I thought maybe you were taking a shower, when you didn't answer right away. You know, one of your long ones."

There was the barest hesitation, and then she said, "No, I was out on the patio having a cup of coffee."

Liar! a voice shouted in his mind. But his own voice was perfectly calm. "Listen," he said, "I'm at the Holiday Inn at Winthrop. I just stopped in to tell you I'm coming home tonight. I just thought I'd let you know."

"Why you're almost home now," she said. Was that actually a pretense of pleasure? It was hard to tell.

"I'll be there in an hour," he said.

"Oh, I'm so glad. That'll be lovely!"

Liar! the voice cried again, but Mike Danziger remained silent and hung up the receiver and closed his eyes. Another roar of laughter came from the cocktail lounge, and the voice inside his head cried, *Filth!* and Mike Danziger muttered, "Shut up!" precisely as a man and woman passed by silently.

But he didn't turn to see if they'd heard or what their reaction might be. Instead he went outside to his Mercedes, got in, and started driving home.

"We'll try it once more," the voice said calmly, "and see what happens *this* time."

Mike Danziger's homecoming was normal in every way. Not a hint did he give Moira that he had come into the house the previous afternoon to face the incredible fact that she had a lover. On the other hand, not a sign did she give that anything was wrong, or that she suspected anything at all, or was hiding anything.

It so happened that Mike's routine was a rotating one, and now he had several weeks in his base office, coming home every evening to be met by a dutiful, domestic Moira, bearing a frosted, silver cocktail shaker and frosted tumblers on a matched tray that her aunt had given them as a wedding present ten years before.

Often during his day at the office, Mike would wonder how It

141

would be revealed. Eventually she would have to break down under the knowledge that *he knew*. Moira had never been either cool or insensitive; she was always the first to give way to suspense when it came to a riddle or game of some sort. She had a vulnerability that was sometimes almost comic.

And yet, at the end of his first week in town, he had to admit that she hadn't given the least sign that anything was bothering her. But what must she be suffering inside? Now *that* was a different matter! Occasionally Mike's fantasies concerning her silent agony verged upon the obscene, and he forced himself to stop thinking such thoughts at the cost of his belief in his own decency. And yet, in spite of such adjurations, he settled quite comfortably into the conviction that—whatever the outcome—his decision to handle this business in precisely this way would prove to be perfect.

During those first days he learned to watch her closely, and in this newly acquired attentiveness, he learned a great deal about his wife that he realized could not have been learned in any other way. Every gesture, every possible nuance of expression, every word choice was now plunged in meaningfulness. Not even their most trivial interactions were spared.

Early one evening he stepped on a piece of glass from a broken bottle behind the patio and cut his foot. This was on a Saturday, and he'd been sunbathing as he studied override reports. She went to get the Mer-thiolate while he propped his bleeding foot up on the stone wall that held the flower borders.

"You really should wear your Italian sandals," Moira said, frowning prettily behind her sunglasses as she wiped the blood away with a Kleenex.

"In my own yard?" he asked. "What I'd like to know is how that piece of broken bottle got out there to begin with. You'd think a man could walk in his own yard without risk of bodily injury!"

She blew on the cut and said, "Oh, don't exaggerate!"

"I'm not exaggerating," he said. In contrast to what he was saying, his voice was so calm it sounded almost lazy. "Frankly, I find that surprising. A *little* surprise, I'll admit. I mean, nothing to lose sleep over. But surprising. It's not like you. *You're* not sloppy. And I haven't been around that much. *I* certainly didn't break a bottle out there."

She looked at him closely. "What's the *matter* with you?"

"Nothing. I just find it all very odd."

"Things get broken all the time," she said, dabbing the cut and then

blowing on it. A curl of her hair fell forward and touched the rim of her sunglasses as she blew on the cut. She blew on it long after it had stopped burning.

When she applied the Band-Aid, he thanked her and said, "Apparently someone just broke a bottle out there, somehow, and didn't manage to clean it up."

She looked at him and said, "Will you please forget it? Who knows how things get scattered around? Maybe it dropped out of the garbage can when the garbage men came last week!"

He held his hands out wide. "What would the garbage men be doing back that far out on the lawn?"

"I have no idea," she said, turning away and gathering up the bottle of Merthiolate and the can of Band-Aids.

"Maybe a wild party one night when I was on the road," he said, smiling and winking at her. But she evidently did not see the wink. Nor did she say anything at all, but simply went back into the house, walking (he almost imagined) as if she had only a hazy sense of direction.

Beyond doubt, Mike Danziger was learning things about her he'd never known. There was almost a kind of courage, even perhaps an air of decency about her—in spite of what he knew. He couldn't have explained it; but he sensed it, and had too much courage and decency himself to pretend he didn't.

Even her appearance semed altered. She was a beautiful woman, beyond anyone's doubt; and yet there were little anomalies, little imperfections that brought her into focus as sharply as if all their married life he'd been watching her from a great distance through binoculars that were slightly out of focus, and now with the slightest twist of the lens, her face had jumped into a startling clarity.

For example, her big cool gray eyes that everyone so much admired: when she'd doctored his foot and looked up at him in anger at his insinuations, he noticed that they were just a little too close together for utter perfection. And already there were sharp, if delicate lines bracketing that pale sensuous mouth that had first attracted him. Had these lines been there before, without his noticing? Or had the strain of her last few days somehow tensed the muscles in her face, making them appear?

These were questions that intrigued him, as well they might. As for the episode with his cut foot, however, he was honest enough to realize that she probably had no more idea than he where that shard of broken bottle had come from; but he told himself that to a guilty mind there is no such thing as innocence.

Another weekend was approaching, and she had not given a sign. Nothing. Lying half-asleep in bed one night, Mike began to think of her secret as blowing up in her, making her expand like an enormous Moira-featured balloon. It continued to expand to a sound of relentless pulsatile hissing as some kind of pump continued to fill her with an expanding gas—something like an unexpressed truth, perhaps.

More and more she grew. Her features disappeared into faint little dimples and puckers in the increasingly transparent integument of her skin. Surely she would burst with the enormity of her secret. But no, she just kept getting larger and larger, filling the house—her delicately tanned, smooth, admired skin as tough as a rattlesnake hide or tougher—as tough as truck tires, even though it was now thoroughly translucent from so much stretching. Then Mike turned over and her bloated image disappeared.

Although this had been the most sustained, most grotesque fantasy, it was connected with a hundred impressions of her ordeal, and—no matter how hard he tried—Mike was unable to ignore the feeling that the coming of the next weekend was somehow climactic, that she would *have* to give way or explode, because it was essential for him to go to Pittsburgh next week. He couldn't put it off any longer, at the cost of grave risks to his business.

On Saturday morning, she played tennis with three women friends—sorority sisters from long ago. He found an excuse to phone her at the club, saying he had to run down to the office for an hour or so, and he wanted to let her know.

She was there—that was the main thing. She seemed a little surprised that he should call for such a trivial reason, but that was all right, too. They both returned home after lunch, and he went out in back to work in the yard. Such work gave him a deep, earthy pleasure, and she seemed to like to sit on the patio and watch him from behind her dark glasses.

While he was working, he once more tried to think of who her lover was. His face had been totally unfamiliar to him. Where had she met him? How had they gotten together? For all her wretchedness in this business, he couldn't believe that she would just pick up with any stud and go to it. She surely had to be courted in some way. But when? How? Where?

By three o'clock, he was thoroughly cooked and dehydrated by the sun, so he went inside and showered and cleaned up. When he came back out on the patio, everything was peaceful: the smooth shadows from the arborvitae lay upon the lawn with the patience of early evening.

Moira hadn't heard him come out. She was lying on a white plastic reclining chair, her arms and legs fastidiously together. Not hearing him return, she seemed as remote as a mountain. She really was lovely, he thought—delicately strong and feminine. Yes, strong was the word. How was she able to endure knowing that *he might know?*

For perhaps ten seconds he stood there looking at her, and then he saw something that shocked him: a small tear spilled out of her eye and eased slowly down her cheek. She reached up and wiped it away with the back of her hand, not bothering to open her eyes.

Even though it must have been something like this he had been looking for, Mike was nevertheless surprised; and he quietly walked away, leaving her there alone on the patio.

And then, one day at work, Lucille Wagner phoned. At first irritated, Mike Danziger soon began to sense that Lucille—for all her legendary gossiping and nosiness—had something important to tell him.

"Could we have lunch together," she asked. "Just the two of us?"

"Is this a proposition?" Mike answered, laughing.

"It's something we really have to discuss, Mike," she said, after a moment's pause.

"Sure, how about tomorrow."

"Can't it be today?"

"What's the hurry?"

"I'm afraid I'll lose my nerve. I've really got to talk to you. Can't you make it today? Can't you arrange to meet me at Helm's?"

Inside his head, Mike heard his own voice saying, *For Christ's sake, make it today!* He asked Lucille to wait a minute and then he checked with his secretary and nodded as he spoke into the phone. "Okay. I'll have my secretary cancel a lunch I had with some people."

"Thanks, Mike," Lucille said.

Later, he would think back upon that time before lunch with Lucille, and he would wonder if he had already suspected that what Lucille had to tell him was about Moira. And as hard as he tried to dismiss the idea as nonsense, he was never able to believe otherwise; and he seemed to remember himself sitting at his desk, staring blindly at papers before him, paralyzed with the realization that Lucille *knew,* and that she was going to tell him that very day, over their lunch at Helm's Garden House.

He was determined not to lose control, not to get there early and find himself sitting at a table alone, waiting for Lucille Wagner. So he walked into the restaurant several minutes late, and saw Lucille at a table,

a well-groomed but rather hard-looking woman, smoking a cigarette and staring out the window. A half-finished Gibson was on the table before her.

"Am I on time?" Mike asked, pulling his chair out.

But Lucille didn't answer, she merely nodded, and waited with obvious impatience while Mike ordered another drink for her and then a martini for himself, and salad for both of them. "Keeping the calories in their proper place," he said.

She nodded vaguely and drank. When she put her glass back on the table she stared at him and said, "Mike, I love you and Moira. Both of you!"

Mike nodded, "Hell, Lucille, we love you too."

She shook her head. "You're making conversation. You're saying the right thing. But I'm not talking about that. I'm talking about needing people, feeling close to them . . . feeling that what they are is what the world's about. And not having anybody under the sun any closer. *That's* what I mean."

The waitress brought their drinks and Mike sipped his martini. "Maybe you'd better explain."

She shook her head. "God knows I'll try! What this has to do with is . . . well, you and Moira never took sides when I had my divorce, but you never cut me out, either. You were both perfect in just about every way. I don't know how two people could have been better friends. Moira first, maybe; because we're both females and, you know, do things together, the way a man and woman can't unless there's something else between them. . . ."

For a moment she paused, and then she said, "What I mean is, I owe the same to you. Both of you. I'm not taking sides. I love both of you, as friends, and I want you both to be happy. At least, as happy as possible. I owe it to you, and I intend to do everything I can to help out."

Mike threw some salted cashews in his mouth. "Take sides regarding what?"

"I think you know," Lucille said. "I don't know *how* you know, but I think you must."

"Know what?"

"Oh, God, are you going to make me say *everything?* Jesus, maybe you *don't* know! Moira has told me everything, Mike. I guess you know she's been drinking, and we've all been worrying about her. And she doesn't know for sure whether you've figured it out or. . . ."

Mike gazed out the window. "So Moira doesn't know whether I know or not. What are you trying to say, Lucille? Come out with it. Tell me Moira's having an affair. Go on!"

146

Lucille looked away and nodded. "Thanks. I'm glad you didn't make me do it all. I'd like to ask how you could have found out, but I won't."

"No, don't ask that."

The sudden coldness of his voice made her glance at him. She swallowed and nodded again. Then when she spoke, her voice was even more hoarse than usual. "I don't know how you're taking it, Mike, but I hope you're okay. I mean, people can't help but have problems. Everybody. And I hope you can somehow forgive Moira, because. . . ."

Belatedly, sounding oddly a little drunk, he interrupted, saying, "Spare me the philosophical observations, okay?"

"Sure. But it isn't as ugly as you might think. I mean, sure it's ugly, all right, but so is Moira's . . . well, her *loneliness.*"

"Oh, shit! Don't try to defend her with that!"

"All right, maybe there isn't any defending her. And I can see you're not about to listen to anything I say. Or at least to anything that has to do with my opinion. But I'll never be able to live with myself unless I tell you something, even if it doesn't do any good. Will you listen?"

Mike shrugged and stared out the window. "Since I'm here, why not?"

"All right. Here it is. Moira met a man while you were gone. He was from out of town, just staying here for a few weeks. She met him at the country club, during her golf lessons. She didn't know anything about him, but he was nice to her. I honestly don't think she had anything in mind, but I could see it happening. Because I've watched her going slowly crazy with you away all the time, Mike, and her left there in that big house with all that money and nothing to do but gossip with broads like me and take golf lessons and. . . ."

"Get on with it," Mike said.

"So they got together. And then for some reason, he just disappeared. I didn't find out about it until I saw that something had happened to Moira. And she said she had been terribly ashamed, because the two of them were half drunk and just this once she'd brought him to the house, and they'd, you know, made·it on the bed and she'd gone to take a shower, but when she came out, *he was simply gone!* He'd vanished. Thin air."

"You have a fantastically big mouth, Lucille!"

"I really don't care what you think about me, Mike. I know it sounds crazy, but I've got to tell you this."

"You're also drunk. Tell me you're not drunk!"

"I'm not, although I've had enough to be. After I tell you, then I'll get drunk and it'll be out of my hands."

"Tell me what?"

"That she's going crazy. It isn't that she loved him or anything. I don't think she did. Or does. Although who could tell about something like that? Maybe not even Moira. But what got to her was that she should do something like that which she was so ashamed of. . . ."

"Bullshit."

" . . . that she was so ashamed of, and then to come out and find the man gone, so that it was all like a dream, because. . . ."

"Because what?"

"Because she wasn't able to find him. When she tried to get back to him, he'd checked out of the motel. And when she tried to find out what company he was with, she found out it was a fake name, so that she didn't have anything to go on. I mean, she came to the conclusion that even the name she had known him by was made up. And he'd completely totally disappeared."

"An extremely touching story. I'm about to cry."

"I can understand how hurt you are. But let's be honest: you have something of a reputation, I guess you must know; and if you're going to play the part of the wronged innocent. . . ."

"Do you honestly think I'm going to stay here and listen to shit like that?"

She reached over and grasped his wrist. "I'm sorry! I promised myself I wouldn't say anything like that. I don't care what you have or have not done behind Moira's back. Just let me tell you what I have to tell you. Okay?"

"Go ahead."

"She's out of her mind, Mike. Maybe she does love him, without realizing it. But this thing that happened to her was so spooky and so terrible and inexplicable that it makes her guilt all the worse. I'm really afraid for her."

"If you ask me, she's always been crazy."

"Mike," Lucille whispered, "can't you see what I'm trying to tell you? I'm trying to tell you that Moira might kill herself."

"I don't believe that for a moment," he said. But he was lying, because he suddenly, at that moment, knew very well that Lucille was absolutely right.

The Gurneys, the Havilands, the Prices and the Weinstocks were all part of the annual charter. Their plane left for the Bahamas the second week of February, as it did every winter, and all of them played golf and swam and drank and played cards, and there was even a little fooling around,

for those couples that approved of that sort of thing (the Havilands were usually the instigators).

Most of them were square, comfortable, middle-class, however. The Danzigers were known to be of this sort, and that delicacy and tact which guides people to seek out those like themselves left them to their own quiet ways and undisturbed socializing (with only a mild indiscretion of flirting or overdrinking to mar the placid surface of their behavior). The divorce rate of these others was predictably high, and afforded the more conservative group with enough gossip to sustain them between their swimming and golf and cards and cocktail parties.

Mike Danziger continued to watch over his wife with an attentiveness that he had never before brought to bear on any but business matters. Never had he paid so much attention to another human being. And he was aware of his awareness, part of him helplessly watching himself as he watched Moira every minute they were together.

He remembered an old professor of literature he had had as an undergraduate, who had told the story of a famous nineteenth-century scientist, whose name Mike could not remember. This scientist had given a small ocean fish to one of his students and had told him to study it and learn all he could about it without referring to a book. The student studied the fish and reported what he saw to his professor, but the famous man said he hadn't yet seen enough. So the student went back and to his surprise found that the specimen was able to give much more information than he'd thought possible. But still his teacher was not satisfied, whereupon the student went back, only to discover things he could not have believed he'd first missed. And so it went, on and on. The professor of literature said that a good poem deserves such attentiveness as that; he argued that almost any message—even one that makes no claim to intensity or literary value—will reveal depths and mysteries to a mind prepared to receive them.

Why this laborious parable should come to Mike Danziger at this time was hardly a mystery: Moira was his fish, and in spending so much time looking at her, wondering about what went on inside her head, he was beginning to see things that he might never have discovered in any other way. The discoveries he was making were by no means happy ones; some of them were profoundly disturbing, especially those that had to do with his growing conviction that not only was Moira physically more complex and more beautiful than he had taken time to remember, but that she was heartbroken, sad beyond all conversation . . . presumably yearning for that son of a bitch who had scored with her in their own bedroom and had then evaporated like the palest dream of a love-starved woman.

149

Near the end of their week in the Bahamas, things seemed to go flat for all of them. Everyone had noticed the change in Moira and asked questions; but the answers were all vague, oblique, dreamy, and soon they stopped asking. Carl Page fell on the swimming pool apron and broke his collarbone. Sissy Weinstock was having nightmares and couldn't stop talking about them to whoever would listen. A gauzy film of cloudiness permeated the air, giving a vague suggestion that pollution from Miami and Havana was beginning to poison them.

So far as Mike Danziger was concerned, Moira was at the heart of all this unfocused discontent. There was truly something unreachable in her. Had she always been like this? How could he have known if he had never tried to reach those depths that now absorbed him?

His golf game had gone to hell; but no one else was playing well either, so his ineptness went unnoticed. Ken Vittori said that he'd never seen a group so despondent, and he devised whimsical theories that the Russians had bombarded the western hemisphere with a depressent gas whose symptoms were fecklessness, seeping horror, and terminal boredom. He played with this notion, elaborating upon it until his wife said if he didn't drop the subject she was going to drown herself. Nobody seemed to think any of this was funny and they listened with the numb detachment of high school students in an auditorium being instructed in schedule changes.

In these last long, dry hours of contemplation, Mike Danziger wove his own fantastic theories, one of which was that it was Moira, not the Russians, who had poisoned all of them. Only she had done so unwillingly, incapable of absorbing all the yearning and love she felt for some strange man without a name.

He kept thinking of that professor in college. He had been famous, in a way. And he did have a strange sort of eloquence when he applied his unquestionably brilliant mind to the various irrelevant ideas that seemed to fascinate him. Mike couldn't remember his name, but he could remember his mannerisms as he lectured and remember some of the ideas he dwelt upon. He had written a book on the idea of love in western civilization, and this was a survey course he was giving for students from every college and department.

Mike was a senior in Business Administration with almost a straight-A average. He had served a term on the student senate. He had developed a taste for excellence; already he was determined to be somebody special, somebody important. He knew he would be rich some day and be married to a fine and beautiful woman. All of this was a certainty in his mind. And since he had always admired the first-rate, no matter what it

was about or how it was expressed, he sought out this professor's course and took it as an elective.

For years that old man's ideas had not entered his mind, and yet now they seemed to dominate it. Not only the idea about the famous scientist and the student with the fish, but another idea he had dwelt on—that modern notions of Cupid were not at all like the original image of the god of love, which was that of a deity of more awesome, less comprehensible powers . . . a god who was capable of bringing terror and destruction into human life.

Studying his thin, pale, half-crazy wife, Mike Danziger could not help but think of this now. It was almost as if that old professor had been talking to him, at this moment, through the intermediary of that smart-ass senior who showed such clear evidence of future success. And what he had said had passed into the memory of that cocksure boy, without rippling the surface of his self-satisfaction. Now, it was surfacing for him to think about, aware that the message was so strange that he could hardly believe he had not dreamed it rather than heard it from the mouth of that dim old campus celebrity years before.

And there was this other emphasis, too; that western conceptions of love all had to do with the idea of the Unattainable. Of course this was true. Mike Danziger studied his wife and wished vehemently that she could have gone off with that furry animal for a few days so that she could have been disillusioned.

But then, just as quickly, he took it all back. For now it was all too obviously reversed.

And while they sat in their charter plane, ready to return, Mike Danziger thought about what Lucille Wagner had told him; and he realized once again how accurate her fear and judgment were, and for an instant he wished that Moira would go ahead and kill herself; but then he took that back, too, horrified by the implications of it, because he had gotten this one fortuitous glimpse into her crazy mind. And now, God, what would he ever do without her!

The Tree Beyond

There is a world other than this one, and she has spent much of her life thinking about it.

Where does she become herself most insistently? It is before the old dented sink, where her mother and grandmother stood in their private generations before. Her two feet occupy the same place, even though the linoleum has been replaced twice within her memory alone.

How often, she asks, do her feet and those of her mother and grandmother fit in precisely the same allotted areas? She is taller and heavier than both of those other women, and yet in a way they are larger than she. In absence, the dead increase in size. And thus it is that sometimes it almost seems as if she has never once ventured outside what they were or might somehow, given time and access, have told her about.

But this is too humble. Things, her husband has said, are meant to convey the real world, which is this one. When her husband speaks, her mother and grandmother silently retire—without reproach or surprise—back into that lasting other room that is dark during the day, but always light enough to see, and never darker than it is at night.

This room exists in that world other than this one. She has never entered that room, nor of course has she even seen the outside wall, or the actual building it must exist in. But it is there, nevertheless. It is conceivably where the dead go when they die, in which event we will all be visitors there some day. She pictures it as a cold parlor with ferns in copper kettles, and the sound of a clock ticking the silence away.

It is also a place we know about more clearly when we dream. Not actually see, but come nearer to understanding. Several times, neither dreaming nor even intent upon such thoughts, she has been surprised by the distant sound of her grandmother's old ash rocker. And once or twice

she has heard her mother very softly call her name: "Edith! Edith! Where are you?"

Can the dead be troubled? No, surely not. Therefore, the question must have been imagined. All that was certain was that her mother was whispering her name. Edith. Edith.

How many women have stood in a place similar to that where their mothers stood? Not so great a number. How many fewer, therefore, can say they and their mothers have both stood in that very place where the One Before stood?

The house was passed down to her, like a comfortable old coat or hat. It has been passed down twice, since Grandfather Weston built it with his own hands, helped only by his deaf mute brother who years later died in a fire in San Francisco during the great earthquake.

How many, how many!

It is exactly 481 paces to where the oak tree stood on the rim of the hill. Her husband, driven to the end of his patience, shrugged on his mackinaw and paced it off one day (even though he had a bad head cold), for she was always *at* him, wondering out loud exactly how far it was from her kitchen window.

"What difference does it make?" her husband had asked, pinching a cluster of Mail Pouch and lifting it like a glass of rare wine up toward his mouth.

The answer to this could have been: "We live in a world of proportions and distances; I want to know exactly how far away it is, when I stand at my window and look at it three times a day."

Surely, this was reasonable.

Might he have answered (if she had really answered his question, instead of merely rehearsing an answer in her head) that her mother and grandmother both were content without knowing what that distance was?

In which case, she would have said: "How could we ever *know* they didn't know? How do we know they just never *said?*" Or perhaps *did* know, and took comfort in such certainty?

Actually, Edith and her husband had seldom argued during their life together. Much was implicit in this peacefulness, and it might well have been otherwise. Certain questions can always be unearthed to poison the air in any marriage. The tacit agreement between them to leave such issues alone . . . was this an evasion or a sweet and humble wisdom?

Even this question could prove divisive and destroy all their strategies for decency and happiness. The important fact was, they took

themselves in hand and *made do*. They looked at each other and refused to imagine otherwise, and said in their deepest monologues: If I don't find love and fulfillment here, with what I've got in myself and in the one I'm married to, I don't have a chance.

So they had raised three girls and two boys, and now these children were all grown and living away, living in the different world of the present—which made them older in the world's time—so that she was now finally free to think long precise thoughts about herself and her mother and her grandmother. The ones who had gone before. Who had *been* before. She could think about standing where they were. Or had been.

Eventually, he had given in to her silence and put on his mackinaw and paced the distance off to that landmark, and she watched his strong thick body moving through the harsh gray October stubble until he became a small clot of darkness beside the huge old oak tree with the wildly crooked limbs, troubling its massive configurations only a little with his presence. A quarter of a mile away, just as she had thought. She had said this a dozen times, even though women aren't supposed to have the sense of distance a man has. But she wasn't troubled by such crude proprieties. A quarter of a mile.

Had he turned to look at her after that journey outward, to face her as a man looks at the utterly mystifying: the bawling of a troubled cow when there's nothing to hear, or the passage of time, or the distant look in a dog's face, as if he is trying to count something, but can't find the numbers in his head?

In remembering that time, she could not recall his returning. Clearly she remembered watching him walk away from her window, going directly toward the tree (in a way she would not have thought of approaching it), his body rocking strongly back and forth as he went away from her. His head was bent, looking at the soil. And yet, he knew exactly where the tree was. His course didn't drift one degree from its destination.

But she couldn't remember his coming back to the house. It was almost as if (in her memory) he had walked to that tree on the horizon and then had simply stepped beyond, falling off the earth, into space. Gone forever. And yet, appearing once again in her warm kitchen—which fact did not change that other one, for now it was as if he had never left at all, and even his sturdy, honest counting of 481 paces was nothing but a wild guess snatched from the lint of some dream.

Certainly, he had resisted doing something so pointless, something that *didn't count*. And the truth was, she was sympathetic to his view. She even said so. But when she began to advance arguments for his not doing something so silly, his look changed right before her eyes. It was as if he

was hearing all the words she was not saying, and it was these utterances that were unanswerable, so that he'd gone over to his mackinaw that was hanging on the hook beside the kitchen door and started to roll down his sleeves before putting it on.

"Don't pace it off *now*," she'd said. "Wait until you're over your cold." But he'd just looked at her, and then picked up his mackinaw, flooding her with a guilty peace.

"It's on the horizon," she'd said once.

"That's not the horizon," he'd said. "That's just the rim of the hill."

"There's nothing but sky beyond it," she said. "Why doesn't that make it the horizon?"

He thought about her question a moment, looking troubled. Finally, he said, "Just what's the matter with you lately?"

His saying that pleased her, although she had no idea why it should. She smiled at the question, and was content not even to think of answering . . . although later, she realized what a dangerous thing this might have been for her to do. She really should not have ignored the question, because for once he was almost in touch with what bothered her, with what *touched her*. He had almost come to her world, in a manner of speaking. Maybe it seemed like a dream to him. She couldn't tell, but she promised herself she would begin to think about *that,* too.

"How old do you suppose it is?" she asked one day.

He said he had no idea, and shook his paper as if that might frighten her thoughts away like so many robins in a cherry tree.

"Two hundred and thirty-seven years," she whispered.

"What?" he asked, lowering his paper.

"It is two hundred and thirty-seven years old," she said calmly. "I feel it."

"I suppose you think you can count the rings, already," he said, narrowing his eyes. "Look right through the trunk and see them circled there, from all this distance."

"Four hundred and eighty-one paces," she said, nodding.

He gazed at her like a man looking into an open fire.

She half nodded and half smiled. It was only later that she realized how fearful his sarcastic comment was: for he had used the word "already," and therefore, at that time, also knew.

Thinking back, she understood how she could have known with such certainty. Or even if not known, could have felt this certainty, which was after all the essential thing. As a girl of twelve, she had swallowed part of the moon, and therefore had lived with this clock inside her body all

those months and seasons since. Along with the counting of her breath and pulse beat, this slow turning over every twenty-eight days in another kind of calendar that was of another world—hers alone—wearing the numerals like borrowed insignia and medallions. All of it, counting. Counting.

Now remembering, she could not precisely locate that other dividing line, created by the news that her husband had brought to her. She could not distinguish when it was she had learned that the divided Interstate highway was going to pass right beyond the rim of the hill, and the oak tree would have to be cut down.

"Interstate," she said to herself, listening to the sound of the word.

This also was in a cold, gloomy October, and the bulldozers started to groan day and night, just over the rim of the hill, beyond the last perspective of land, out of sight. A yellow glow, shimmering with dust, like the ghost of lemonade, filled the sky beyond, making the oak tree look even stranger, more crooked, and, in spite of the distance, vaster than usual.

Not once did she complain about it. She didn't even mention to her husband that now she would look out her window in a way that her mother and grandmother probably could not have imagined, for that old tree had always been there, like a ragged nail to stab and fasten their dry loneliness on.

As with all deaths, there was a sly mixture of excitement in this one, for when the familiar departs—even if it is beloved—we are made to step into a new room that is clean in a way that no room has ever been before.

In the winter, when the wheat begins to grow and soften the contours of the land with a green haze, she sees once again the old forms made by the pattern of erosion.

This, too, has changed; but it has changed so subtly that there has never had to be anything in the way of adjustment. Even the rim of the hill—her "horizon"—will remain the same, untroubled by the ponderous metallic monsters that still trundle growling, night and day, on the other side.

Once her husband said, "Edith, how come you don't come along and take a look?"

She remembered that he'd already asked her several times; but *this* time was almost like the first, because she really thought about his offer, and didn't simply shake her head no.

But after an instant's thought, she said no, anyway.

"Why not?" he asked.

156

Again she smiled. "I remember how it used to look when I would walk to the horizon."

Something made him angry. "Don't start that again," he said. "It's ridiculous to call it that. It's just the rim of a hill, and you know it."

At that instant she came dangerously near to trying to explain it to him: nearness doesn't carry truth with it. Why should a closer view be truer than a distant one? What truth can be said to emerge simply upon coming closer to an object, when it changes before your eyes?

The softness of grass is part of distance, for when you come closer, you see that it's harsh and stiff, and if you put a baby down in it, its legs will be scratched. But this, too, is only an impression, and it does not supersede that other.

Thus she knew that the oak tree would grow larger and coarser with each step if she approached it, and the distant fact she had hung so much of her looking upon would be made to appear an illusion. She had no need for such a false revelation; she had no prurience in that way. She had told herself that she would always refuse to let the superstition of the eye dominate the vision of the mind.

"I'm the third one," she said.

"Now *what* is that supposed to mean?"

"Mother and Grandmother used to gaze at that old tree. Every blessed evening, while they washed the dishes, they'd look out and see it."

He nodded grimly. "We shouldn't ever have decided to come back here to live," he said.

As for her part, she said nothing.

What the land looked like, as it stretched to the right of her view, was . . . well, it looked like part of a woman's body. The line of hip, the start of a leg—both perfectly evident . . . at least on the lower slope, although the upper was a simple, gradual, smooth ascent, as if that part of her flesh had melted into the dark earth.

Then, with astonishing lifelikeness, there was the swerve of loin and what she thought of as a perfectly formed breast (this was on the upper slope, her other side). And then, no head, of course: just a rumple of folds that gathered to follow the south hill up to the rim of hardwood trees beyond an old tangle of rusty fence that a neighbor named Alonzo Sherman had built years before.

God knows what this would have looked like if she had gone over there to stand in the midst of that figure, allowing one illusion to replace another.

Directly in front, there was only the long swell of the earth up to that rim. The heavy machinery was gone, and the workmen had departed. Other ceremonies of construction were now awaited. The road bed, her husband had told her, was completed.

Also, as she did not mention, but noticed every time she stood at the window, the oak tree was missing. They had droped it one day while she was in town, buying groceries for the week.

When she'd returned that evening, she saw immediately that it was gone, and then did not look at its place again until after dinner. Her husband rinsed his face in cold water at her sink, put a toothpick in his mouth, and walked comfortably into the front room.

She got all the familiar plates and glasses and cups and silverware together and put them in the sink to lie there and soak. Then she reached up and pulled the light cord behind her head, turning the window black before her face precisely as she lighted her kitchen.

That evening there was a wind from the northeast, carrying the feel and smell of snow in it. In the front room, her husband turned on the television, and she could hear the voices of the news commentators as they talked of various important events throughout the world. She couldn't hear what they were actually saying, however.

After she had put more detergent in the warm water, and was starting to massage the plates with her soft foamy sponge, she thought she heard her mother whisper her name.

For an instant, she paused: then she allowed herself actually to look into the blackness of the window, pretending that she was standing precisely where they had stood before, and pretending that she could feel the presence of a great and beautiful tree 481 paces before her, on the rim of her hill, that they also had gazed upon in their time.

In the simple darkness of this moment, that tree was no more not there than any conceivable tree that man or woman has ever gazed upon. Therefore, she knew as surely as she knew that her hands were plunged in warm soapy water, and that there were words coming from an electronic box in the front room, that she had been given another sign of the existence of that other place, where—upon some high rim—the tree existed in permanent and unapproachable distance, outside of time and remote from all the terrible flurry of human need—majestic, commanding, a thing of spirit, gripping with unfailing strength the whole sorry world, and holding it by the awesome purchase of its rooted claw.

158

Jack Matthews is Distinguished Professor of English and twice direc-
tor of the creative writing program at Ohio University. He is the au-
thor of six novels, *Hanger Stout, Awake!; Beyond the Bridge; The
Tale of Asa Bean; The Charisma Campaigns; Pictures of the Journey
Back;* and *Sassafras,* along with three previous volumes of short stor-
ies, *Bitter Knowledge* and *Tales of the Ohio Land,* as well as *Dubious
Persuasions,* published by Johns Hopkins. He is also the author of
Collecting Rare Books for Pleasure and Profit. Several anthologies,
including *The Best American Short Stories* and *Prize Stories: The
O. Henry Awards,* have featured his work, as have such publications
as the *New York Times, New Republic, Nation,* and *Mademoiselle.*

The Johns Hopkins University Press

Crazy Women

This book was composed in ITC Garamond text
and display type by Brushwood Graphics Studio,
from a design by Chris L. Smith. It was printed on
S. D. Warren's Sebago Eggshell Cream Offset
paper and bound in Kingston Natural and Multi-
color Antique by the Maple Press Company.